C000133454

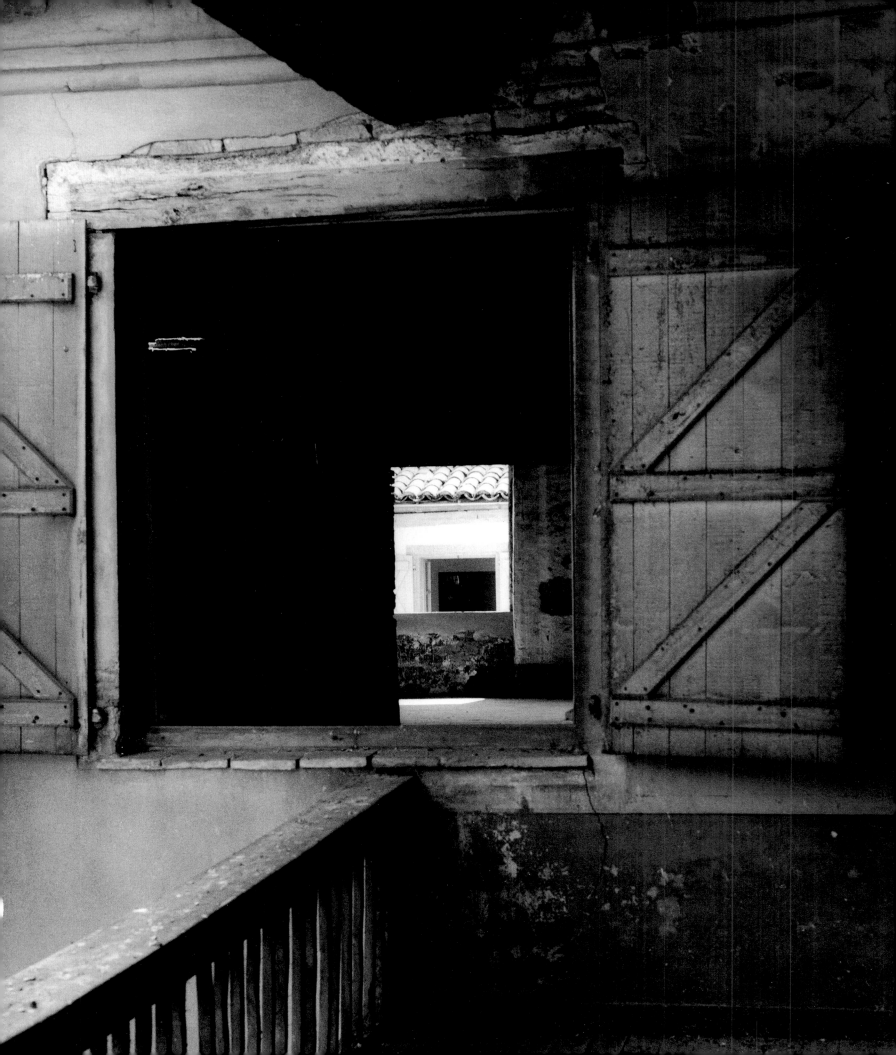

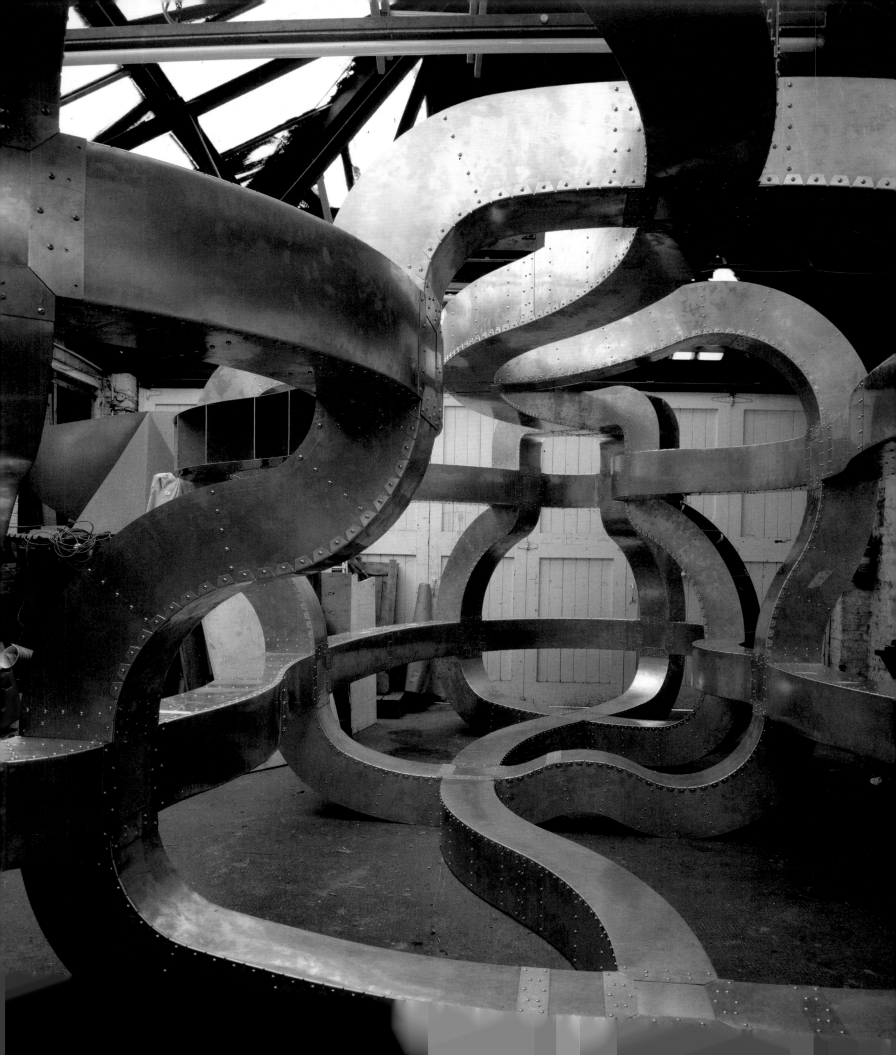

previous page Eighteenth-century restoration project, Montauban, France, 2006
following pages **Helen Chadwick** standing in her installation *Blood Hyphen*, 1988, Woodbridge Chapel, Clerkenwell and Islington Medical Mission, London, for the EDGE 88 international art festival

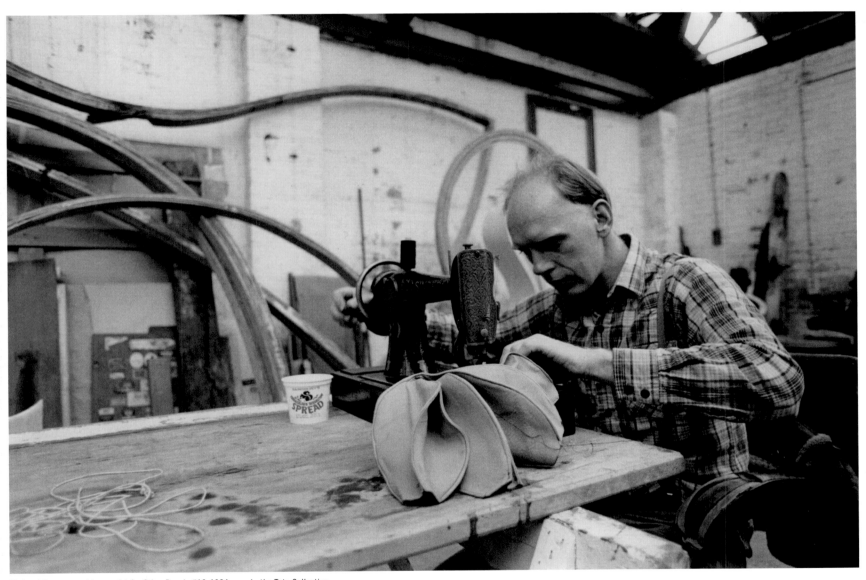

Richard Deacon working on *Art for Other People #12*, 1984, now in the Tate Collection

Richard Deacon, *Body of Thought #1*, 1987–8 (detail), in the artist's Brixton studio, 1988

following page **Julia Wood**, *Frame Infinite*, 1988, Plymouth City Museum and Art Gallery

Julia Wood, *Frame Infinite*, 1988, Battersea Arts Centre, London

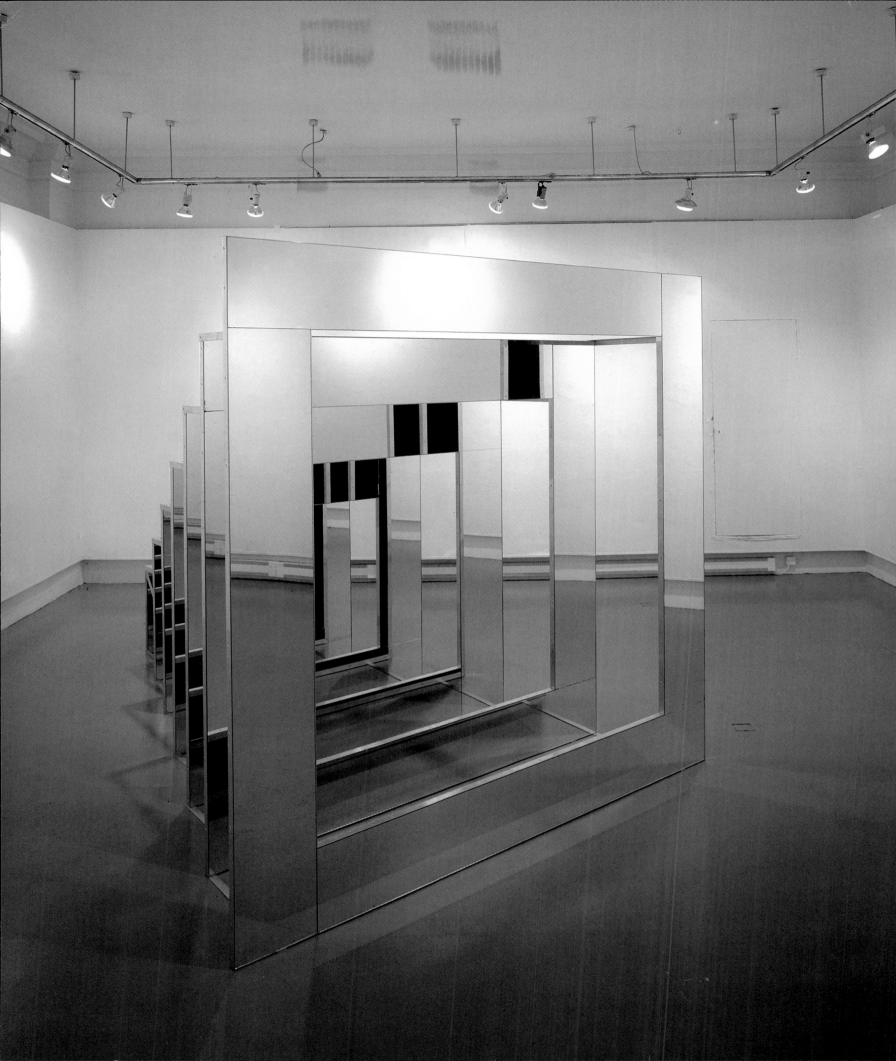

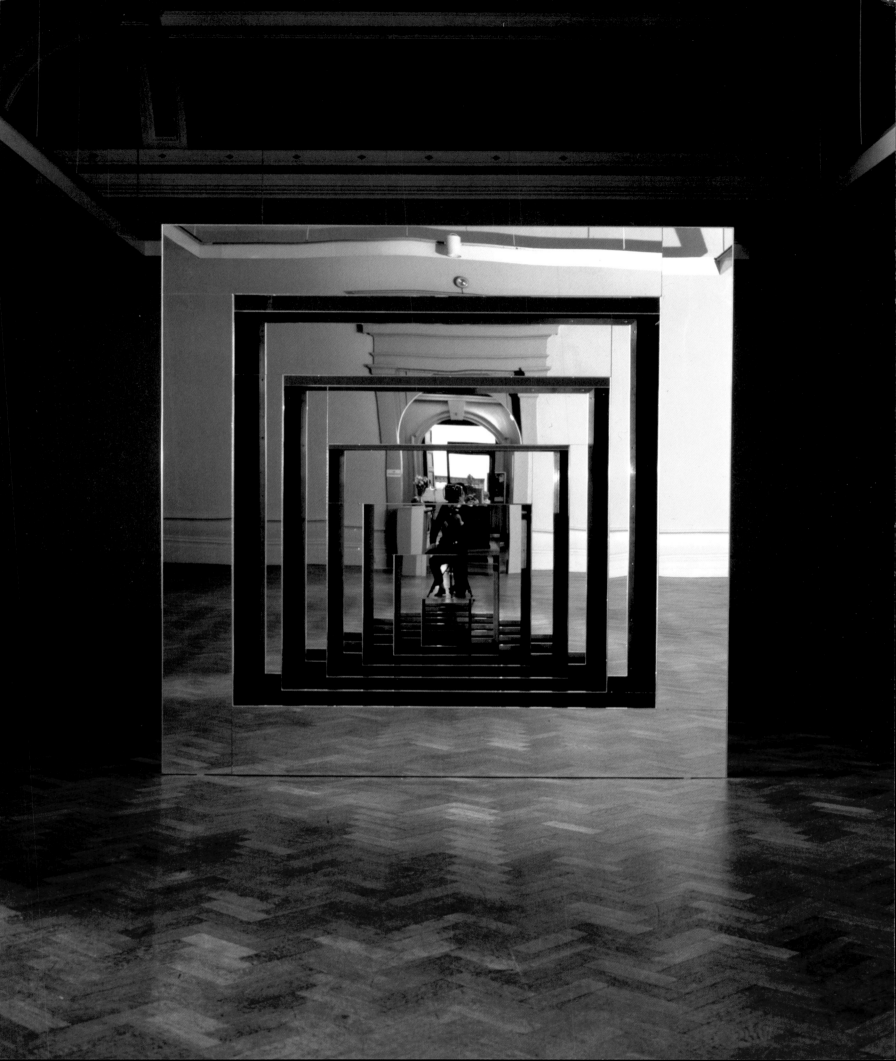

EDWARD WOODMAN
THE ARTIST'S EYE

edited by
Gilane Tawadros and Judy Adam

foreword by
Phyllida Barlow

with texts by
Gilane Tawadros
Woodrow Kernohan

ART/BOOKS

In association with Art360 Foundation
and John Hansard Gallery

First published in the United Kingdom in 2018
by Art Books Publishing Ltd
in association with Art360 Foundation and the
John Hansard Gallery, University of Southampton

Published on the occasion of the exhibition
'Space, Light and Time: Edward Woodman, A Retrospective',
John Hansard Gallery, University of Southampton,
24 November 2018–2 February 2019

Art Books Publishing Ltd
18 Shacklewell Lane
London E8 2EZ
Tel: +44 (0)20 8533 5835
info@artbookspublishing.co.uk
www.artbookspublishing.co.uk

British Library Cataloguing-in-Publication Data
A catalogue record for this book is available from the British Library

ISBN 978-1-908970-41-1

Designed by Herman Lelie
Layouts by Stefania Bonelli
Printed and bound in Italy by EBS

Distributed outside North America by
Thames & Hudson
181a High Holborn
London WC1V 7QX
United Kingdom
Tel: +44 (0)20 7845 5000
Fax: +44 (0)20 7845 5055
sales@thameshudson.co.uk

Available in North America through
ARTBOOK | D.A.P.
75 Broad Street, Suite 630
New York, N.Y. 10004
www.artbook.com

CONTENTS

Foreword
Phyllida Barlow

photography and sculpture – sculpture and photography?

are they inherently opposites?

or reciprocal?

one so controlled by the frame, the other escaping beyond the frame …

(but which refers to photography and which to sculpture?)

sculpture, with its desire to manipulate gravity, space, and time as if they are physical

materials in their own right, has to succumb to their supremacy

does photography have a similar relationship with light:

does light have supremacy in all the processes of making a photograph?

does photography have to succumb to light?

and the shadows?

a game of shadows – so essential for sculpture to play the game, or not …

to eliminate as well as to enhance how darkness and light fall

or, best of all, to leave light and dark to work through their twenty-four-hour cycles

as they will, unhindered by artifice;

so the install is finished, the stage is set, the work has to fend for itself;

it has left the studio and its place of production behind,

and is now a different species – alone and unprotected by its making processes;

but there is a final act of making: documentation;

and with this comes the dread of how the work will survive the ruthless acts of framing,

and become an image …

to be reduced to a single viewpoint,

where the physical circumnavigation of object and space is removed –

those restless qualities that repudiate the stillness of sculpture,

and which are beyond the reach of photography (documentation);

or are they?

Phyllida Barlow, *Deep*, 1991, Museum of Installation, London

Edward Woodman has an innate understanding of how the seemingly irreconcilable qualities of the physical interventions and interruptions of space, light, and time can be held within an image. The cleansed and anaesthetized glamour shot of an artwork, which is the preferred orthodoxy of catalogues, is radically challenged by his photographs. Vulnerabilities are exposed: works press up against the frame, and so too, with images where the work is at a distance, do the spaces in which they are located; drama and intimacy are given precedence, sometimes contradicting one another – demonstrative theatricality becomes quietened to allow space, light, and time to claim significance, while more subtle interventions are enhanced to allow exploration. The resulting images do not evoke a loss of what was actually there, but offer the stimulus of what the experience of being present initiated.

Edward's images of artists' works are themselves the work of an artist. His art is a visual poetry: it harbours profound observations of what the work is doing … what it is affecting … how the flesh and blood of the human encounter with it is aroused … and how time, place, light, materiality, physicality become emotional realities capable of being registered through the rigours of photography. He manipulates these rigours to open up what the act of being in a space with an artwork actually is – the realities. But he also provokes the camera into doing what it can do to its limit: to stalk and to capture, to seek out darkness, to displace brightness, to extol awkwardness, to be unafraid of depth, and height, and to ensnare mood as it is at the time … Edward's Time.

Those of us who have had the great fortune of having our work photographed by him will always treasure the images, and we realize more and more how conspicuously unique they are. We have the beauty of Edward's Time inscribed within our work – that is truly a great honour and privilege – but we have also his great artistry to reveal qualities about the work beyond the visual, an artistry that is now forever part of the work, as it was in the fleeting moment of his being there. That is Edward's Time.

'I had to make this gigantic knot of material at one end of the gallery, which is what he's standing behind, so he's got the full curve of the work, which in that space was very difficult to capture. To photograph sculpture and create an anticipation that there's more than what is in front of you is an extraordinary thing to achieve. He makes you sense that this isn't the whole story. There's a natural visual editing that goes on that isn't just about composition – it's about being there.'

Phyllida Barlow

Phyllida Barlow, *Expanse*, 1987, Unit 7 Gallery, London

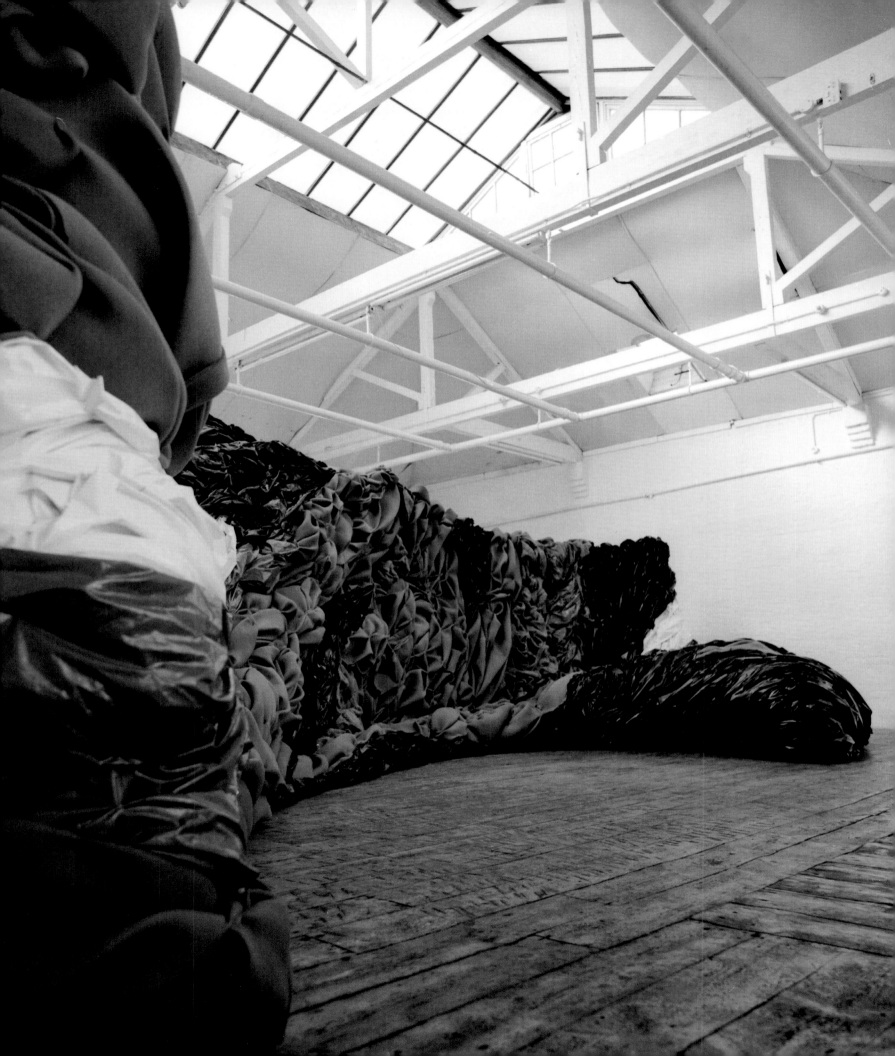

Photographing in Time: The Art of Edward Woodman
Gilane Tawadros

Photographer, artist, observer, diarist, collaborator, Londoner: Edward Woodman occupies a unique place in the history of British photography and contemporary art. For more than fifty years, he has recorded the changing face of London and the community of artists in its midst. His lens has been both an attentive witness to the architectural, social, and cultural transformation of the capital since the late 1960s, and a diligent observer of the shifting ways in which artists have made and presented their work over the past four decades. A key protagonist in the London art scene of the 1980s and 1990s, he became an intimate friend and collaborator to two generations of British artists, many of whom were to achieve international acclaim and bring about a sea change in our understanding of what art can be.

The singularity of Woodman's achievement lies in the collaborations that he undertook with these artists. At a time when new forms of sculpture were emerging, and site-specific installation and performance were becoming central to art practice, he became the photographer of choice for a range of artists who recognized his unparalleled ability to present their radical works and ideas through photography. Having worked initially as a commercial photographer and then in television news, Woodman brought a sharp eye to documenting contemporary art that resulted in a groundbreaking vision that was highly valued by those who collaborated with him. But his beautiful and distinctive images go beyond mere documentation, for they are traces of creative relationships that became intrinsic to the artworks and the way they have been received by audiences. According to artist David Ward, Woodman has a special way of communicating with and establishing a rapport with his collaborators.[1] He has an acute sensitivity to their creative needs and ambitions, takes particular care in the way that he photographs their work, and transmits his genuine interest and love for their art. Woodman's insight into their intentions and what they wish to articulate through a work enables him not only to represent the art, but also, more importantly, to interpret it, transforming the act of photography into a form of curation.

In 1988, Woodman was invited to document an exhibition organized by a small group of art students from Goldsmiths' College inside a disused Port of London Authority building in Surrey Docks, on the banks of the River Thames in south-east London. The historic docks, which had been in use since the seventeenth century, were closed in 1969 and subsequently filled in by the Port of London Authority and the London Borough of Southwark. In 1981, the London Docklands Development Corporation (LDDC) was established with a brief to regenerate the depressed area around the former dockyards. At that time, the place was 'characterised by vast tracts of vacant development land in the infilled docks, a collection of temporary industrial and storage uses on short-term leases around the remaining docks, the vestiges of some wharfage-related activities on privately owned sites around the riverside and a ring of local authority housing, much of which was in a poor state of repair'.[2] It was here that a twenty-three-year-old Damien Hirst organized the now-celebrated exhibition 'Freeze', in three rolling cycles,

Edward Woodman, photographed by **Helen Chadwick** in her Beck Road studio while working together on *Wreath to Pleasure No. 9*, 1992

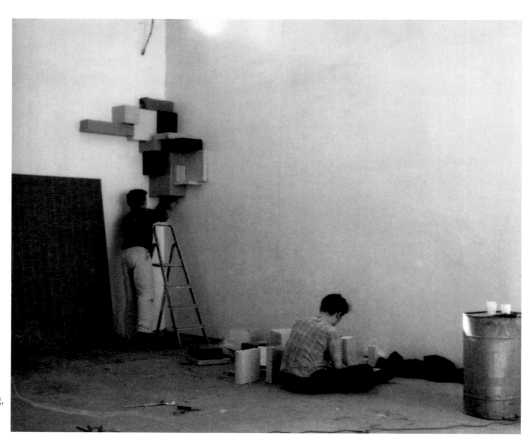

Ian Davenport (seated) helping **Damien Hirst** to install the latter's *Boxes* for the 'Freeze' exhibition in the Port of London Authority building, Surrey Docks, London (painting against the wall by Angus Fairhurst). Photographed in July 1988.

opening on 6 August 1988 and running until the end of September. The show featured work by Hirst and fifteen of his fellow Goldsmiths' students, and attracted leading art-world figures including Nicholas Serota, Norman Rosenthal, and Charles Saatchi. A critical aspect of the exhibition for Hirst was the creation of a high-quality catalogue, modelled on those produced by commercial galleries such as Anthony d'Offay, where Hirst had a part-time job:

> I met Edward Woodman for the first time when he did the photography for the 'Freeze' publication, but I'd known of him before that because I'd seen his images in the catalogue for the 'Objects & Sculpture' show.… As soon as we decided to put on 'Freeze', we wanted it to feel as professional as possible.… I really believed in all the work that my friends were making, and I didn't want people to not take us seriously just because we were students. I knew that not all of the art world's bigwigs were going to come down to Docklands … so I wanted to keep a record of the whole thing. Properly documenting the show and producing a catalogue was a huge part of that. I got a guy called Tony Arefin to design it. He asked me, 'Which photographers do you like?' I wanted the best I could think of, someone who was working with the leading galleries. Edward was the only one that I wanted. Tony said, 'Let's ask him!' We needed someone who really understood art, which is why I was so excited when we got him.[3]

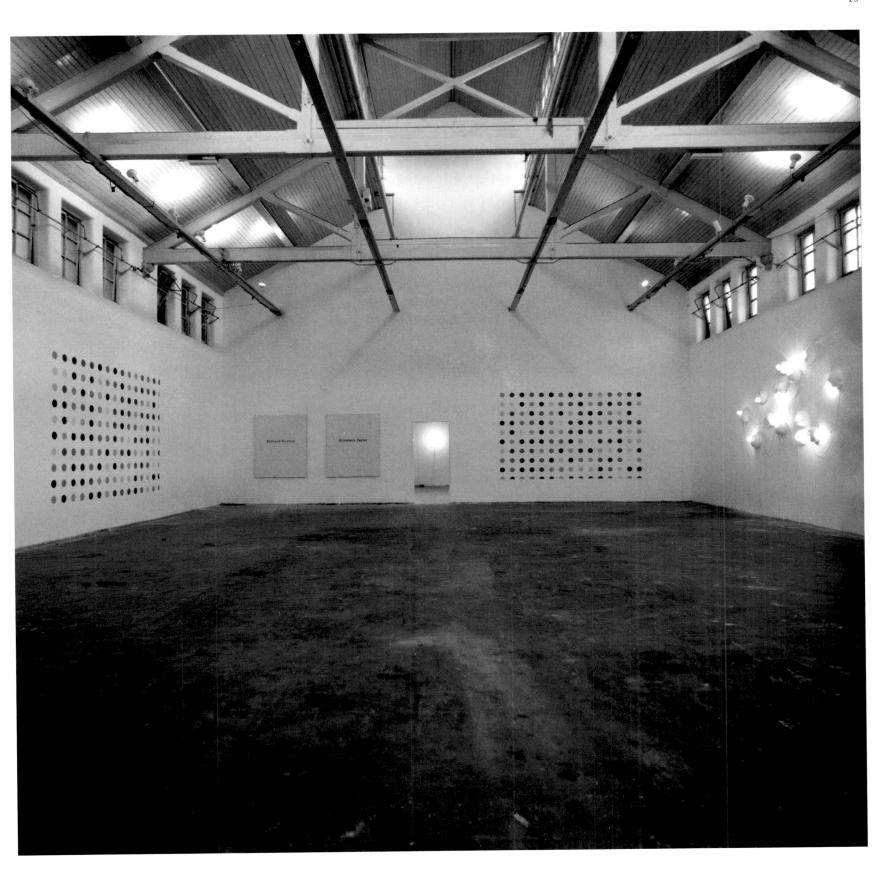

Installation view of 'Freeze', showing works by **Damien Hirst, Simon Patterson**, and **Angela Bulloch**. Photographed in November 1988.

The exhibition 'Objects & Sculpture' had been organized in 1981 by Sandy Nairne, then director of exhibitions at the Institute of Contemporary Arts (ICA) in London, assistant director of exhibitions Iwona Blazwick, and Lewis Biggs, then director of Arnolfini in Bristol. It was shown in two parts across both venues, with half of the exhibited artists appearing initially at the ICA and then at the Arnolfini, while the other half showed first in Bristol followed by London. The exhibition had been a response to an emerging generation of sculptors (whose work would soon be convened under the rubric 'new British sculpture') who created witty, urban sculptures that were quite distinct from the landscape approach of artists such as Richard Long and Hamish Fulton, and far removed from the more traditional work of an earlier generation.

The eight sculptors in the show – Edward Allington, Richard Deacon, Antony Gormley, Anish Kapoor, Margaret Organ, Peter Randall-Page, Jean-Luc Vilmouth, and Bill Woodrow – were each represented in the exhibition catalogue with a short biography, an artist's statement, and photographs of their work, the majority of which had been taken by Woodman.[4] As would become his hallmark, the photographs were not conventional documentary images, but reflected Woodman's attentiveness to the intentions of the artist and the needs of readers of the catalogue. One page of the book shows an installation shot of Allington's plaster works alongside the same artist's drawing of similar forms (see left). Characteristically, Woodman's photograph is not a face-on view of the installation but a shot taken at an angle from above. Anticipating the requirements of a future audience who would not have seen the work in situ, and who needed to make sense of the sculptures from a two-dimensional black-and-white image after the event, he photographed the sculptures from this awkward perspective to give the viewer a peculiarly immersive and intimate sense of the physical artwork.

The artist Phyllida Barlow has commented on the particularity of Woodman's photographic approach to sculpture, which has been eclipsed in recent years by more conventional approaches that tend towards flawless and all-embracing views of a work:

> I don't think Edward bothered about the glamour shot. I think the death of photographing sculpture has been this obsession of finding the best view as an image of a piece of sculpture, and it usually reduces that sculptural language to a pictorial language…. He had an intriguing way of being able to actually give you what might be quite an uncomfortable view of a work, and to face up to that, and then allow that to become extremely beautiful as an image.[5]

Woodman frequently occupies a precarious position to take his shot. He suspends himself dangerously high up above Richard Wilson's celebrated pool of engine oil (pp. 75 and 140–1) and Anya Gallaccio's bed of roses (pp. 170–1), for instance; and he seems close to being smothered by the abundant folds of heavy fabrics and materials (recycled from earlier works) with which Barlow had inundated the space with her work *Expanse* at Unit 7 Gallery in 1987 (p. 15). He edges up to the periphery of the same gallery to reveal Lucia Nogueira's hybrid form *Untitled* from 1989 (p. 23); and with Richard Deacon's *Other Men's Eyes #2* at Interim Art in 1986, he appears to hover above the metallic curves of the sculpture, which occupies the entirety of a corner of the gallery (p. 22).

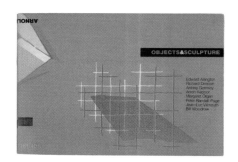

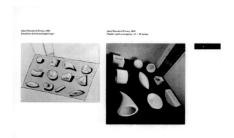

top Cover of the catalogue for 'Objects & Sculpture', published by the Institute of Contemporary Arts, London and Arnolfini, Bristol, 1981
bottom Edward Allington, *Ideal Standard Forms*, 1980, as reproduced in the 'Objects & Sculpture' catalogue

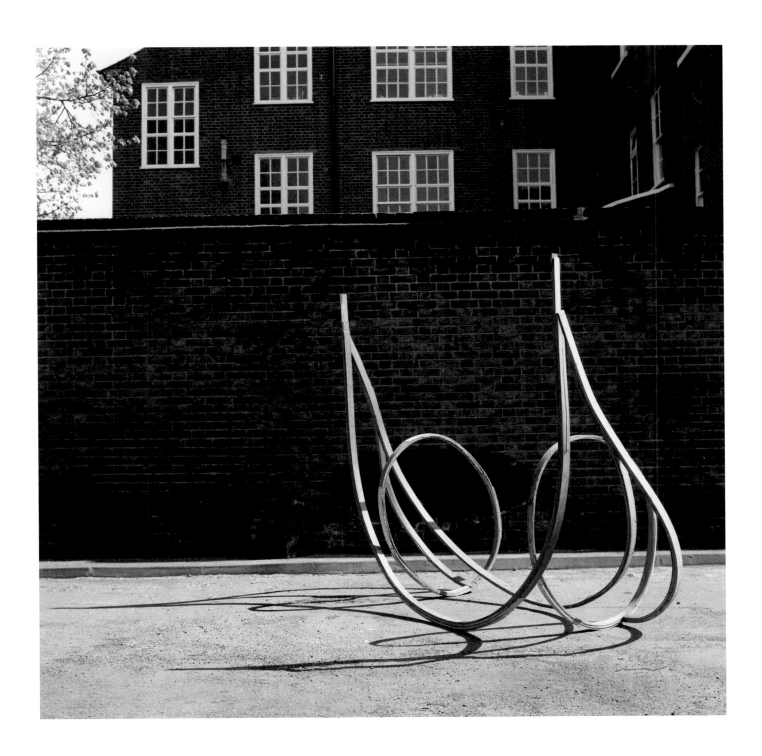

Richard Deacon, *Untitled*, 1981, photographed for the 'Objects & Sculpture' catalogue

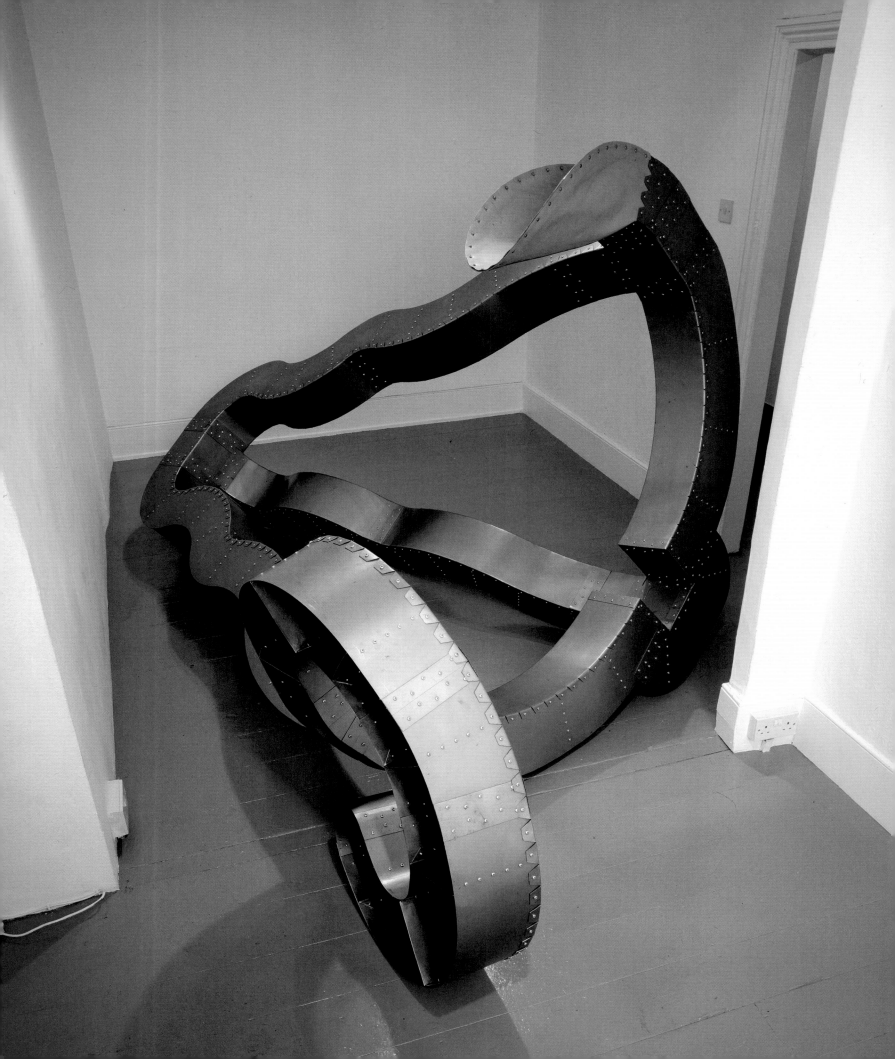

Lucia Nogueira, *Untitled*, 1989 (detail), installation at Unit 7 Gallery, London

Richard Deacon, *Other Men's Eyes #2*, 1986, Interim Art, London

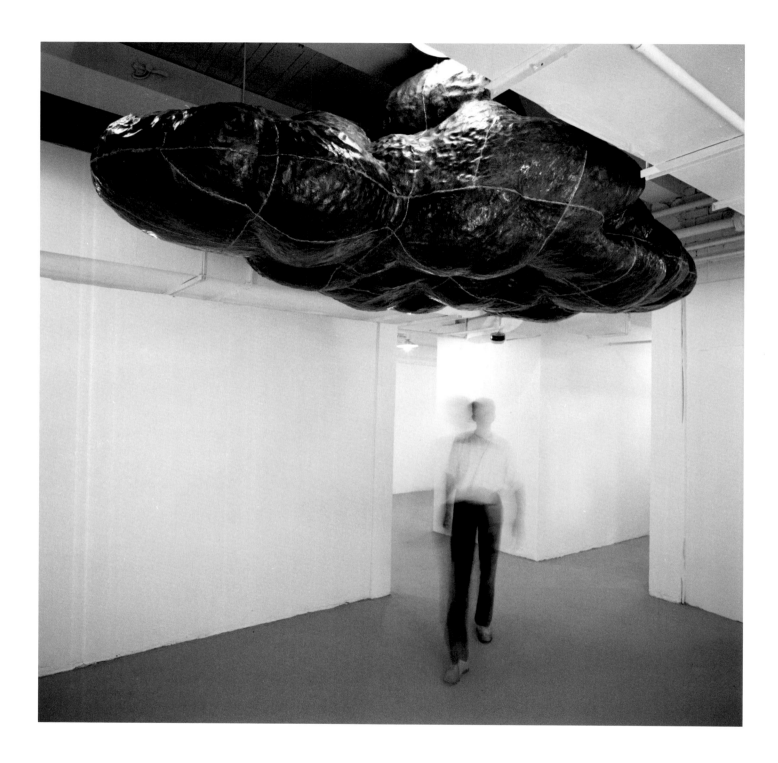

Antony Gormley, *Mind*, 1983–4, in the solo exhibition 'New Sculpture', Riverside Studios, London, 1984

There is a filmic quality to Woodman's images, which, as David Ward observes, enables him to create an immersive environment that places the viewer, intimately, at the very heart of the artwork: 'Many of these photographs ... [go] beyond the notion of the camera as a frame-making device … opening a window or a door onto the world; it's more to do … with apprehending the whole thing as a screen.'[6] An avid student of the movies, Woodman was exposed to film throughout his childhood in the East End of London, where his father managed a local picture house. Evoking the New Wave French cinema of the 1950s and 1960s, which he would have watched looking down from the projection box, he offers us a cinematic view of sculptures and installations in which the camera appears to have been cranked up in a confined space to look down onto the artworks below.[7]

Woodman would go on to work repeatedly with a number of the artists in the 'Objects & Sculpture' exhibition, including Deacon, Gormley, and Allington. In doing so, he became, as he would do on a number of occasions, a friend and collaborator with a group of artists who were taking British artistic practice in a radically new direction. Woodman's deep understanding of what these young sculptors were wishing to express enabled him to reconstruct their three-dimensional works in two-dimensional images that could represent their practice long into the future.

Woodman began working with Allington in 1981. It was to be a collaboration that would last for more than a decade, resulting in a series of photographic works that pictured Allington's 'ideal standard forms' – pastiches of classical architectural fragments fabricated by the artist – appearing anonymously and enigmatically in the English landscape and other peculiar settings. Influenced equally by Western and Eastern aesthetic ideas, Allington had been deeply influenced by the Japanese philosopher Yanagi Sōetsu, who developed the notion of *mingei*, or people's craft, which was underpinned by the principle of anonymous devotion to simply making things well. As an artist, Allington was committed to art as an ordinary, everyday activity, a product of social labour no different from a beautifully made Rolls-Royce Silver Cloud, which might appear 'silently … from behind a hill on the road' in the Welsh countryside, not unlike his own 'ideal standard forms'.[8] As part of their long-term project *Decorative Forms Over the World*, Woodman was dispatched with various versions of Allington's 'forms', which he would photograph in different locations of his choosing. The appeal for the artist was in the humorous incongruity or, as he put it, 'the sense of wrongness' of the juxtapositions.[9] This 'wrongness' also appealed to Woodman, whose own early performances displayed a similar surreal wit (see, for example, p. 185).

Throughout the 1980s and 1990s, Woodman was the photographer to whom artists, arts organizations, and commercial galleries in London turned to document paintings, sculptures, installations, performances, and site-specific works. Many of the galleries for whom he worked were small independent or commercial spaces that have long since closed – Unit 7 Gallery, the Museum of Installation, Mario Flecha Gallery, Lewis Johnstone Gallery, Riverside Studios, and Slaughterhouse Gallery, among others – or were located at non-art sites that were later to be substantially developed and transformed, such as Surrey Docks, Smithfield Market, and Wapping Hydraulic Power Station.

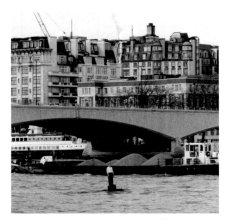

Stephan Balkenhol, *Figure on a Buoy*, 1992, in the exhibition 'Doubletake: Collective Memory and Current Art', Hayward Gallery, 1992

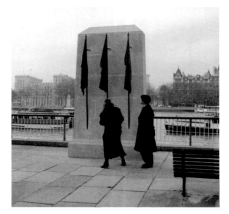

Juan Muñoz, *Untitled (Monument)*, 1992, in the exhibition 'Doubletake: Collective Memory and Current Art', Hayward Gallery, London, 1992

Jenny Holzer, Selections from *Truisms* and *Survival*, 1992, in the exhibition 'Doubletake: Collective Memory and Current Art', Hayward Gallery, London, 1992

Woodman, who has lived in London for almost his entire life, witnessed and captured on film the demolition in the late 1960s of the existing housing stock in Bloomsbury, where he then lived, as it was destroyed to make way for the concrete ziggurat structure of the Brunswick Centre (p. 62). Completed in 1972, this iconic complex became his home, and it remains so to this day. His vast archive of negatives, transparencies, and hand-made prints is housed within his apartment in the building, where he also retains a darkroom for personal use. His interest in architecture and building forms has resulted in a number of projects with architects. In 1983, he was asked to photograph some paintings that Zaha Hadid had produced of her Peak Project in Hong Kong. Happy with the results, Hadid then invited him to photograph her architectural models almost exclusively for the next seventeen years (p. 186). Woodman's approach to photographing the models was not to make them look like fake real buildings. His interest in them was as objects – but objects possessing a relationship to a full-scale three-dimensional reality. His experience in television and also of observing location movie-making led to his exclusive use of tungsten lighting and, especially, a small focusing spotlight as a key light – that is, one 'believable' light source against which all other sources become subservient. This approach, Woodman claims, goes against the trend in studio photography of the last thirty years…. Also, as Hadid's models are built mainly in translucent materials, such as Perspex and cast resins, these demand an intense illumination in order to induce internal reflections that, in turn, define the edges of planes. 'I attempt to show their jewel-like appearance' says Woodman.[10]

Some years later, Woodman would combine his close observation of the city with his skill in documenting art to produce a body of images that provide a lasting record of several public artworks commissioned for the Hayward Gallery's 'Doubletake' exhibition in 1992. Curated by Lynne Cooke, Bice Curiger, and Greg Hilty, the show explored the idea of collective memory in relation to contemporary art. David Ward was invited to photograph the works inside the gallery, while Woodman took photographs of the exterior works, including Stephan Balkenhol's figure of a man floating on the surface of the Thames below Waterloo Bridge; Juan Muñoz's displaced cenotaph bearing three bronze flags; and Jenny Holzer's LED aphorisms that rolled above the counters of the Royal Festival Hall box office. These images strangely echo earlier photographs by Woodman of a city that was on the brink of radical transformation: the artist Helen Chadwick sitting on a sofa in Beck Road in Hackney, surrounded by the contents of her house, which have been ejected onto the street (pp. 112–13); a draper's shop window in Spitalfields, which is reminiscent of Brassaï's haunting images of deserted Paris streets (p. 149); and Michael Landy's fictitious *Scrapheap Services*, for which the artist had made thousands of small cut-out figures from rubbish that Woodman photographed being crushed under foot by passers-by (opposite). There is a sense of something surreal and even sinister in Woodman's cityscapes, informed perhaps by his work as a stills photographer for Thames Television in the mid-1980s for whom he recorded crime scenes, which he told the artist Cornelia Parker had 'ruined the landscape of London for him'.[11]

Robin Klassnik, founding director of Matt's Gallery in London, has always been fastidious about the documentation of his projects, and he employed Woodman to photograph all the exhibitions at the gallery's earliest spaces, first in London Fields and then in Mile End. Many of the artists who worked with Klassnik were invited especially to test the possibilities of installation and the

Michael Landy, *Scrapheap Services*, street performance, January 1995

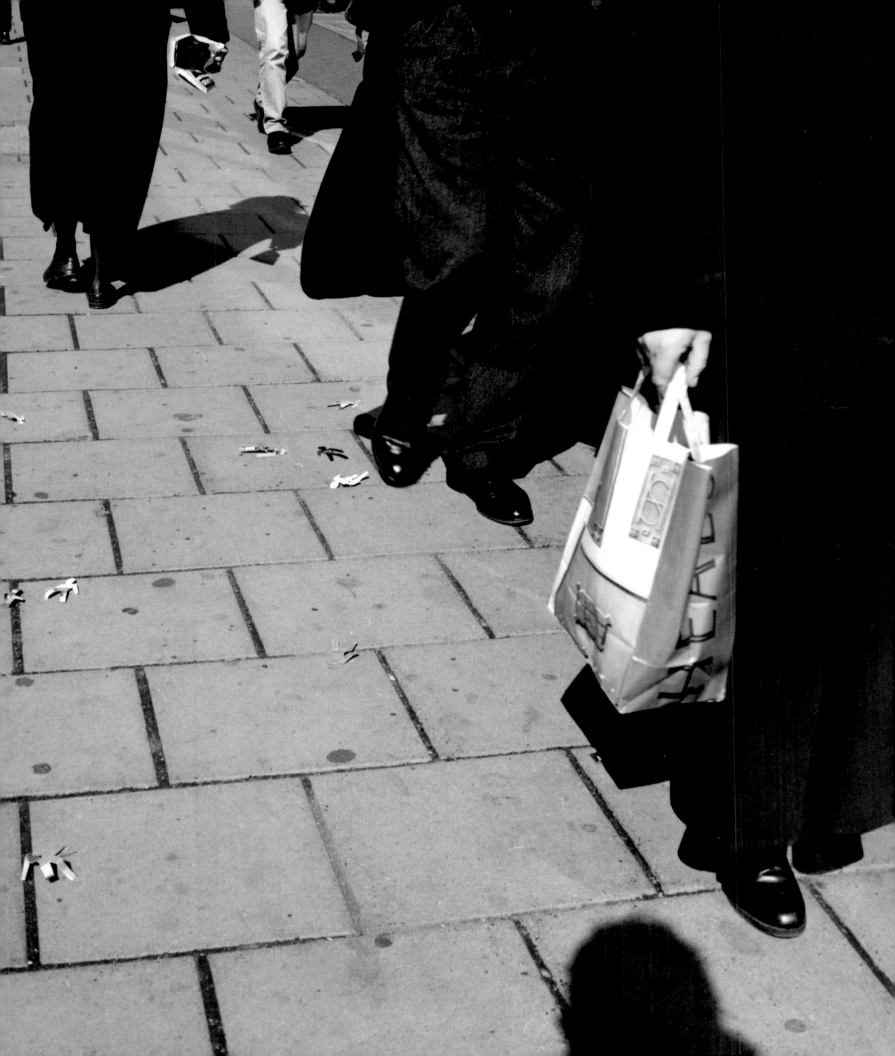

very nature of site-specificity. In 1989, for his third show at the gallery, sculptor Richard Wilson made *She Came in Through the Bathroom Window*, a site-specific intervention that involved removing a twenty-foot section of the steel-framed window running along the length of the longest wall of the building, and installing it inside the space at an angle of forty-five degrees, suspended from one of the interior gables. In his essay on artists and public space, Edward Allington speculates on the reasons for the emergence of site-specific art in America in the late 1960s and early 1970s as a way of dealing with a world that was becoming too full: 'If site-specificity is, as I suspect, a response to an overcrowded and now culturally complex world, it is also an idea with subtexts: site determined, site orientated, site conscious, site responsive, site related, site generated. It has, as a term and a methodology, absorbed previous concepts such as the memorial, the community, the decorative and the art work in public.'[12]

Works like *She Came in Through the Bathroom Window* pushed the boundaries of contemporary art practice and used the physical fabric of the gallery as the raw material for creating new artworks. As Wilson explains, 'The window [of the gallery space] was actually drawn out of the space where it is normally located, and brought into the room so that the outside world expands but the interior architectural space shrinks.' Woodman was perfectly placed to collaborate with this generation of British artists who were exploring site-specificity in new ways, using the city and its architecture as integral components of their work. Two years earlier, Wilson had made *20:50*, again at Matt's Gallery, where he transformed the space into a reflective pool, filling the gallery to waist height with recycled engine oil (pp. 75 and 140–1). In the absence of a traditional art object, Woodman's documentation of the site-specific installation was all that remained after the exhibition had closed, transforming the role of photographer into one of artistic collaborator who was now charged with creating the only permanent record of the work.

> Edward was a genius. He was the only real practitioner at the time who was professionally documenting artists' work. And so he was in big demand. The fabulous thing was that he could bring emotion into the photographs. [The] photograph of *She Came in Through the Bathroom Window* [was] the only one he shot.... He would come in and ... look at the piece for about half an hour. He would then set up and he'd go click, and that's it, one image.... He'd always do a Polaroid. He'd look at it and say, 'Right, that's the shot', then he would mount the film stock on the back, so he always had a check, like they do today.... I remember when we did *20:50*, he climbed on top of the office at Matt's Gallery and shot down.... It's a bird's-eye view. I thought it was very clever because he accentuated this idea of looking down into the oil, of falling into the void of the sky, by climbing up and setting up the tripod to look down at me. It's a classic image.... He was able to give a feel for the sensuality of the work and the way in which the form actually played within a space. He was able to pick up on various aspects and hold that within the shot.... I don't think he was making documentation. He was making an artwork out of an artwork. He was finding an artwork for himself, and in finding that, he was also able to produce a fantastic image for the artist and for the gallerist to have as documentation, so you completely understand what's going on.[13]

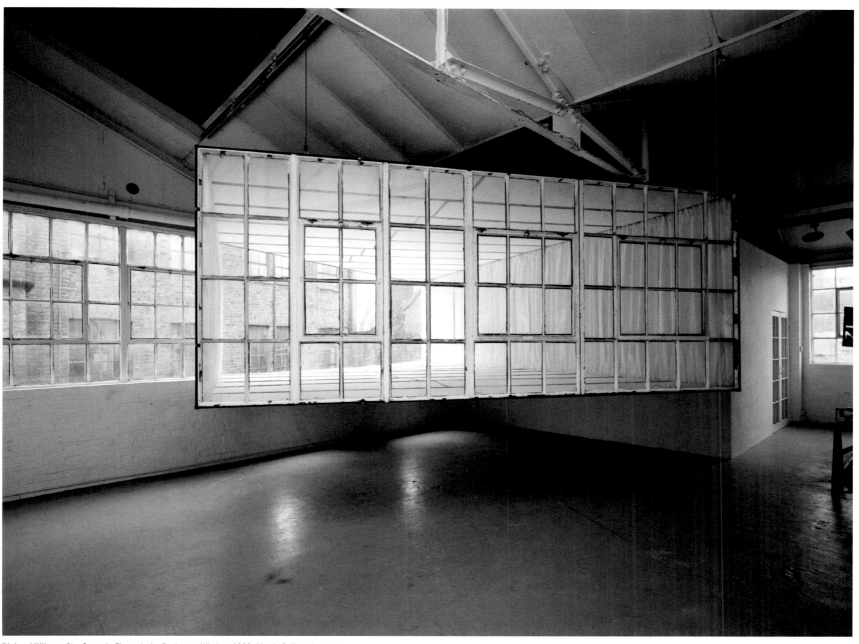

Richard Wilson, *She Came in Through the Bathroom Window*, 1989, Matt's Gallery, London

'It only needed one shot to sum it
all up like an architectural drawing:
the inside, the outside, the aperture,
and the ambiguity of the planes ...
but thankfully, it still looked a puzzle
of a picture.'

Edward Woodman

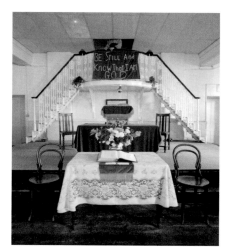

Woodbridge Chapel, Clerkenwell and Islington Medical Mission, London in 1988, showing **Helen Chadwick** standing in the pulpit with her head poking through the false ceiling into the darkened space above

Woodman was to work collaboratively in this way with a number of British artists to document their key works throughout the late 1980s and early 1990s. One of the most important of these collaborations was with Helen Chadwick, with whom Woodman created photographs of several of her most iconic installations. In 1988, he photographed *Blood Hyphen*, which had been commissioned by the curator Rob La Fresnais for the EDGE 88 festival and was presented in the Clerkenwell and Islington Medical Mission in Farringdon (pp. 4–5, 68–70). Staged by Chadwick as an 'artificial "miracle"', the piece took advantage of the history and function of the site. La Fresnais explained how he and the artist had come across the building in 1987:

> Wandering around the streets, looking for a site with Chadwick, we happened on a queue of elderly people outside a door. It turned out, anomalously in this now prosperous area, that an almost Victorian institution existed here. Even since the founding of the NHS, the local clients of the mission came here for medical treatment in exchange for taking part in a prayer meeting. Chadwick insisted we try to get a meeting with the doctor/priests who ran this place, and it turned out they were a unique small fundamentalist Christian sect dating back to the last century. We asked to see the adjoining chapel, and were astonished to find an interior where the pulpit seemed to extend right up to a sixties-style false roof. We asked to climb into the pulpit and discovered that by removing a panel, you could put your head into the top part of the artificially divided chapel and see the gallery above, complete with traditional pipe-organ with an extraordinary, melancholic light coming in, giving the roof interior an almost gothic air.[14]

Woodman's enigmatic colour photographs of the installation capture the hallowed nature of the space as well as emphasizing the erotically charged and profane aspects of Chadwick's intervention. The warm and subdued tones of the shuttered wooden interior of the chapel are illuminated by a piercing beam of red light that cuts across the space before landing on a large photograph of human cells laid out on the floor below. Writing about the work in the *New Art Examiner*, Oliver Bennett described the red laser beam as 'representing the link (or "hyphen") between the blood of Christ and procreation, shone from a crescent in the wall, cutting through the top bit of the chapel, to land in a photograph of cells, referring to high-tech healing processes for cervical cancer. In the darkened interior of the chapel, it had a similar beatific radiance to stained glass and a feeling of erotic abstraction that would have delighted St Teresa of Avila.'[15]

With these and other photographs, Woodman displays an unerring appreciation of the distinctive character of site-specific artworks and the need to represent the different modes through which they operate, combining simultaneously 'the memorial, the community, the decorative and the art work in public', as Allington had described. His photographs of Caroline Wilkinson's *Correspondence* at the Whitechapel Open in 1992, for example, are elegiac images of an elegant installation that taps into the historical past of the city and its inhabitants. A descendant of a Huguenot family, Wilkinson had inserted a series of copper plates in between cobblestones near Old Spitalfields Market, each one bearing a Huguenot place name still in use in the city hundreds of years later (opposite).

Further east in Wapping, Woodman had two years earlier photographed Anya Gallaccio's *Prestige*. Located in an old pumping station, the installation was made up of a collection of tea kettles that expelled a torrent of steam up through a narrow but tall chimney, greeting visitors with a piercing noise as they emerged from the Tube station and before they had even entered the space (overleaf). The artist had been drawn to the history of the chimney, which had released steam to generate the power that supposedly operated the curtain at the Royal Opera House in Covent Garden, as well as lifts and other machinery around London. For Gallaccio, only Woodman fully grasped the overall structure and meaning of the work:

> I love those photographs of the tea kettles. It's like a weird, fairytale space with the glinting of the metal and the darkness of the space, but I feel like you get the sense of the height.... Other people came and looked at that and tried to work out how to photograph it, and they just wanted to photograph the kettles on the table and I kept saying, 'But it isn't really about the kettles on the table; it's about the whole context and the environment.' You could hear the kettles when you came out of the Tube at Wapping. You didn't recognize what it was at first, but as you got closer to the building, you realized that you were coming close to the sound, which was getting louder. So, for me, that was an important part of it, that when you were walking towards the work, you didn't know that

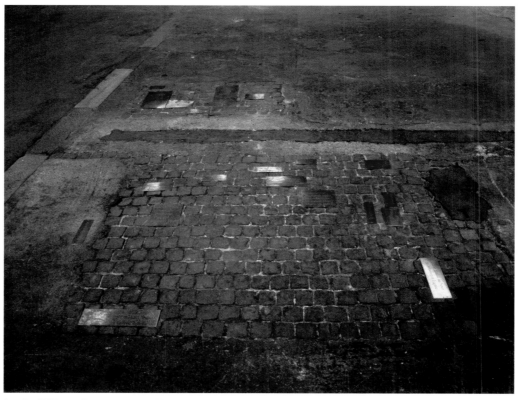

Caroline Wilkinson, *Correspondence*, 1992, Old Spitalfields Market, Whitechapel Open, London

you were approaching it, but then as you left the building, you knew what the sound was.… [It] functioned … like a memory or a nagging child or something tugging at you. You could walk away from it, but it was there in the back of your senses and your memory.[16]

The scale and ephemeral nature of Gallaccio's installations, coupled with their multi-sensory dimension, make them particularly difficult to document, but she found in Edward Woodman a photographer who was able to represent the abundant and sensuous quality of her work through shimmering, jewel-like colour photographs shot on a large-format camera, and could capture their brooding and melancholic aspects in rich and deeply intense black-and-white images: 'I think I used the black-and-white pictures more often than the colour ones, strangely. There's a richness to his photography that I really enjoy, the intensity of tone, [and] there's a sense of the colour in the black-and-white. The roses look more like scabs or wounds, so there's more of a sense of death or something intense from the black-and-white pictures.'[17]

Woodman's black-and-white photographs of Gallaccio's early installation works are reminiscent of Bill Brandt's female nudes: the intensity of tone; the seemingly infinite gradations of black and grey; the abstracted, sculptural form of the female body set in the landscape; the sense of intimacy and closeness to the figures; and the awkward angles at which Brandt shot his

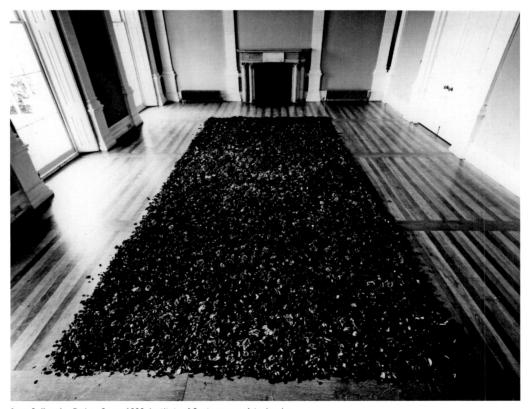

Anya Gallaccio, *Red on Green*, 1992, Institute of Contemporary Arts, London

subjects. Just as Brandt's female subjects appear to be integrated into the landscape, Woodman's images suggest a seamless continuity between the artworks he photographs and the sites in which they are situated.

David Ward, who at one time also photographed other artists' works, locates Woodman as part of a continuum of artist-photographers who have gone against the grain of conventional photographic documentation to develop new ways of picturing works of art, which in turn have become artworks in themselves, from Brassaï's photographs of Picasso's sculptures to Brancusi's photographs of his own works:

> Man Ray's autobiographical recollections describe the occasion when Brancusi was dissatisfied with a photograph that he'd received – I think it was [from] Stieglitz. First of all, it is quite interesting that Brancusi felt able to be critical of the photograph by an acknowledged master of the medium of photography, as he would have been described; but also that it stimulated him to want to photograph his own work. Man Ray was the friend who taught him how to use a plate camera, how to build a darkroom in the corner of his studio. Brancusi presented Man Ray with a stack of photographs on a later visit, declaring, 'This is how my sculpture should be photographed.' Brancusi's photographs are very often quite different from the technical proficiency that many artists require in the recording of their work. They can be in and out of focus, they can be over- or under-exposed, they can carry Brancusi's own fingerprints and splashes of developer and fixative. In other words, they have all sorts of qualities that would conventionally be regarded as faults, and these, of course, are the signature of the artist.[18]

Like Brancusi and Brassaï, Woodman creates an equivalence between the artwork and his image of it, which render his photographs as works of art in their own right rather than prosaic records of others' artworks.

Woodman's cinematic eye and his interest in performance also made him the ideal photographer of important early and iconic performances by artists as diverse as Stuart Brisley, Mona Hatoum, Michael Landy, David Medalla, and Cornelia Parker, among others. In late 1988, Parker worked with Woodman for the first time when she began to create *Thirty Pieces of Silver*. It involved Parker crushing under a steamroller more than a thousand silver and silver-plated metal objects, which she had laid out on the tarmac at a breaker's yard in Chorleywood. Woodman shot 'before' and 'after' images of the event. He photographed the steam roller as it moved off and after it had flattened the silverware. The viewpoint of the camera is at ground level, looking up at a sharp angle at the dark, imposing mass of machinery that has done its work and is now lumbering away from the scene of the crime.

Four years later, Parker asked Woodman to drive down to the White Cliffs of Dover on a wet and blustery day to photograph a performance piece, *Words That Define Gravity*, that involved Parker throwing the dictionary definition of 'gravity' (which she had cast in lead in her own

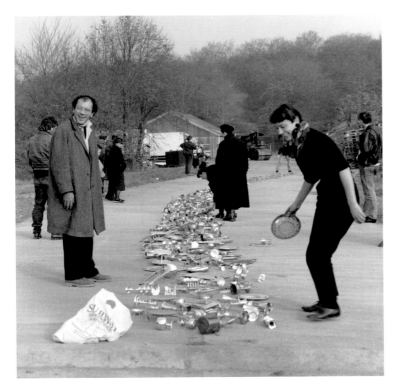
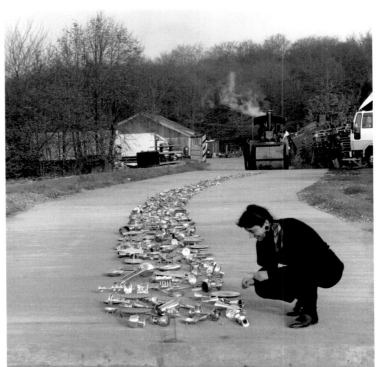
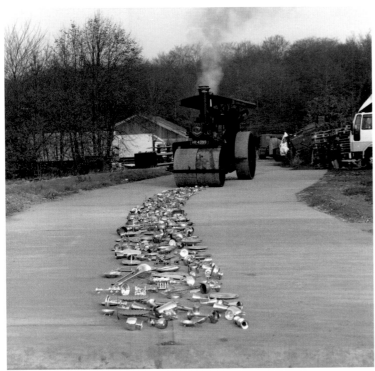

Cornelia Parker, *Thirty Pieces of Silver*, 1988 (work in progress)

'I laid all of the silver out and then Edward recorded it, a sequence of about twelve photographs. He was always very economical. He didn't take hundreds of images, just a few. He was almost like the one-shot wonder.'

Cornelia Parker

handwriting), word by word, over the edge of the cliff. In one of the images, Parker has hurled the work 'specific' into the air and over the precipice, where it hangs, frozen, like a still from a poetic and oblique arthouse film. Just as the Russian film-maker Andrei Tarkovsky, whom Woodman greatly admires, transformed film-making into a process of sculpting in time, Woodman's archive of images of London and its artists reflects a life devoted to photographing in time. His deep insight and acute sensitivity to his subjects enable him to create photographs that allow us as viewers in the future to experience the city and its artists in the present tense.

In a photograph of Julia Wood's sculpture *Frame Infinite* taken in the Plymouth City Museum and Art Gallery in 1988 (p. 8), Edward Woodman is visible at the very centre of the image, framed and contained by the artwork. Reflected in the mirrored surface of the sculptural installation, the photographer – sharply dressed and wearing brown brogues and red socks – sits on a stool looking through the viewfinder of his large-format Linhof Technika. Man and camera are fused together. As Phyllida Barlow observed, 'It's as though he's not frightened of almost touching the work…. He's using the camera as a sort of sensory device. You feel that he is not afraid to get as close as possible to a tactile experience. Edward [has] an extraordinary relationship with the camera as the object that can almost extend his sensory experience of a work, that transcends … visual experience. He's right in, fearlessly, into the work.'[19]

1
David Ward, interview with the author, 23 November 2016.

2
LDDC Completion Booklet: Surrey Docks, July 1997, <www.lddc-history.org.uk/surrey/index.html>, accessed 19 June 2018.

3
Damien Hirst, email interview with the author, August 2016.

4
It is interesting to note that the 'Objects & Sculpture' catalogue credits Stephen White as the lead ICA gallery technician for the exhibition. White would later become one of the most sought-after photographers of contemporary art in the wake of Edward Woodman.

5
Phyllida Barlow in conversation with Gilane Tawadros and David Ward at David Roberts Art Foundation, September 2017.

6
David Ward, ibid.

7
Phyllida Barlow, as above.

8
Edward Allington, 'For Your Pleasure, or notes on public art from someone else's memory of a Silver Cloud in Wales', in *Review: Artists and Public Space*, Black Dog Publishing, London, 2005, pp. 21–5.

9
Stuart Morgan, 'Edward Allington: Getting it Wrong', in *Edward Allington: New Sculpture*, Riverside Studios, London, 1985.

10
Tom Porter and John Neale, *Architectural Super-models: Physical Design Simulation*, Architectural Press, Oxford and Boston, Mass., 2000.

11
Cornelia Parker, interview with the author, November 2016.

12
Edward Allington, 'For Your Pleasure, or notes on public art from someone else's memory of a Silver Cloud in Wales', op. cit., p. 24.

13
Richard Wilson, interview with the author, July 2016.

14
Rob La Fresnais, quoted from his blog, https://www.artscatalyst.org/artist/helen-chadwick, accessed 20 June 2018.

15
Oliver Bennett, *New Art Examiner* (1989), pp. 62–5.

16
Anya Gallaccio, interview with the author, June 2016.

17
Ibid.

18
David Ward, interview with the author, October 2016.

19
Phyllida Barlow in conversation with Gilane Tawadros and David Ward at David Roberts Art Foundation, September 2017.

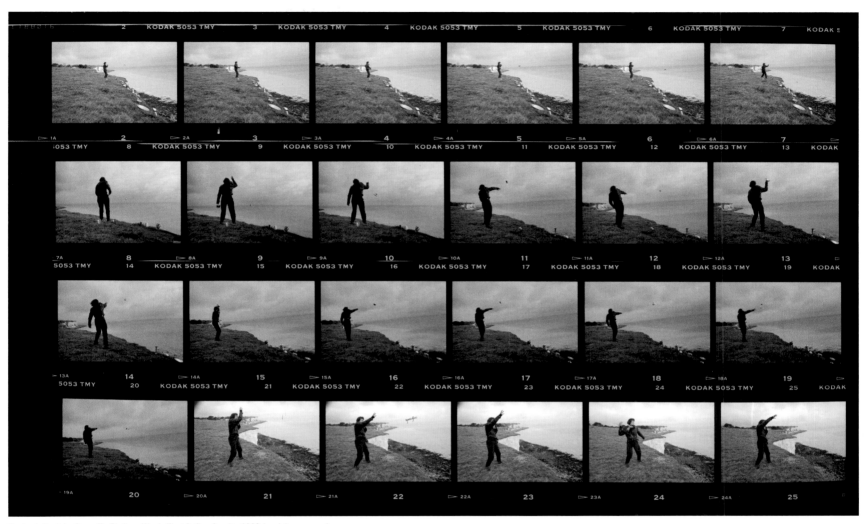

Contact sheet for **Cornelia Parker**, *Words That Define Gravity*, 1992 (work in progress)

'We talked about what I was trying to achieve and he had an incredible response to that. He seemed to understand what you wanted more than other photographers who were just about recording things. He was more like an art director perhaps. He had a great sense of composition, I suppose, because very often it was something quite disparate that he was trying to photograph.'

Cornelia Parker

'He was very shy, very calm, and you could see that he was just considering everything and using his fantastic eye to find the right spot. It's curious because the word that's caught mid-air is "specific" – talking about the specific gravity. All the other words are blurred, except that one. Everybody thinks it's a photomontage, but it's not, it just happened to be the one.'

Cornelia Parker

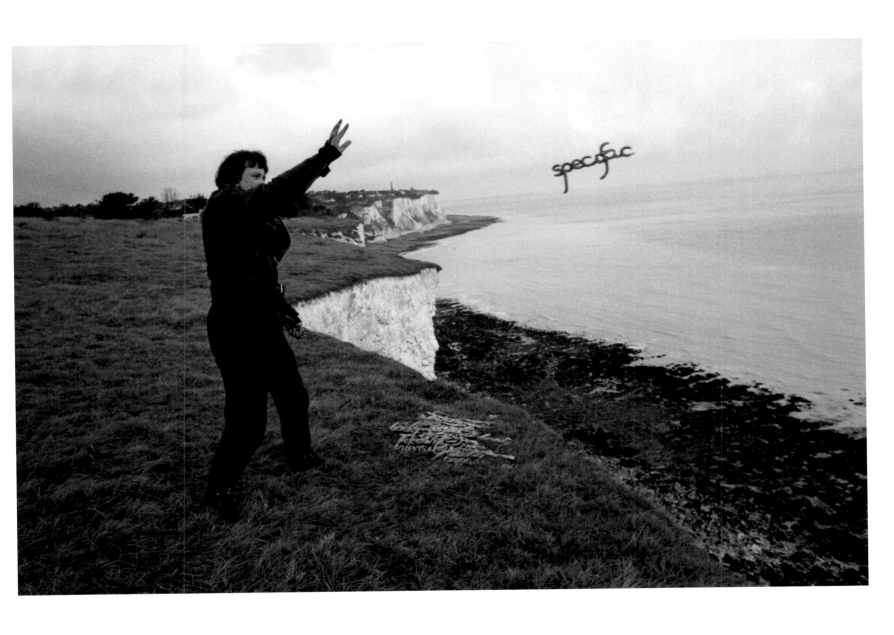

Cornelia Parker, *Words That Define Gravity*, 1992 (work in progress)

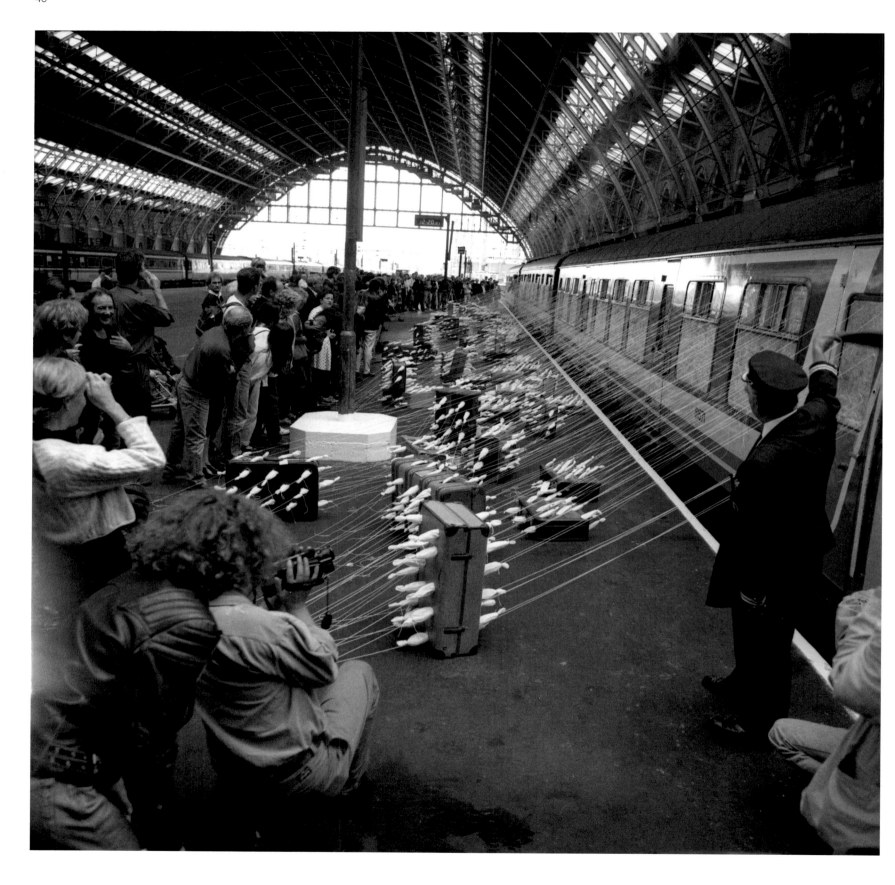

Cornelia Parker, *Left Luggage*, 1989, installation for EDGE 90 international art festival, St Pancras Station, London, destroyed when the train departed

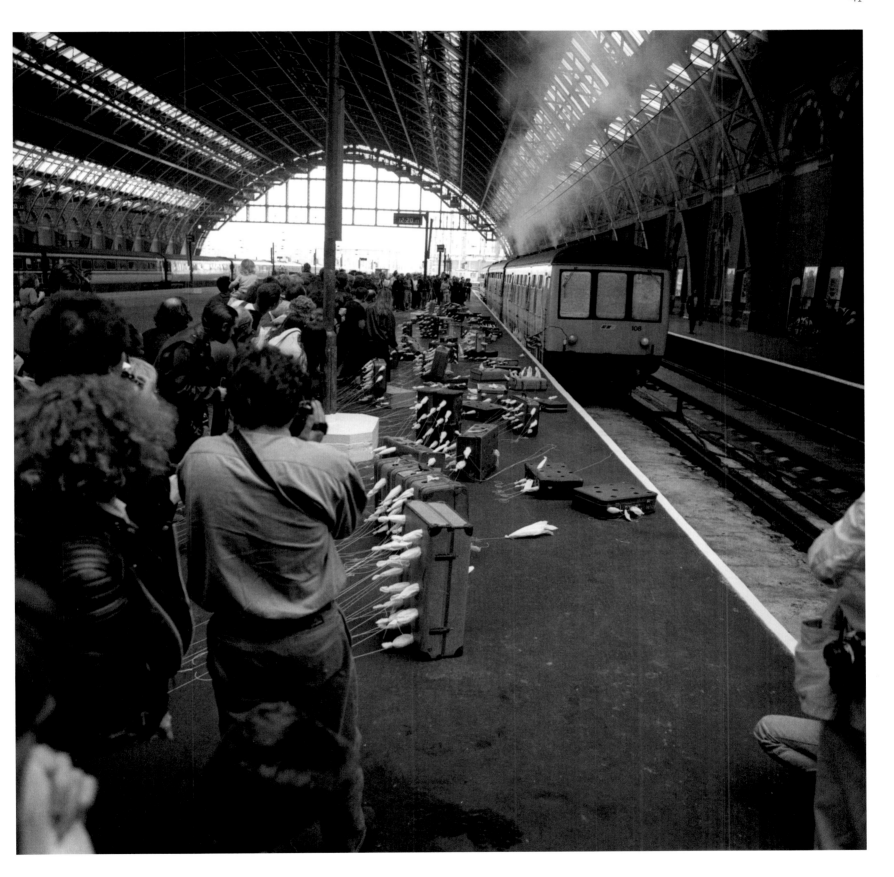

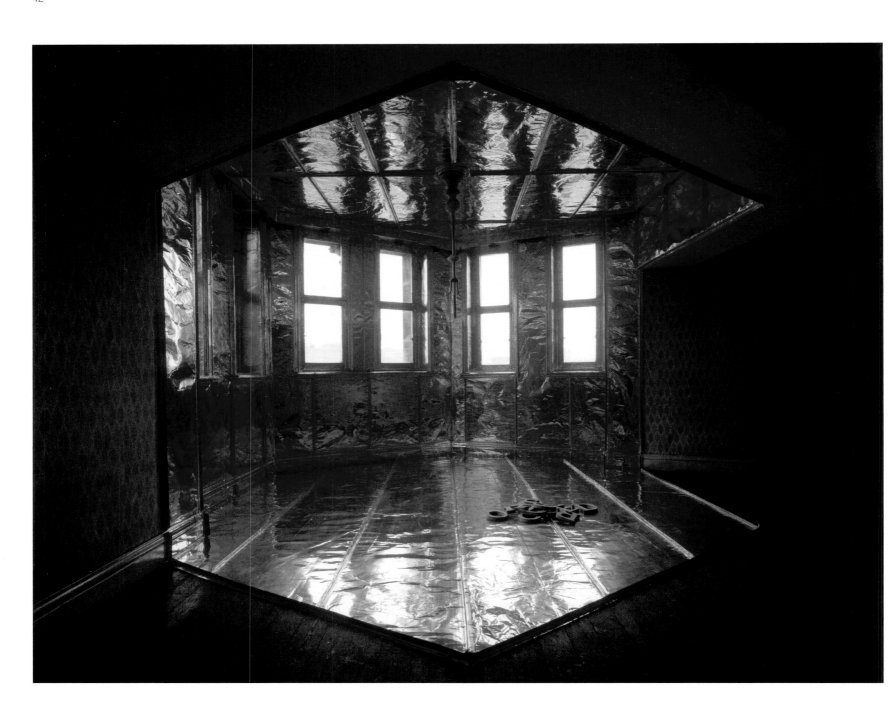

Cornelia Parker, *Inhaled Roof*, 1990, installation for EDGE 90 international art festival, Newcastle-upon-Tyne

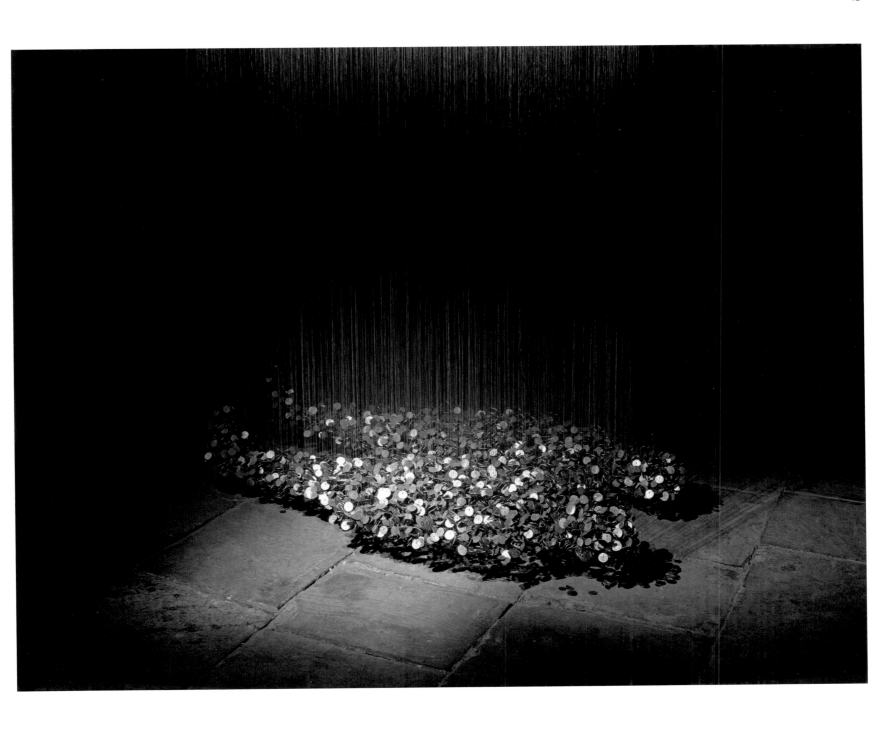

Cornelia Parker, *Matter and What it Means*, 1989, Spitalfields Heritage Centre (19 Princelet Street), presented by the Whitechapel Gallery, London, 1991

'Installations are inevitably illuminated
for the eye and not for the camera; the
temptation is to bring in your own lights
in order to see better. Sometimes it's
necessary to compensate for a film's
limited range, perhaps by exposing the
same frame or piece of film several
times over in the same shot. At other
times, all you can do is go in and
shoot; if you're lucky, the photograph
looks as though you couldn't have
done it any other way.'

Edward Woodman

Vong Phaophanit, *tok tem dean kep kin bo dai (what falls to the ground but can't be eaten)*, 1992, Ikon Gallery, Birmingham

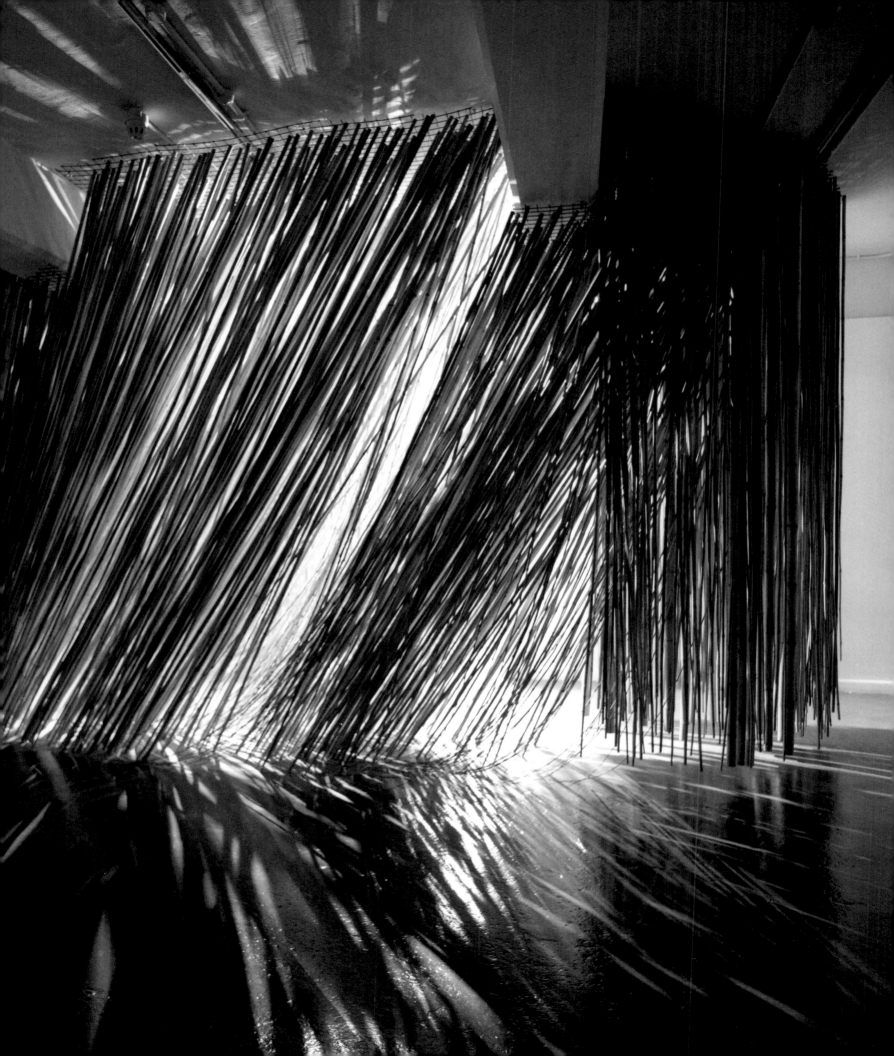

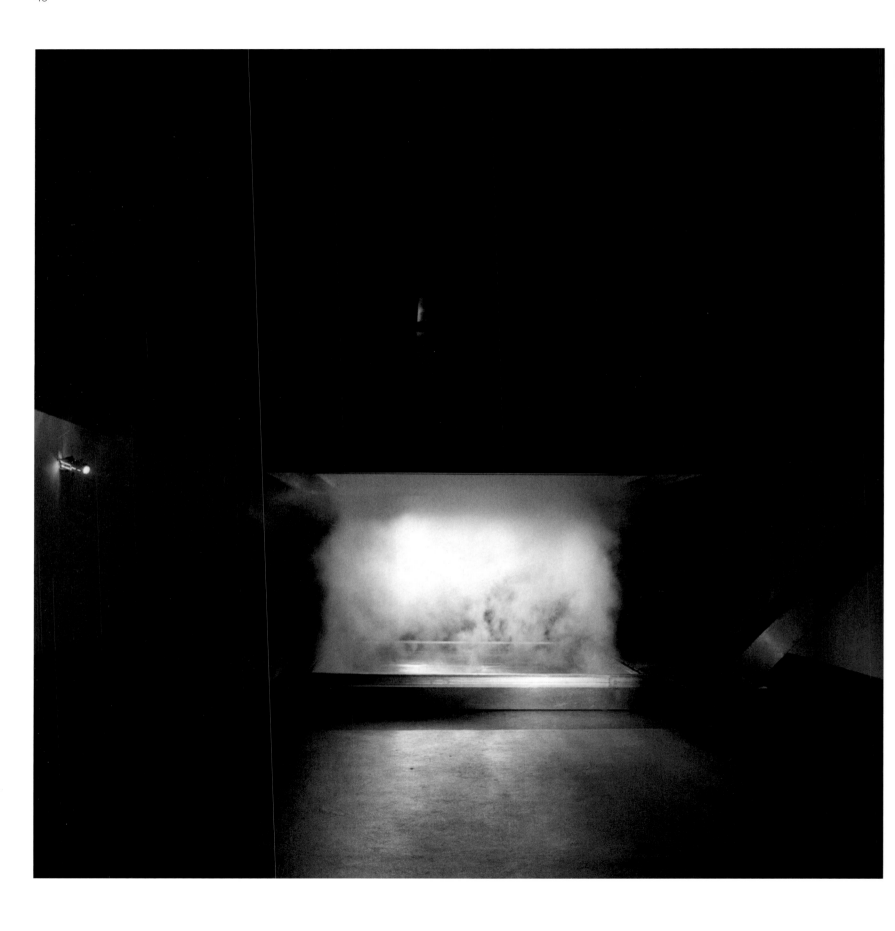

Rose Finn-Kelcey, *Steam Installation*, 1992, in the exhibition 'Young British Artists II', Saatchi Gallery, London, 1993

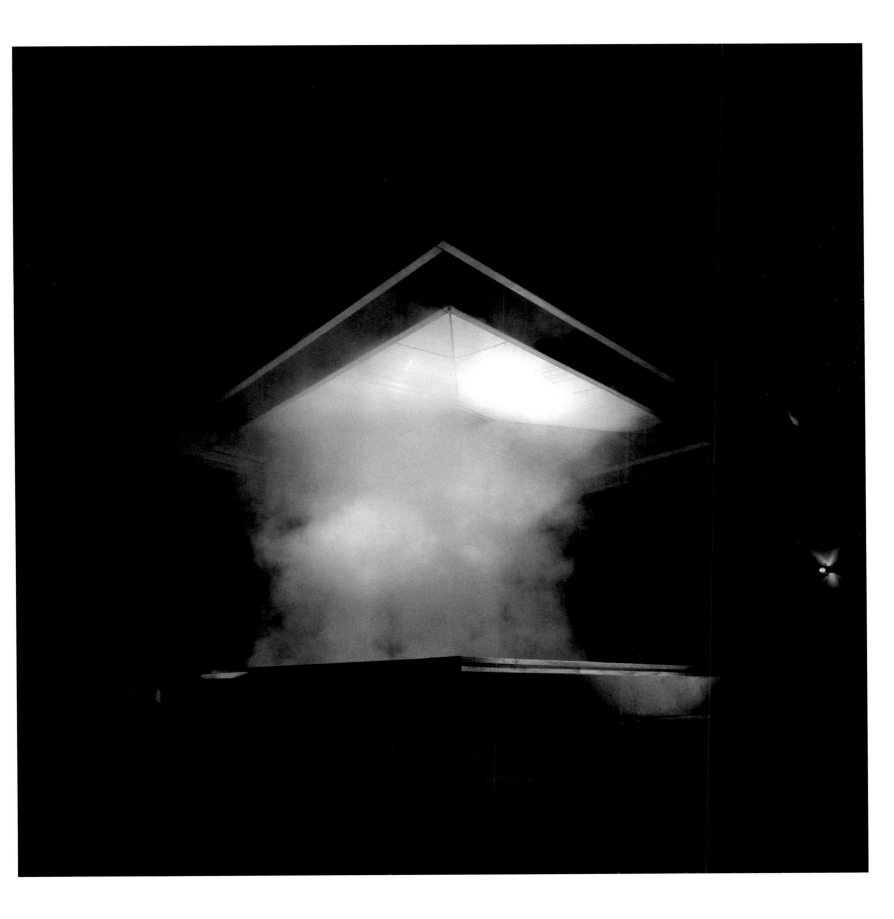

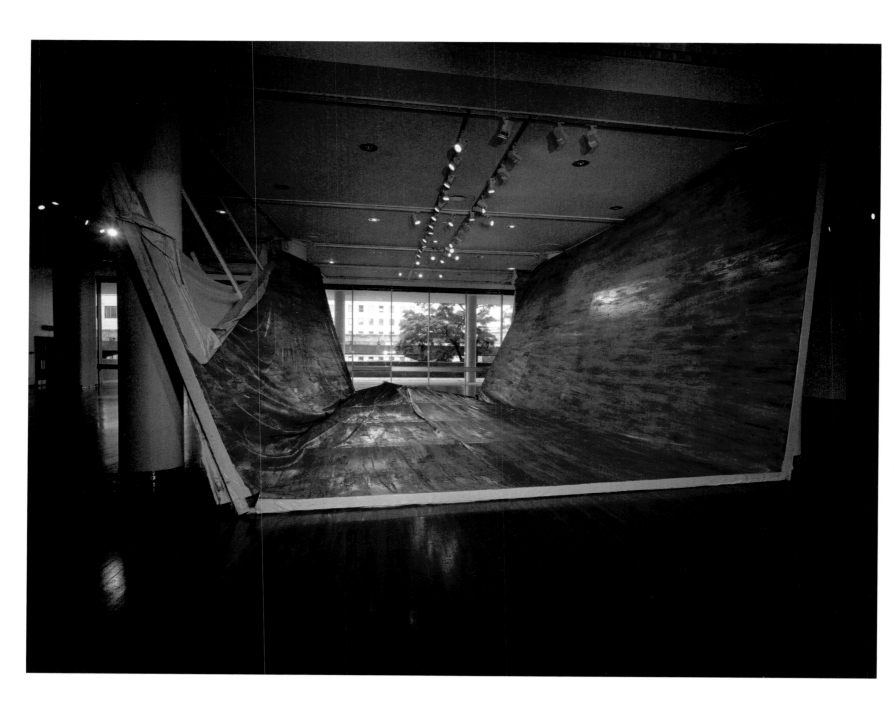

Angela de la Cruz, *Larger than Life*, 1998, Royal Festival Hall, London

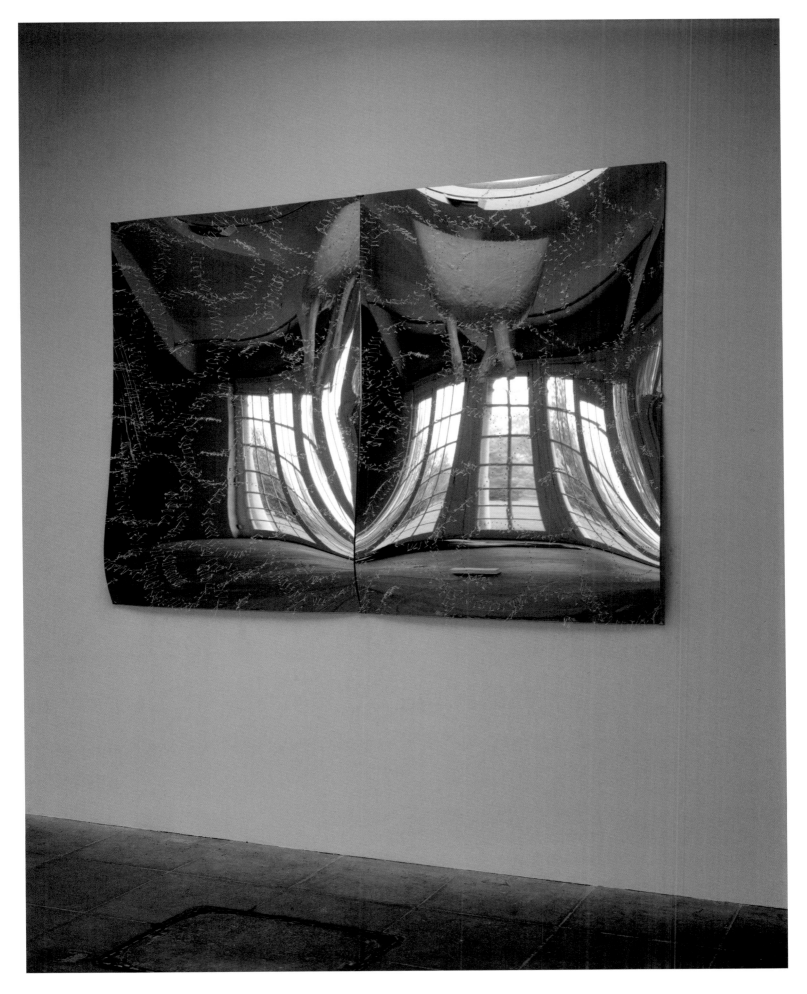

Angus Fairhurst, *mirror attachment*, 1994, in the exhibition 'Some Went Mad, Some Ran Away', Serpentine Gallery, London, 1994

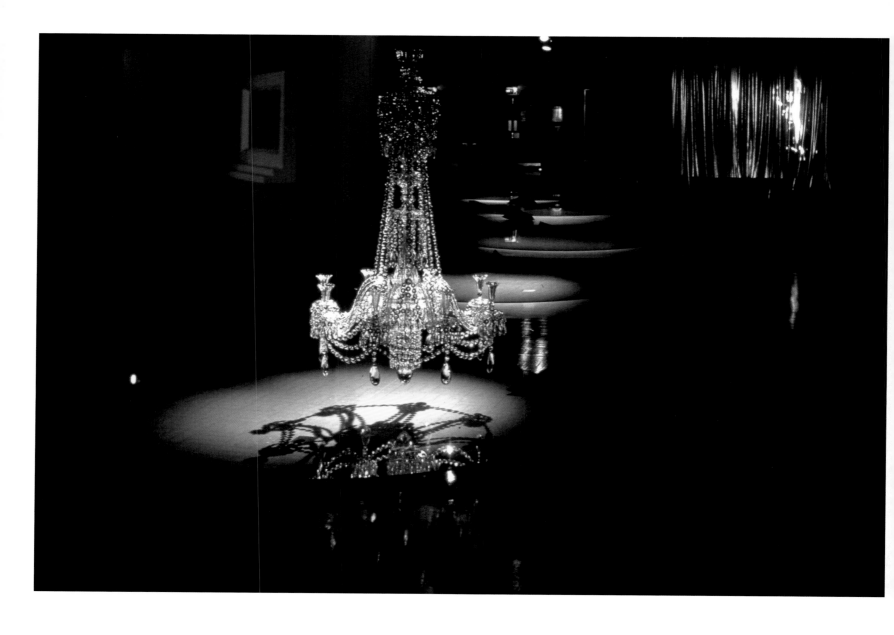

'What is very interesting given the
extremely low light levels is that
Edward has managed to achieve a depth
of field that brings the chandelier in
the foreground and the screen of the
pirouetting ice-skater in the deep
background all resolved into perfect
focus. The aperture of his camera will
have been shuttered right down with
an exposure of several seconds in
order to register the light. These are
complex balancing acts.'

David Ward

David Ward, *Silver Lining – Silver Screen*, 1996, in the exhibition 'Luminous',
Northern Gallery of Contemporary Art, Sunderland

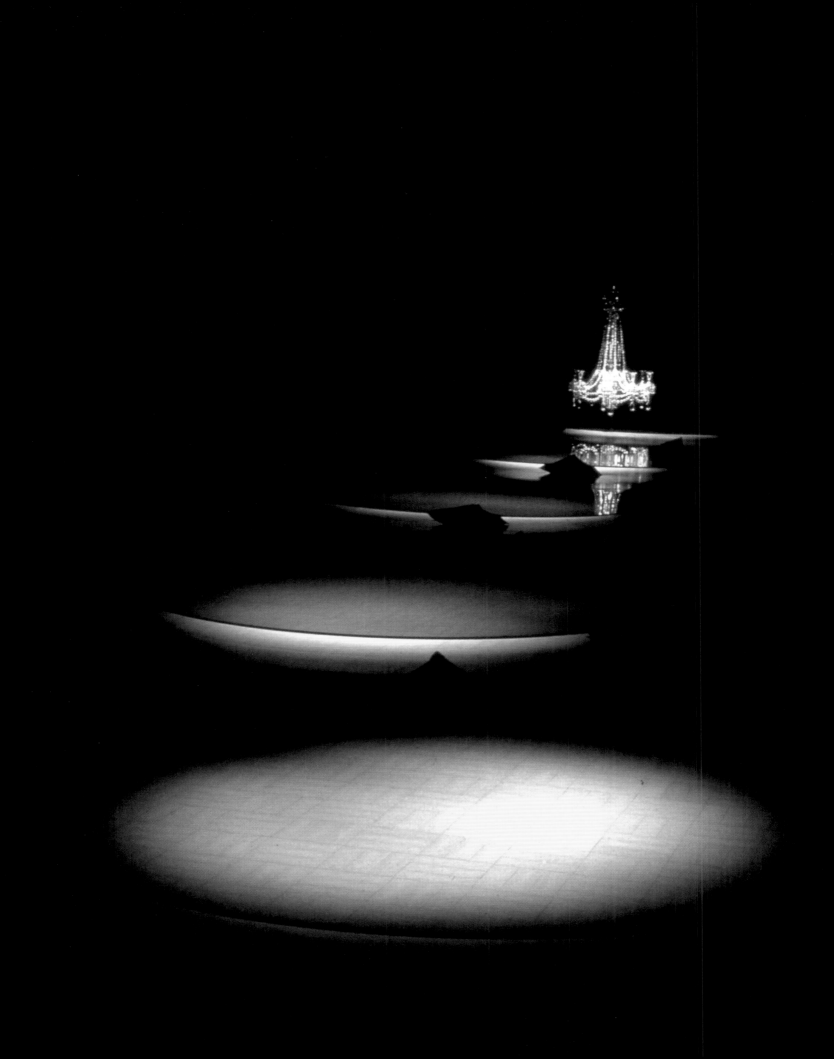

'As viewers, we become aware that we are not passive observers of fixed objects but are active in our experience of the works by passing through them, by the time that we spend, and by an awareness of our own physicality in the face of spatial and multimedia experiences. In certain photographs by Edward of complex installations, you feel that he has managed to convey that sense of involvement of physical engagement in the experience of the artwork and it transmits off the page, off the photograph, out of the two-dimensional image.'

David Ward

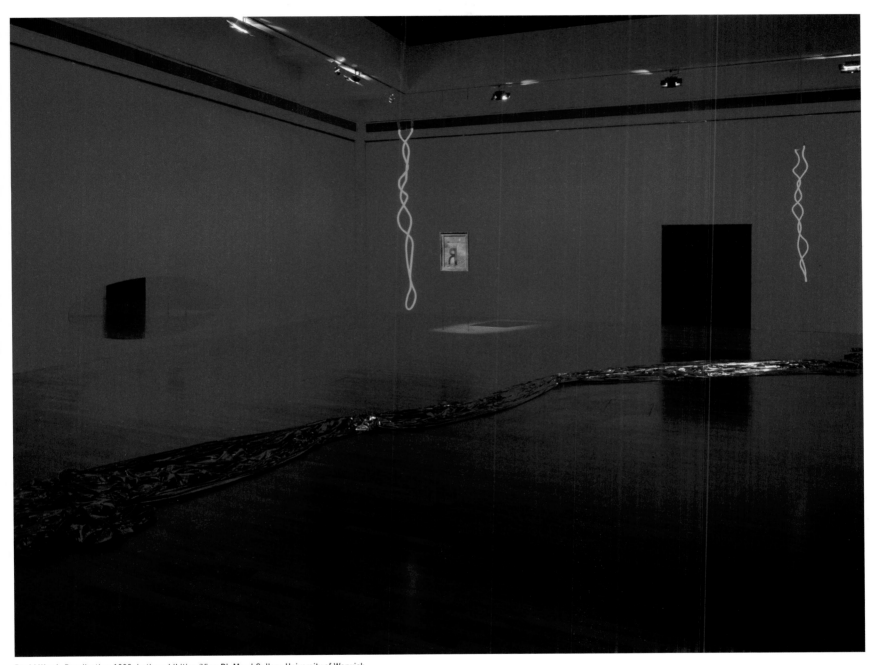

David Ward, *Recollection*, 1999, in the exhibition 'View R', Mead Gallery, University of Warwick

following pages **Andrea Fisher**, *The Transparency of Forms*, 1988, The Showroom, London

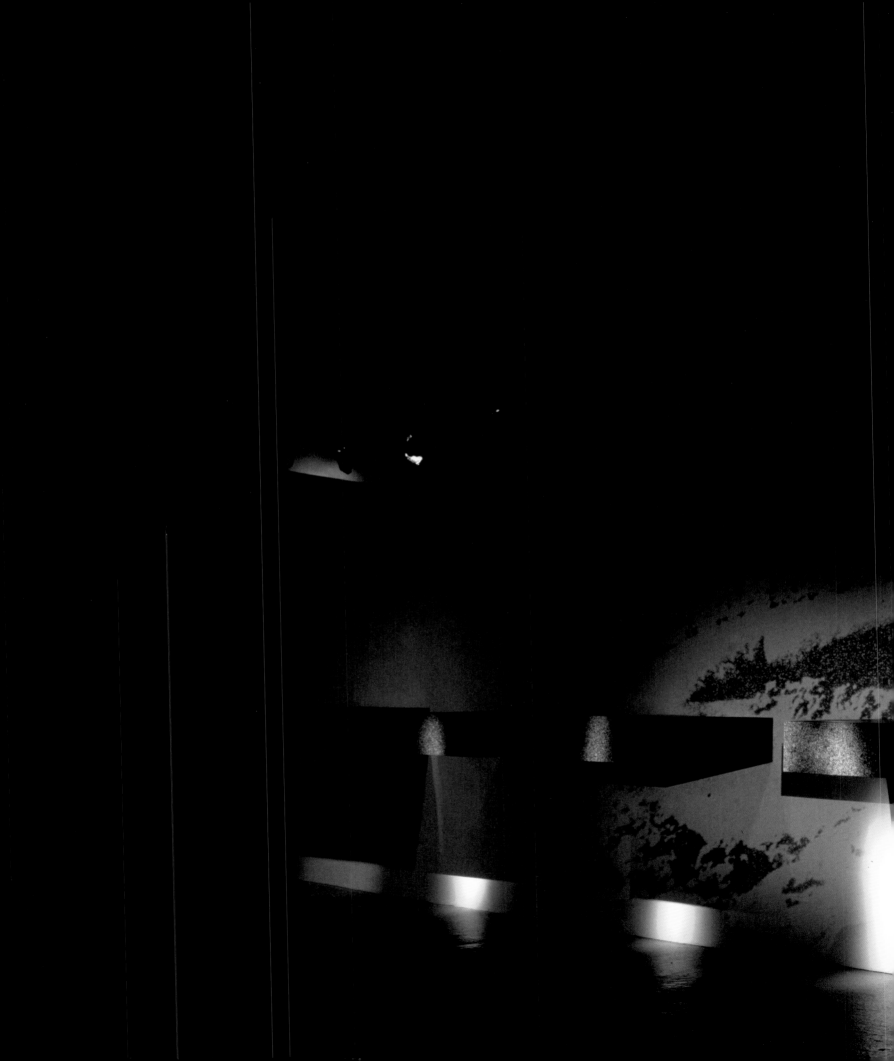

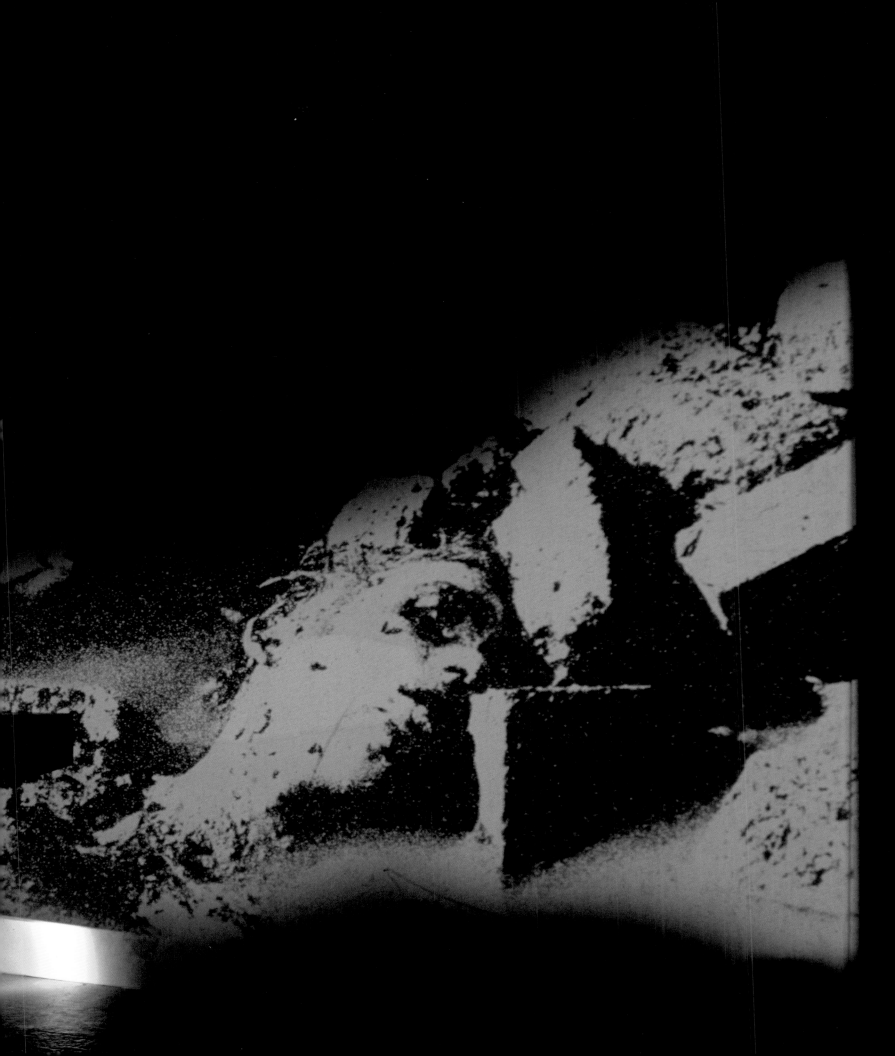

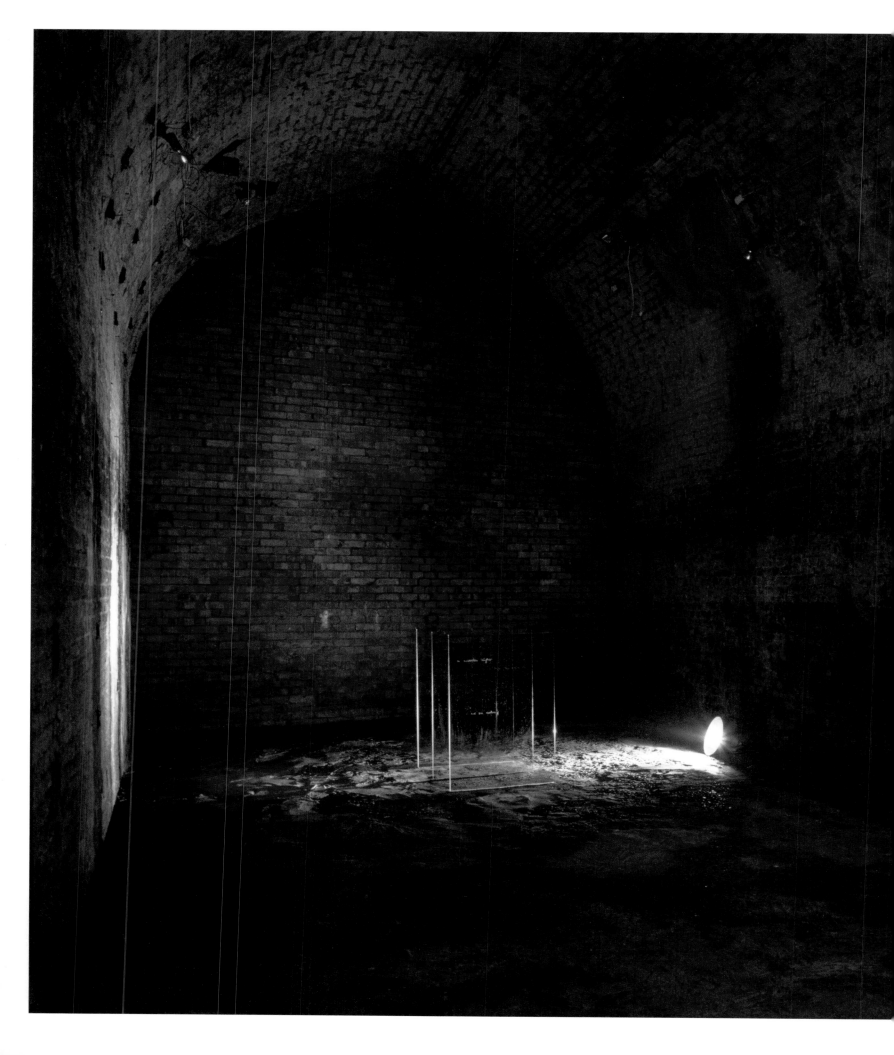

Caroline Wilkinson, *Unity*, 1991, Slaughterhouse Gallery, Smithfield, London

Mona Hatoum, *The Light at the End*, 1989, The Showroom, London, now in the Arts Council Collection

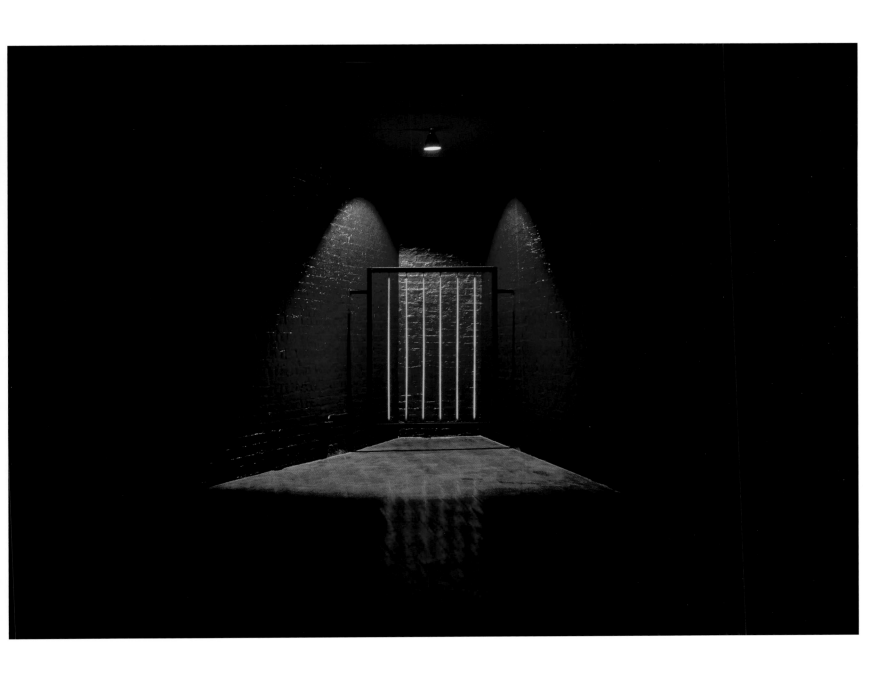

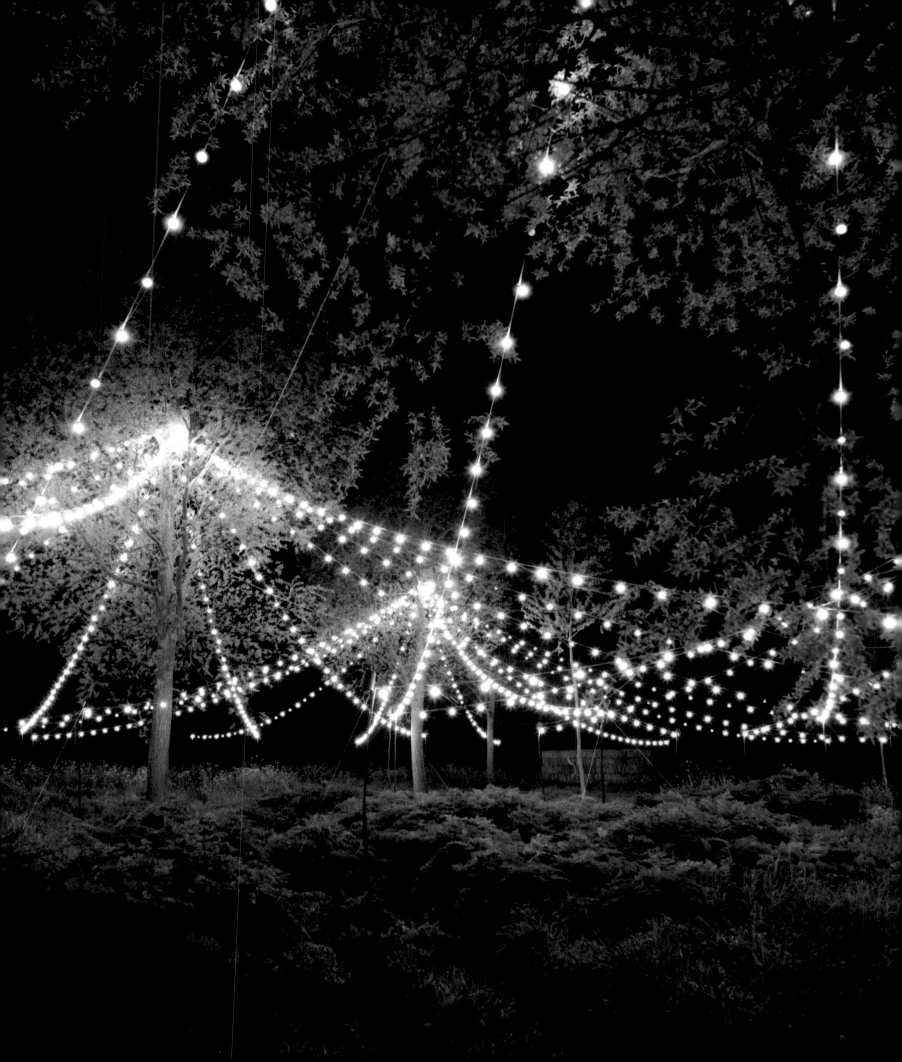

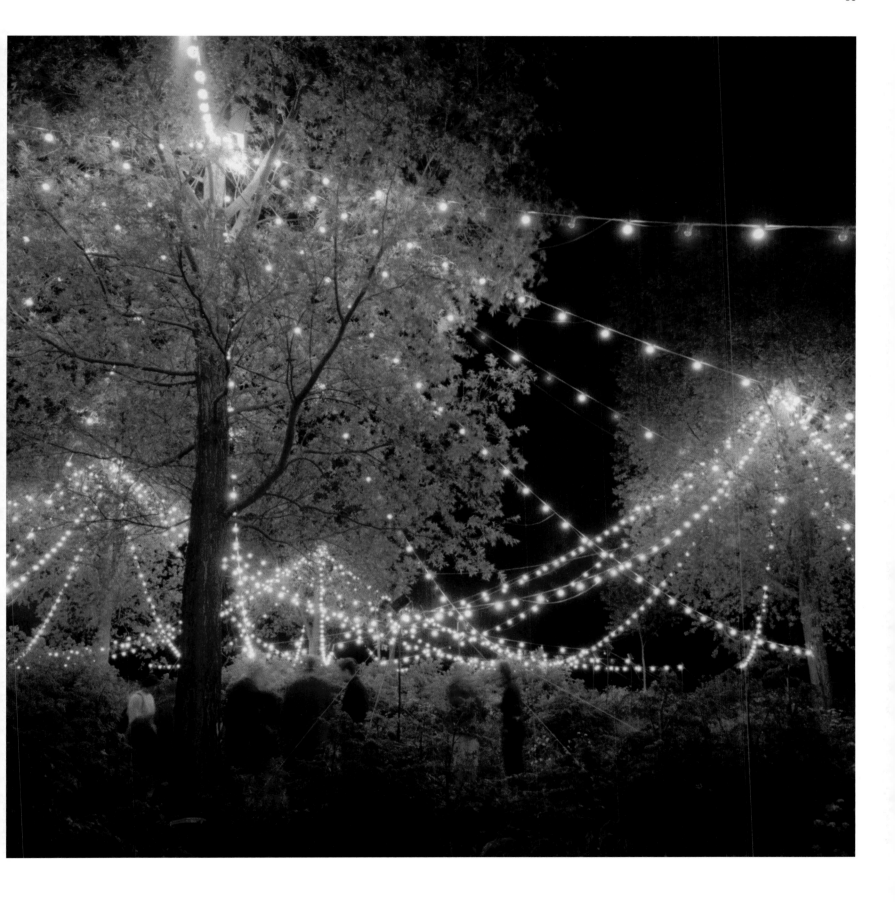

Ron Haselden, *Fête*, 1989, Feeringbury Manor, Essex

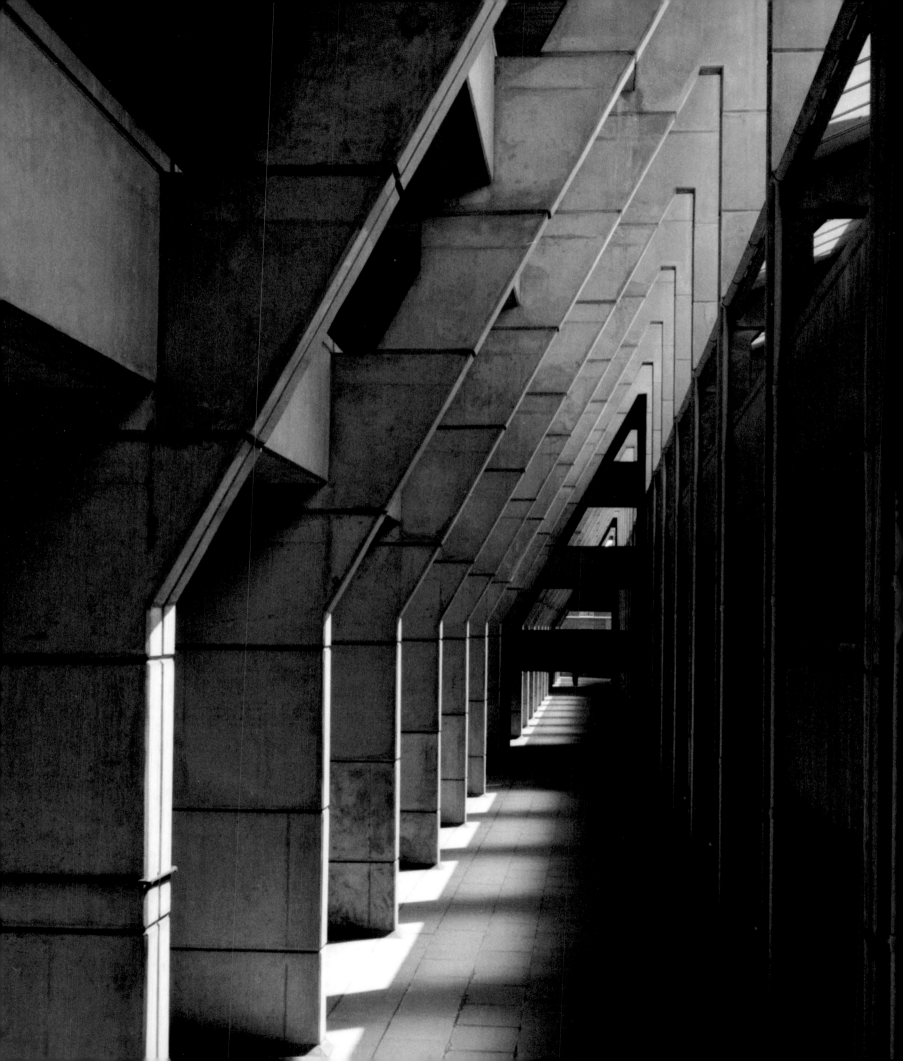

The Translation of Experience
Woodrow Kernohan

The image in cinema is based on the ability to present as an observation
one's own perception of an object.
Andrei Tarkovsky, *Sculpting in Time: Reflections on Cinema*

I did not know it at the time, but I was familiar with Edward Woodman's photographs long before
we met. It was through his images that many of my generation became familiar with some of the
most iconic works of art produced in Britain in the 1980s and 1990s. A great number of these
works were ephemeral or performative in nature, their sites of production and presentation since
disappeared. In several cases, we were able to encounter these works only through Woodman's
compositions, which are the sole trace left of objects, installations, and events that transformed
the perception of contemporary art in Britain. As a result, it is often not the original work as such
that we 'know' but his photographs that translate the experience.

Apart from a short break, Woodman has lived in Foundling Court, part of the brutalist architecture
of the Brunswick Centre in Bloomsbury, London, since 1974. For much of this time, his flat
could have been mistaken for a working photographer's studio, one with en-suite living and
sleeping facilities. Many of the apartment's original domestic features remained, but most of
one bedroom had been converted into a darkroom with an enlarger and developing trays, while
hand-printed black-and-white photographs hung drying over the bathtub, and plan chests burst
with contact prints. The flat embodies a lifetime of looking and framing moments in time, in
which Woodman's archive and negative reference book are the index. Dotted around the walls
are examples of the close friendships and photographic conversations that he has maintained
over many years with other artists. Among the catalogues, monographs, and magazines that
weigh down the shelves are examples of his pivotal role within emerging contemporary art
in Britain during the 1980s and 1990s. Legendary publications about the Beck Road artists'
housing association sit alongside catalogues from the seminal Young British Artist exhibitions
'Freeze' and 'Gambler'. Woodman created so many of the photographs that represent our
communal memory of these foundational exhibitions, installations, and moments.

Friendship
When Woodman was invited to photograph the seminal exhibition of new British sculpture
'Objects & Sculpture' in 1981, it propelled him to become the most sought-after photographer
of art of the day. As a result of this assignment, Woodman forged his long friendship with
Edward Allington, which continued until Allington's death in 2017. The pair worked together
almost forty times over the next six years, the photographer recording the artist's formative
exhibitions, capturing him at work in the studio, and creating portraits that only a friend could
take. Their collaborative photographic travelogue – *Decorative Forms Over the World* – saw
Woodman take Allington's sculptural motif of a baroque scroll on an inversion of the Grand Tour.

Foundling Court, Brunswick Centre, London, 1978/9

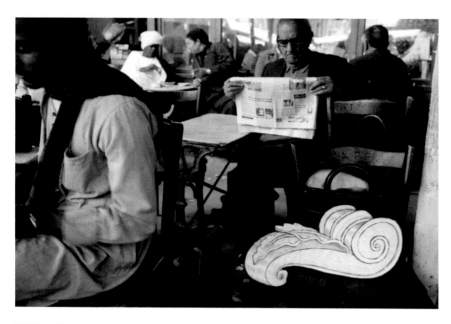

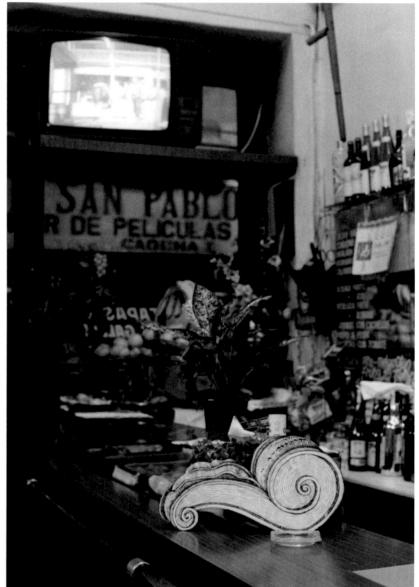

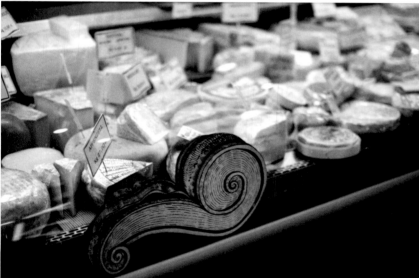

top left **Edward Woodman** and **Edward Allington** in collaboration,
Decorative Forms Over the World, Cairo, Egypt, 1987
bottom left **Edward Woodman** and **Edward Allington** in collaboration,
Decorative Forms Over the World, Montauban, France, 2006
right **Edward Woodman** and **Edward Allington** in collaboration,
Decorative Forms Over the World, Barcelona, Spain, 1995

Edward Allington, *Resting Form*, 1987, St Martin-in-the-Fields, London, as part of the TSWA 3D public-art project

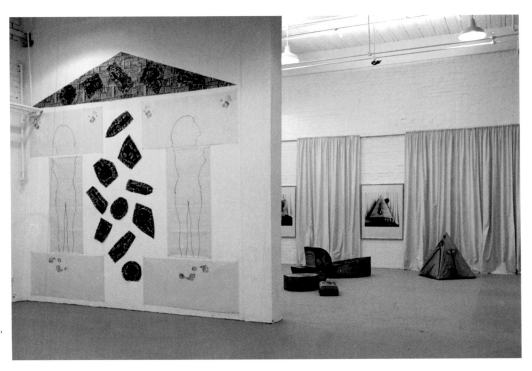

Installation view, **Helen Chadwick**,
Ego Geometria Sum, 1982–4,
Riverside Studios, London, 1985

The motif is inserted within the frame of photographs that could appear in any holiday album: in a café, at the bar, by the cheese counter, next to a ruin, creating what Allington described as 'a perverse form of tourism'. These awkward interventions question the arbitrariness of decoration within the everyday, highlighting the absence of a shared symbolic order.

My first and lasting encounters with Helen Chadwick's installations and photographic works created with Woodman were at the Serpentine Gallery while I was studying fine art in London in the 1990s. Woodman had met Chadwick in 1985 during the showing of her installation *Ego Geometria Sum* at Riverside Studios, where he photographed most of the exhibitions. Their friendship and collaborations blossomed from there. In a 1997 letter to arts writer Louisa Buck, he wrote about their relationship:

> After documenting 'Of Mutability' [1986] at the ICA, I was involved in all the tougher photographic challenges she set herself, eating our way through the more palatable remains of meatlamps when we'd checked the transparencies, and wooing our partners with bouquets from 'Bad Blooms' after a weekend closeted in her workroom at Beck Road.

Intimacy
In 1988 Woodman photographed Chadwick's ephemeral *Blood Hyphen*, which she created in the Clerkenwell and Islington Medical Mission for EDGE 88, Britain's first biennial of experimental performance and installation work. In the upper half of the bisected chapel, a red laser beam shone from a crescent in the wall, illuminating a photograph of cervical cells that formed part of the boundary between the two halves of the space and was visible from below. In one of his most remarkable images, Woodman captured the divided chapel, the diagonal red laser beam slicing the dark upper half of the frame, the empty pews in the stark white of the lower half.

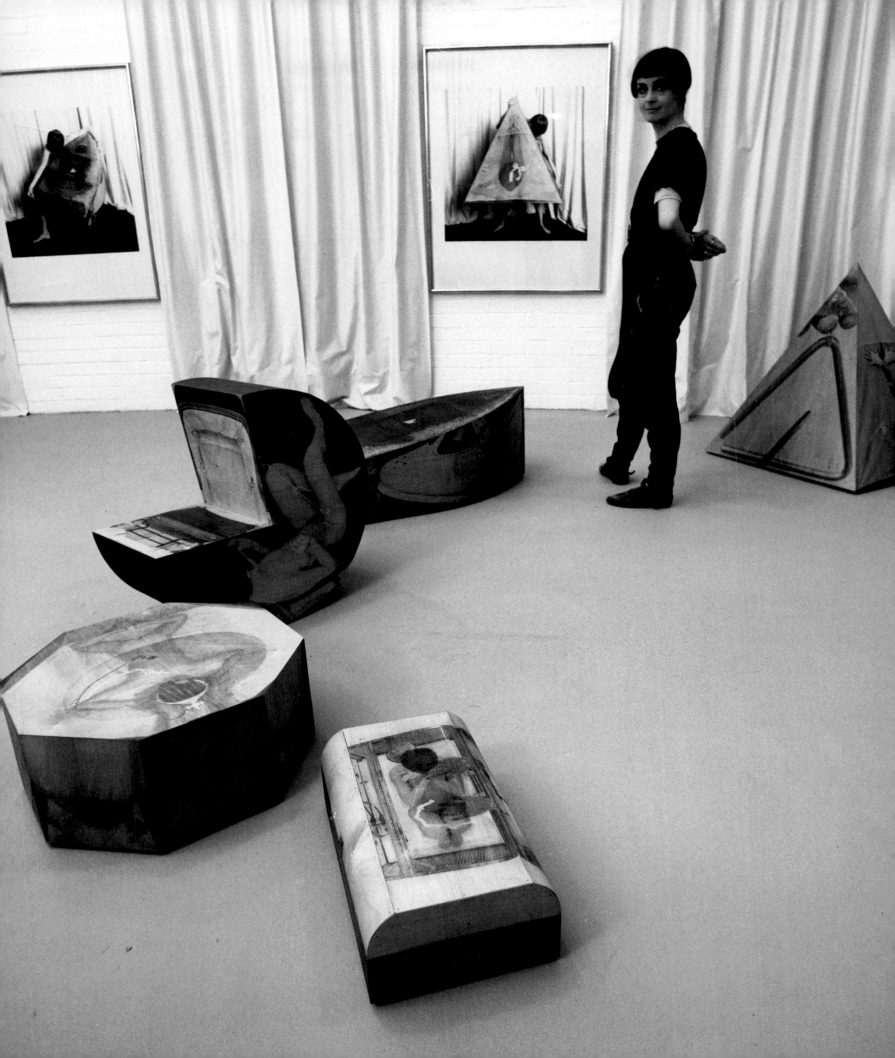

'*Blood Hyphen* was made in a chapel with a false ceiling that sealed off the entire choir loft, preserving it in a kind of dusty gloom. It was obscured even more by the smoke machine that Helen installed in order to track the shaft of ruby laser light. For me, standing on the pulpit to photograph was a little like Heaven and Hell: a bright, sterile chapel for a dwindling congregation below, and a rich, warm space of uncertain dimension above. I added no light to any of the photographs, exposing for the principal elements but leaving the details of the environment vague.'

Edward Woodman

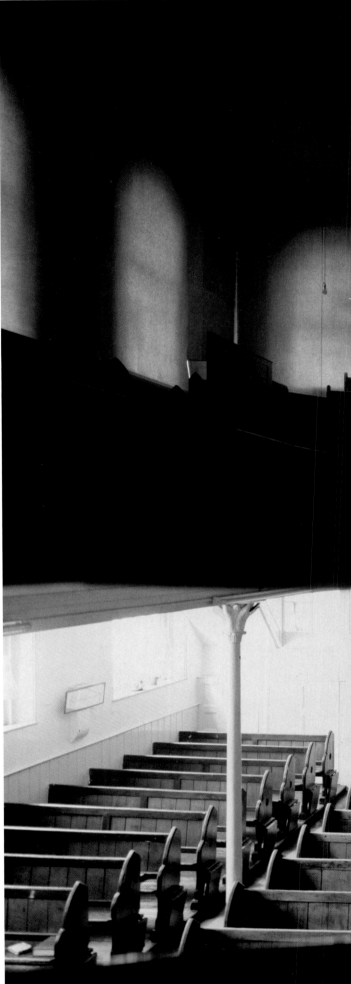

Helen Chadwick, *Blood Hyphen*, 1988, Woodbridge Chapel, Clerkenwell and Islington Medical Mission, London, for the EDGE 88 international art festival

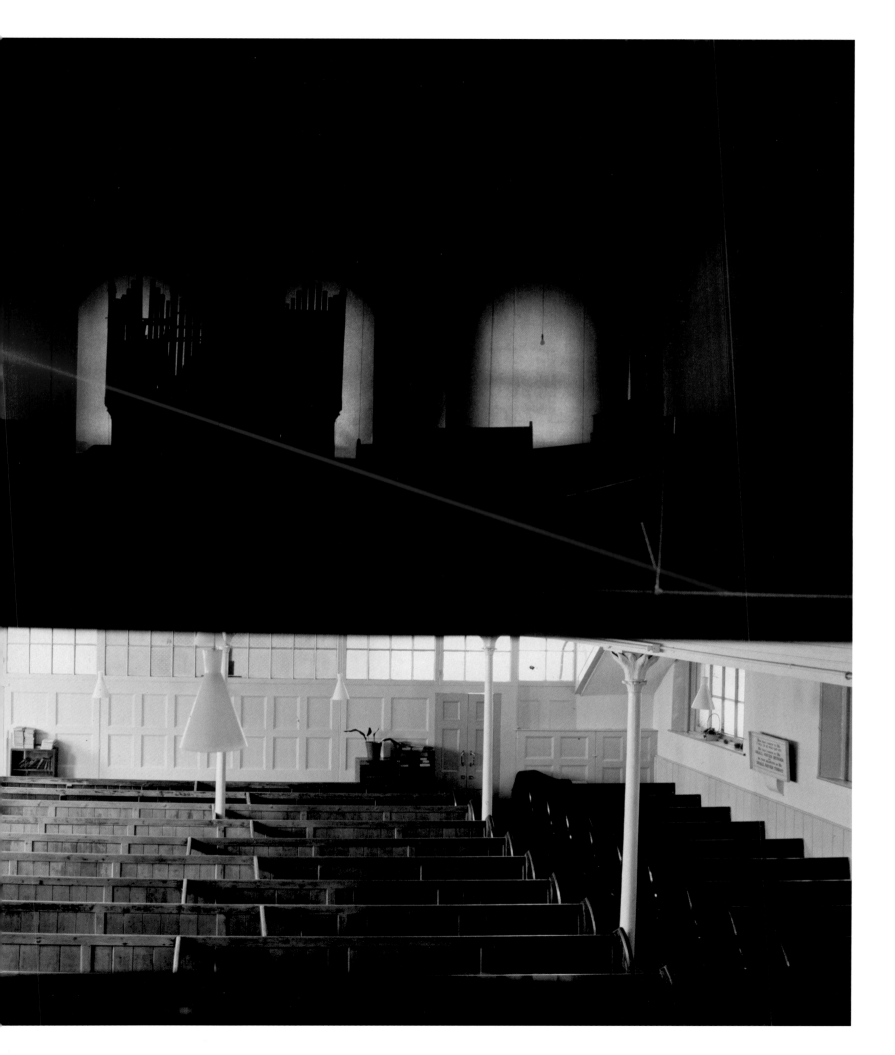

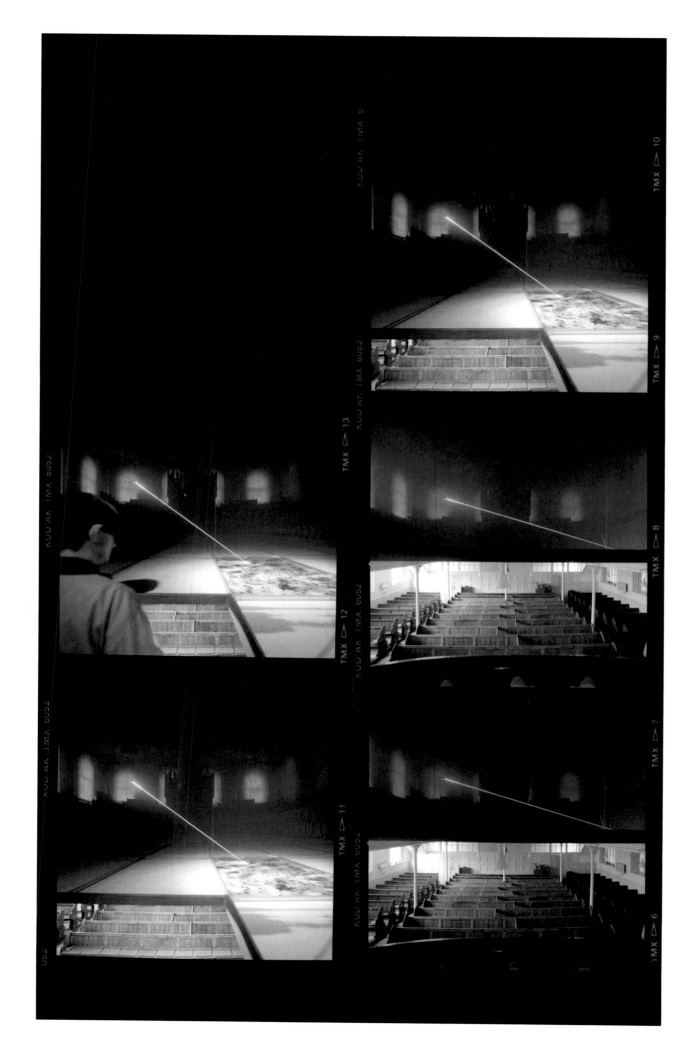

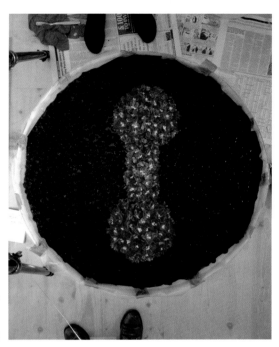

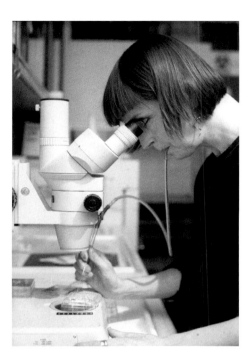

right **Helen Chadwick**, *Wreath to Pleasure No. 9*,
1992 (work in progress)
far right **Helen Chadwick** working with
embryonic tissue at King's College, London, 1996

Rather than painstakingly documenting the installation, this photograph translates the viewer's experience and the tension between the medical application of technology – in this case for the treatment of cervical cancer – and religion – represented by both the chapel beneath and the looming pipe organ above.

Also within Woodman's archive are unused examples of the transparencies that he created with Chadwick for her *Wreaths to Pleasure* series of 1992–3. The truth of the creative act is captured in their pairs of feet either side of a circular vat, containing carefully arranged blackberries and blue flowers, floating in an unidentified liquid. These intimate insights outside of the familiar frame are further amplified in Woodman's production portraits of the artist, which hint at the intensive process behind her iconic photographic works. However, rather than the saturated colour of the final works, Woodman's photographs are in black and white, somehow capturing Chadwick and her practice as a vivid encounter, unhindered by the distracting colour of the flesh, fluids, and flowers that surround her.

> Strangely enough, even though the world is coloured, the black and white image
> comes closer to the psychological, naturalistic truth of art.
> Andrei Tarkovsky, *Sculpting in Time: Reflections on Cinema*

While Chadwick was undertaking a residency at the Assisted Conception Unit of King's College Hospital, London, in 1996, Woodman created a series of portraits that framed the artist as scientist. Working towards a project she called *Stilled Lives*, she hovers intently over a microscope, with a pipette in hand and tube at her lips. Unknowingly suffering from myocarditis at the time

Contact sheet for **Helen Chadwick**, *Blood Hyphen*, 1988, Woodbridge Chapel, Clerkenwell and Islington
Medical Mission, London, for the EDGE 88 international art festival

of the residency, Chadwick suddenly died of a heart attack on 15 March 1996. These last portraits by Woodman provide an extraordinary insight and point of reflection.

Time

Woodman's production photographs from Cornelia Parker's performative piece *Words That Define Gravity* of 1992 capture the word 'specific' suspended mid-air as it is flung over the White Cliffs of Dover. This highly reflexive photograph operates independently of the work, and through its slicing of time and space, demonstrates both the parameters of photography and the impossibility of representing performance.

Parker first worked with Woodman in 1988 during the production of her ground-breaking exhibition of *Thirty Pieces of Silver*, shown at Ikon Gallery in Birmingham and Aspex Gallery in Portsmouth in 1989, and then at the Hayward Gallery in London a year later. As with many of Parker's works that freeze an imperceptible moment of destruction, the installation explored the transformation of an object through the use of extreme force. More than a thousand silver and silver-plated items, including plates, cutlery, candlesticks, trophies, cigarette cases, teapots, and trombones, were laid out on a road in Chorleywood and crushed by a steamroller. Woodman recorded both the fleeting production process and the subsequent installation of thirty suspended 'discs' formed from the crushed artefacts. For Parker, these photographs remain the definitive images that represent and communicate her project.

Woodman also captured Parker's performative work *Left Luggage* (1989) at St Pancras Station in London, which launched the 1990 edition of the EDGE biennial (pp. 40–1). Handkerchiefs, which had been inserted into small holes in suitcases along the platform, were tethered by strings to a train. As the train pulled away from the platform, the handkerchiefs were pulled loose and the work was both realized and destroyed. Woodman captured the split-second moment of potentiality before the destruction and afterwards, capturing the work in its essence.

Space

In her authoritative account of contemporary art in Britain in the 1990s, *Moving Targets: A User's Guide to British Art Now* of 1997, Louisa Buck wrote that Woodman 'has been responsible for pinning down some of the most elusive, ephemeral and evanescent artworks made in this country over the last decade'. She no doubt had in mind works such as Richard Wilson's space-bending installations *20:50* and *She Came in Through the Bathroom Window*. These uniquely site-specific projects often explicitly included elements of the location in their form. Both initially installed at Matt's Gallery, *20:50* (pp. 75, 140–1) and *She Came in Through the Bathroom Window* (p. 29) were seemingly inseparable from their site and contingent upon the viewer's experience of the space. While the Tate holds the artist's drawings, diagrams, and instructions for the production of these installations, the true works are the realization of these instructions in situ in the gallery. They do not exist outside of that context.

Wilson describes elsewhere in this book how, when Woodman came to photograph, he would look at the installation for up to half an hour before setting up his camera on its tripod to take one shot, which would then become the definitive image of the work. His photographs became

'He took some black-and-white photographs of the piece that were beautiful and ended up in almost every publication. Now the work belongs to the Tate and they have their own photographs of it, but the one I use in the books is Edward's. I think it's because he got the essence. His photographs allow you to see the piece the way it was intended to be, rather than just being documentary shots.'

Cornelia Parker

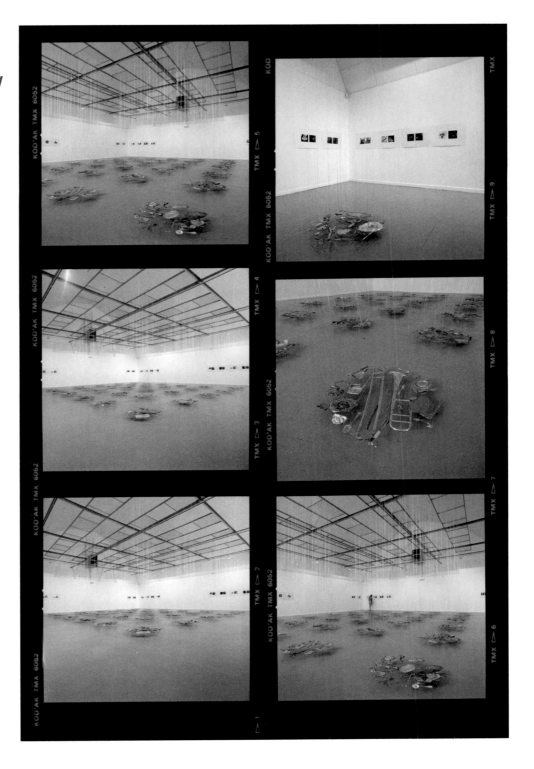

Contact sheet for **Cornelia Parker**, *Thirty Pieces of Silver*, 1988, at Aspex Gallery, Portsmouth, 1989, now in the Tate collection

(and remain) the representative images of these artworks by translating the viewer's experience, rather than painstakingly recording their material form. Wilson puts it succinctly: 'I don't think he was making documentation. He was making an artwork out of an artwork.'

Being slightly too young to have seen *20:50* at Matt's Gallery in 1987, I experienced its reiteration four years later at the Saatchi Gallery in Boundary Road. As with many artists and curators whom I know, the work had a profound impact on me. However, the lasting image in my mind is Woodman's original bird's-eye view from the top of the office at Matt's Gallery, which shows the reflective oil surface, walkway, and Wilson standing in the middle. For me, and for many others, this exquisite photograph captures our memory of that first encounter with the artwork. Rather than recording an isolated object, Woodman somehow translates the subjective multi-sensory experience.

In 'The Creative Act' of 1957, Marcel Duchamp stated: '[T]he creative act is not performed by the artist alone; the spectator brings the work in contact with the external world by deciphering and interpreting its inner qualifications and thus adds [their] contribution to the creative act.' To Duchamp's prescient assertion, I would add that when the work is intrinsically ephemeral or contingent on the circumstance of its presentation, the photographer also performs an important role in the creative act by disseminating the work beyond the confines of the immediate encounter. First, there is the work; second, there is the subjective experience of the work; and third, there is the photograph that both represents the work and translates the subjective experience of it.

Memory

In 2000, Woodman had a near fatal cycling accident near King's Cross in London, which resulted in him suffering from aphasia, an impairment of the brain's language centres. During his long recuperation, over many years he worked with speech therapist Judith Langley to recover his speech and language processes. At the same time, the area around King's Cross was undergoing radical redevelopment and regeneration. Although Woodman was no longer undertaking commissioned photographic assignments, he was carefully recording the demolition and rebuilding of this district of London that was so familiar to him, and that he had photographed for so many years previously. Woodman collaged the resulting photographs together in a representation of architectural remembrance and erasure that reflects his own process of transformation and recovery.

Through Langley, he was introduced to the artist Imogen Stidworthy, who has a particular interest in the voice and language. In 2007, she worked closely with him to produce her remarkable audio-visual installation *I hate* for documenta 12 in Kassel, Germany, which also included Woodman's photo-collages of King's Cross. This process reignited Woodman's collaboration with artists and his photographing of exhibitions. As a result, he was invited to Kassel by documenta to photograph *I hate*, along with installations by Trisha Brown and Charlotte Posenenske, among others.

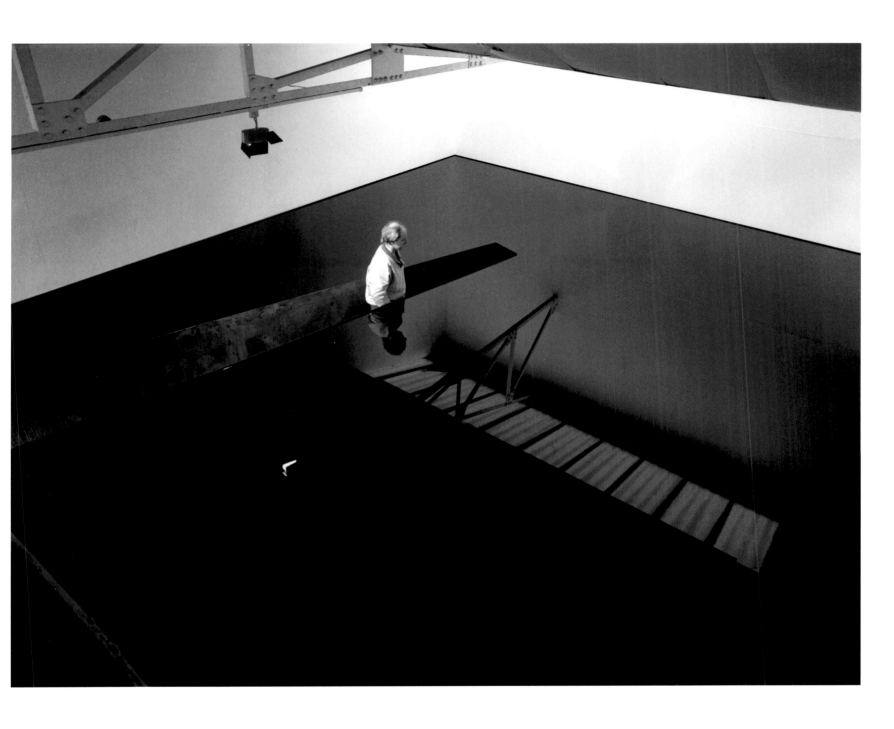

Richard Wilson, standing in the original installation of *20:50*, Matt's Gallery, London, 1987

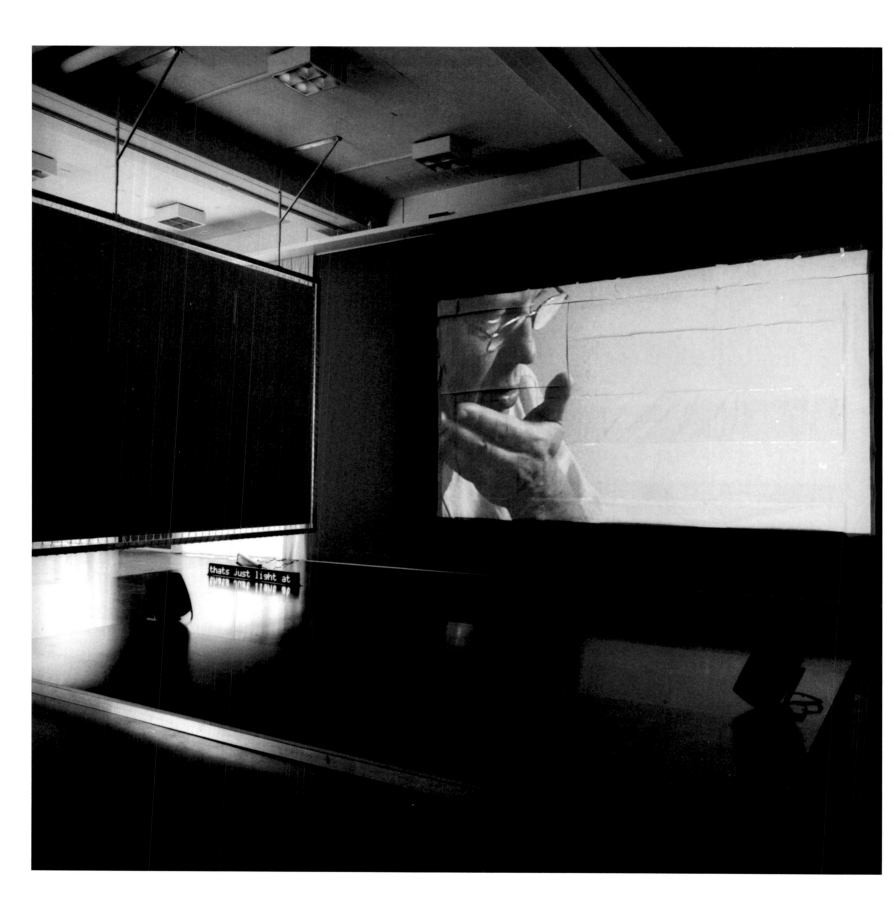

Imogen Stidworthy, *I hate*, 2007, documenta 12, Kassel, Germany, photographed during the installation process

Woodman's reflections on memory and his longstanding collaborations with artists can be seen in his most recent photographs, some of which are multiple exposures, while others are illusory abstractions and perspectival architecture shots. His close collaboration with Edward Allington has yet to be presented as a whole, but his photographs from travels in Greece and Italy, where classical columns are shrouded in mist or stand in ruins, display a longing for the motif of a baroque scroll.

This book reflects but a fraction of Woodman's archive. His journey as a photographer has taken him from recording crime-scenes to intimate portraits of Sharon Tate and Sidney Poitier; from photographing design interiors to overnight photoshoots in Zaha Hadid's architecture studio. He has created some of the most poignant portraits of artists and captured some of the most iconic moments of contemporary art in late twentieth-century Britain. Woodman's open and collaborative approach has taken us along with him on this journey. Without him, these fleeting moments could have been lost.

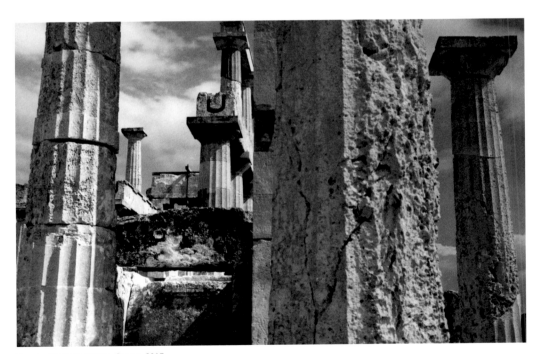

Temple of Aphaia, Aegina, Greece, 2017

Edward Woodman, *Portrait of Helen Chadwick*, 1986 (photographed at the same time as for her work *Vanity*)

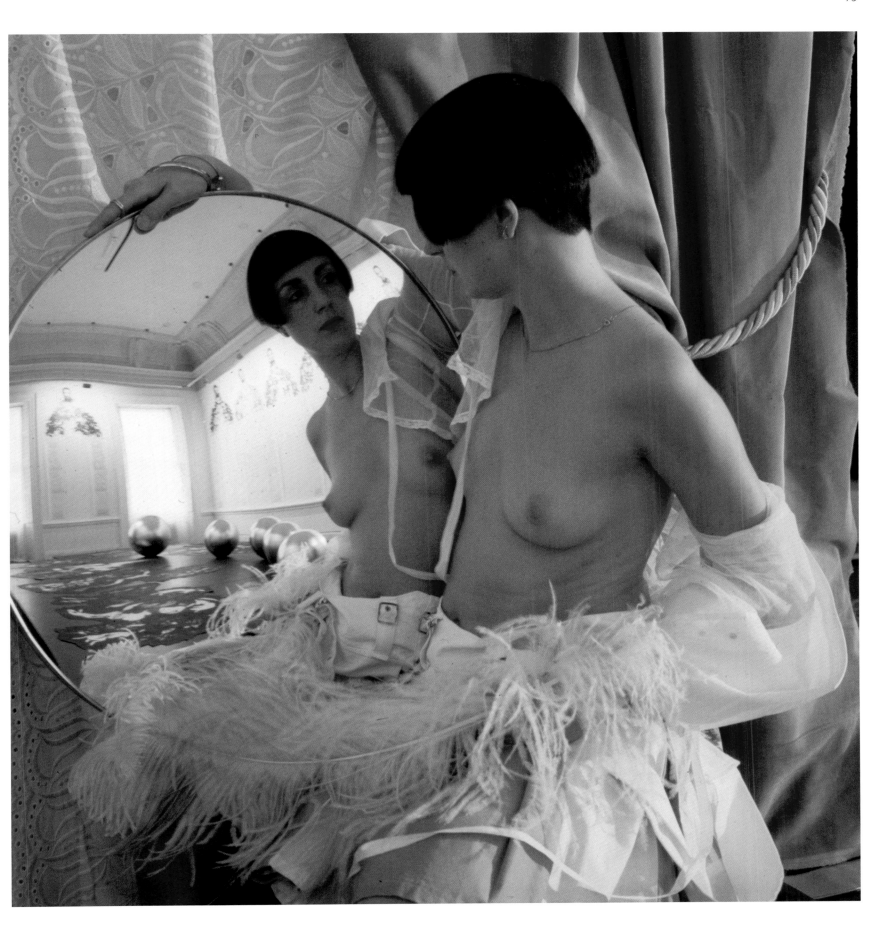

Helen Chadwick, installation view of 'Of Mutability', 1986, Institute of Contemporary Arts, London

Helen Chadwick, in front of the painted wall for her slide-projection work *Three Houses – A Modern Moral Subject*, 1987, Hayward Gallery, London.
Commissioned by the Arts Council of Great Britain and shown in the exhibition 'Art History' as one of nine artists' reactions to contemporary Britain.

Helen Chadwick, *Three Houses – A Modern Moral Subject*, 1987, Hayward Gallery, London (right- and left-hand images photographed by Edward Woodman)

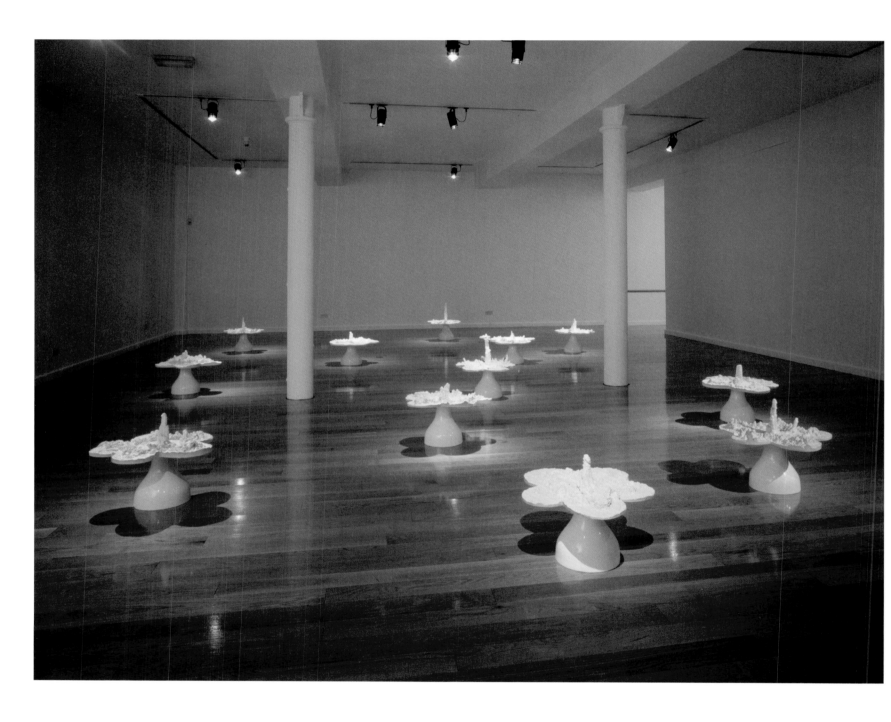

Helen Chadwick, *Piss Flowers*, 1991–2, in the solo exhibition 'Bronzes', Angel Row Gallery, Nottingham, 1993

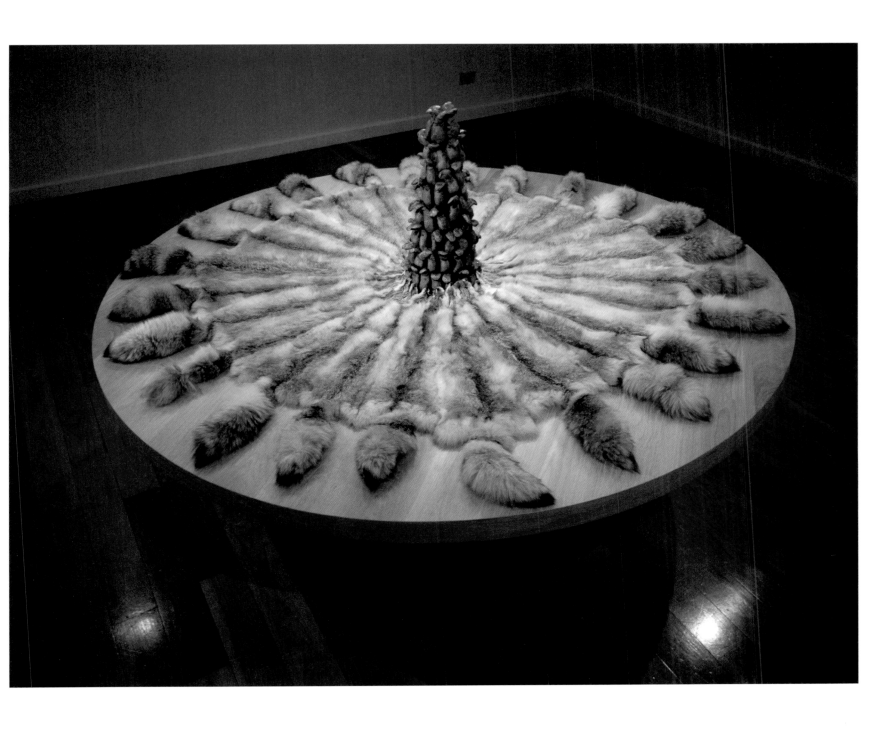

Helen Chadwick, *Glossolalia*, 1993, in the solo exhibition 'Bronzes', Angel Row Gallery, Nottingham, 1993

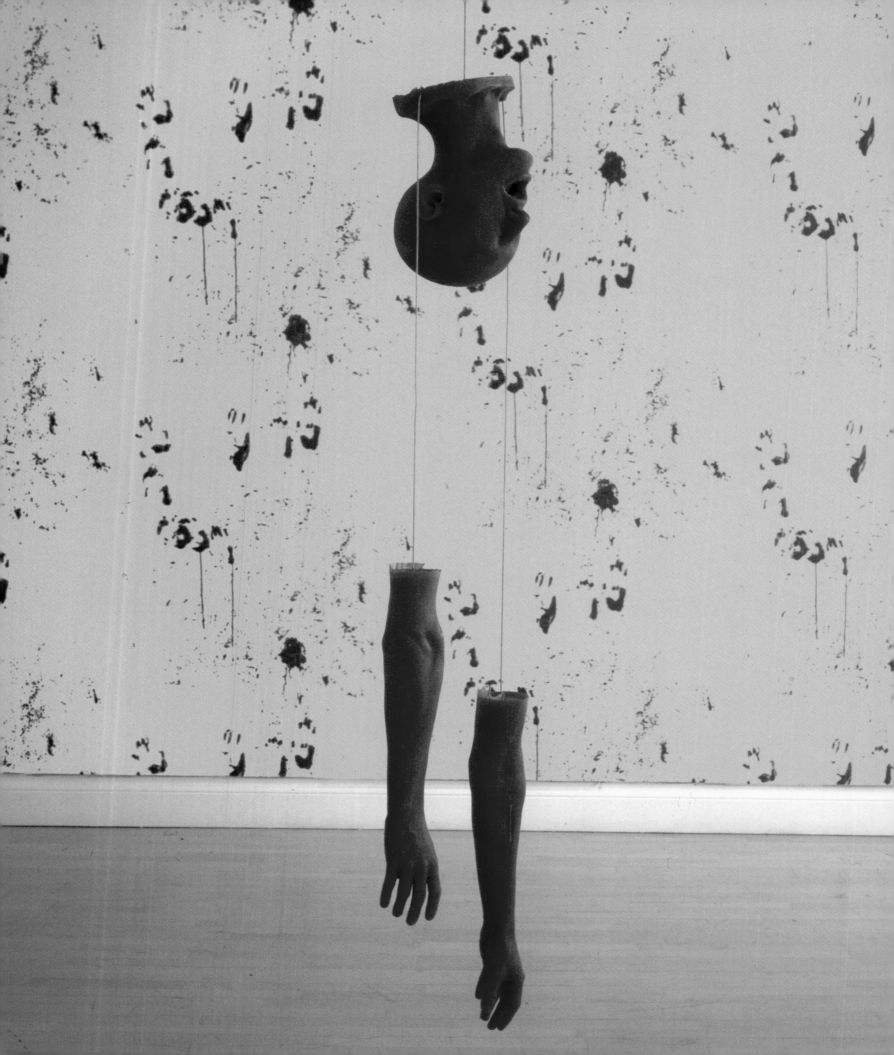

Abigail Lane, *Red Vertigo*, 1995, in the solo exhibition 'Skin of the Teeth', Institute of Contemporary Arts, London, 1995

Mark Wallinger, *Miracle*, 1997, in the solo exhibition 'Credo', Tate Liverpool, 2000

Mark Wallinger, *Brown's*, 1993, and *Half-Brother (Diesis-Keen)*, 1994–5, in the Turner Prize exhibition, Tate Gallery, 1995

Kathy Prendergast, *Still Life*, 1999 (detail), in the exhibition 'The End and the Beginning', Irish Museum of Modern Art, Dublin 1999

Cathy De Monchaux, *Secure*, 1988

Kathy Prendergast, *A Dream of Discipline*, 1989, Douglas Hyde Gallery, Dublin

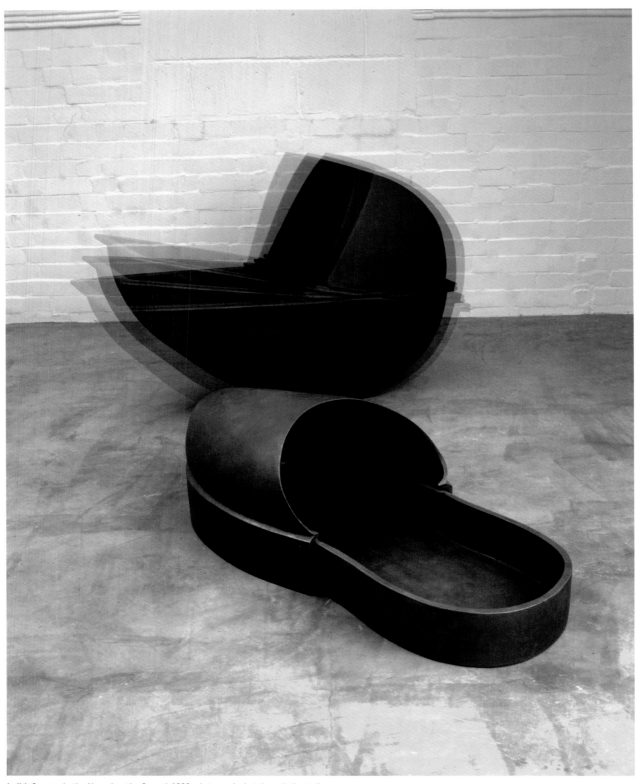

Judith Cowan, *In the Air and on the Ground*, 1989, photographed at the artist's studio
for her solo exhibition 'New Sculpture', Oriel Mostyn, Llandudno and Oriel, Cardiff

Tina Keane, *Escalator*, 1988, Riverside Studios, London

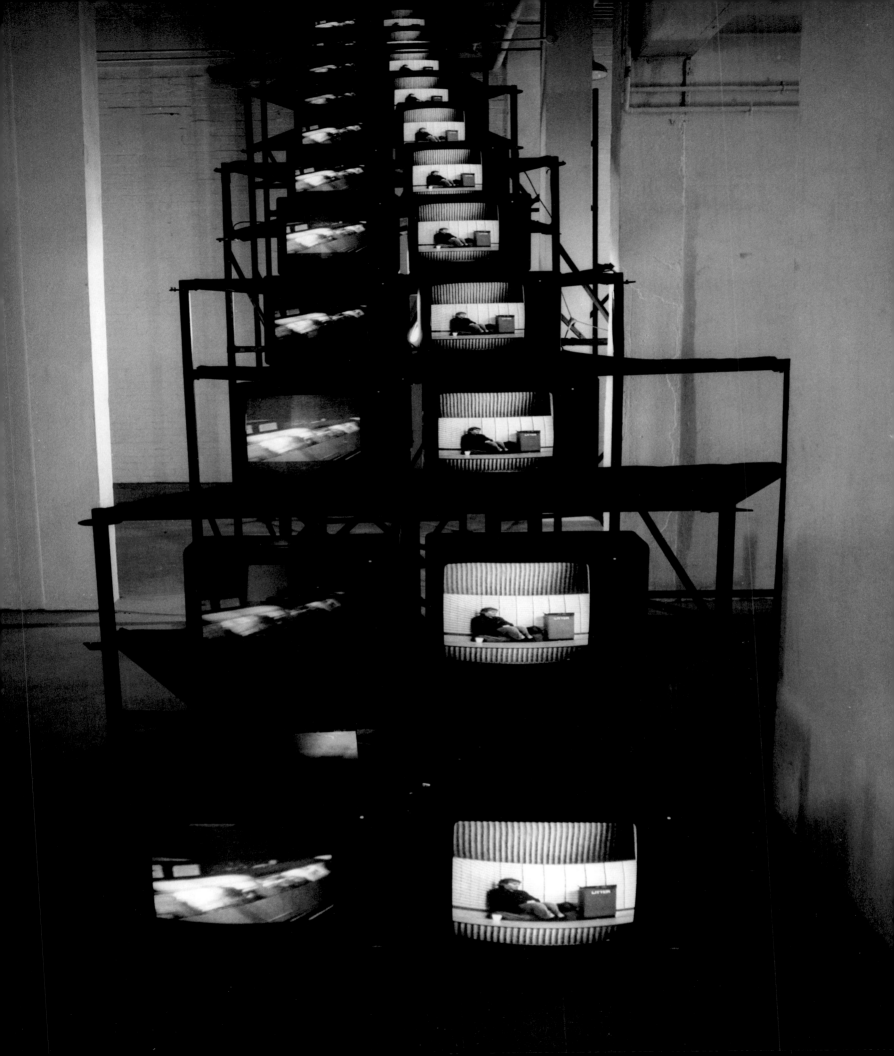

96

Installation view, 'Freeze' (Part One), 1988, Port of London Authority building, Surrey Docks, London, with **Anya Gallaccio**, *Waterloo* (on floor),
Stephen Park, *Wall-Mounted Sculpture* (middle of wall), drawings by **Richard Patterson** (far wall), and an untitled **Angus Fairhurst** painting
(on right). Photographed in July 1988, ahead of the opening in early August.

Installation view, 'Freeze' (Part One), 1988, with two *Untitled* works by **Sarah Lucas** (on the floor), and *Astra, Sovereign,* and *Cavalier* by **Michael Landy** (on the wall).

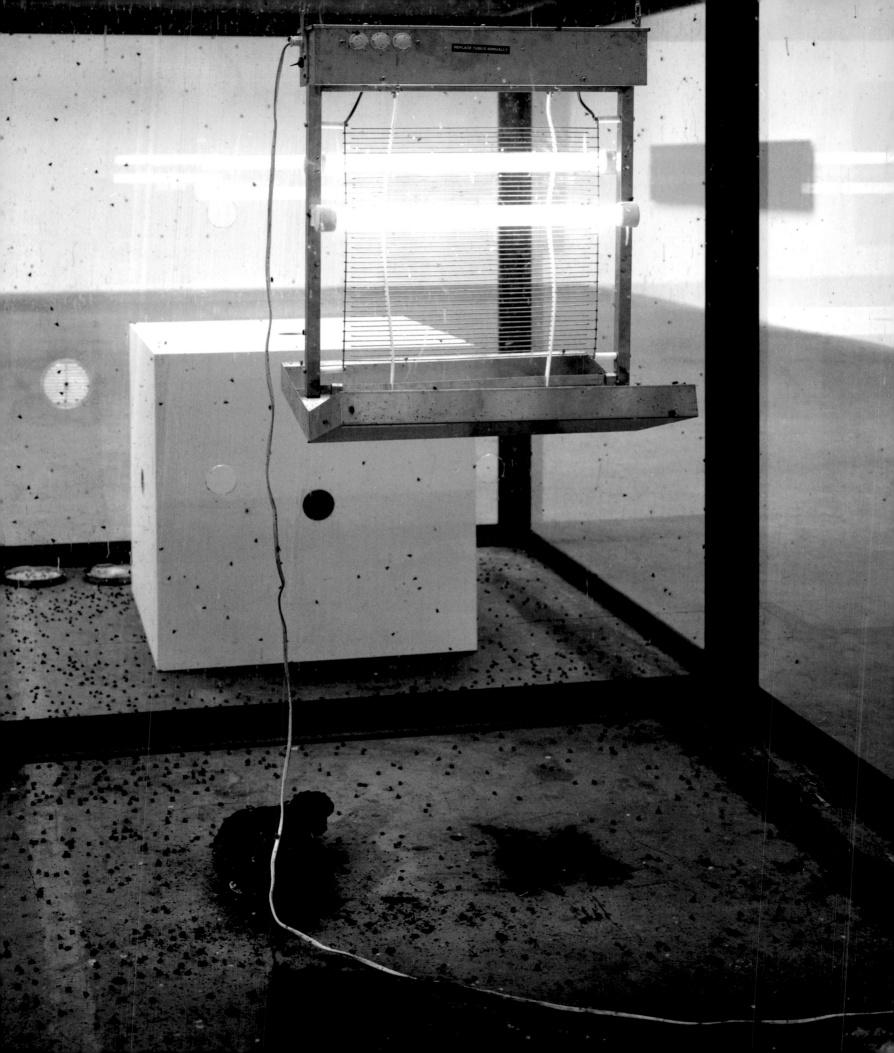

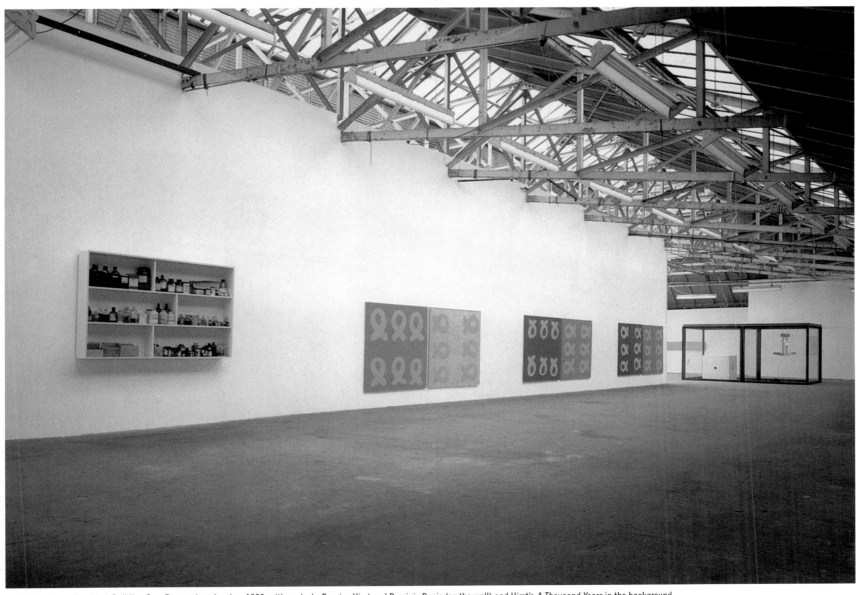

Installation view, 'Gambler', Building One, Bermondsey, London, 1990, with works by Damien Hirst and Dominic Denis (on the wall) and Hirst's *A Thousand Years* in the background

Damien Hirst, *A Thousand Years*, 1990, in 'Gambler', Building One, Bermondsey, London, 1990

Damien Hirst with *Never Mind*, May 1991

'His open-minded approach was brilliant, and he's a dude. There's a fundamental difficulty in trying to capture the power and weight of a three-dimensional work in a photograph, but Ed understands how sculpture works and it comes across in his images. He is able to communicate what the artist is trying to achieve, and that's pretty rare. He shot my graduation show in 1988, which included my first Medicine Cabinets. He just totally got the best way to capture them: they're on the wall but they're three-dimensional. And they have to be perfect, that was really important. Ed's photographs just got all that. I still photograph my works in the same way.'

Damien Hirst

Damien Hirst, **Billee Sellman**, and **Carl Freedman**, January 1990

Yinka Shonibare, May 1989

Mark Wallinger, with *Tattoo*, 1987, at the Serpentine Gallery, London, 1987

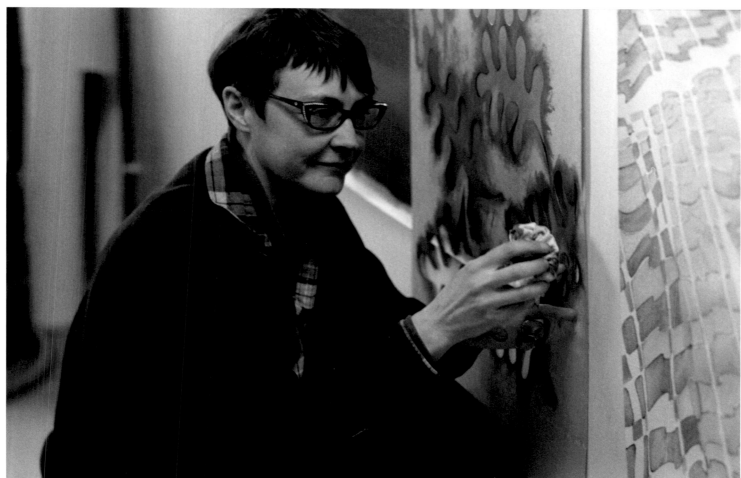

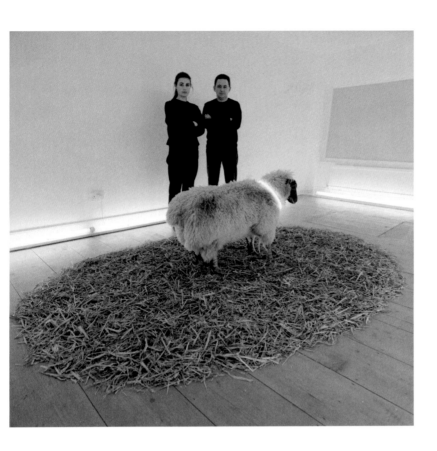

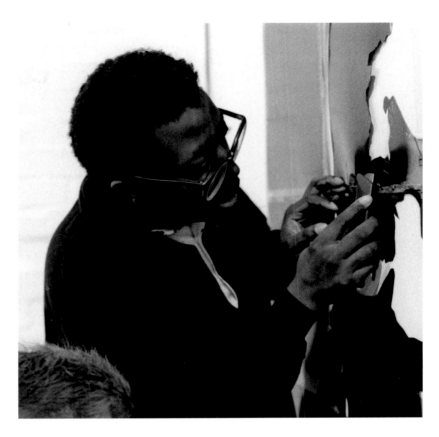

top **Art in Ruins** (Glyn Banks and Hannah Vowles) with *Contaminated Colour Field*, 1988, in 'Colour Field – New Realism' at Actualities, Limehouse, London
bottom **Tania Mouraud**, in her solo exhibition 'Words', Riverside Studios, London 1988

top **Donald Rodney**, workshop during his solo exhibition 'Crisis', Chisenhale Gallery, London, 1989
bottom **Mikey Cuddihy** in her studio at home in Beck Road, Hackney, London, December 1984

top **David Mach** working on *It Takes Two*, outside Euston Station, London, 1991
bottom **Jacqui Poncelet** in her studio, 1994

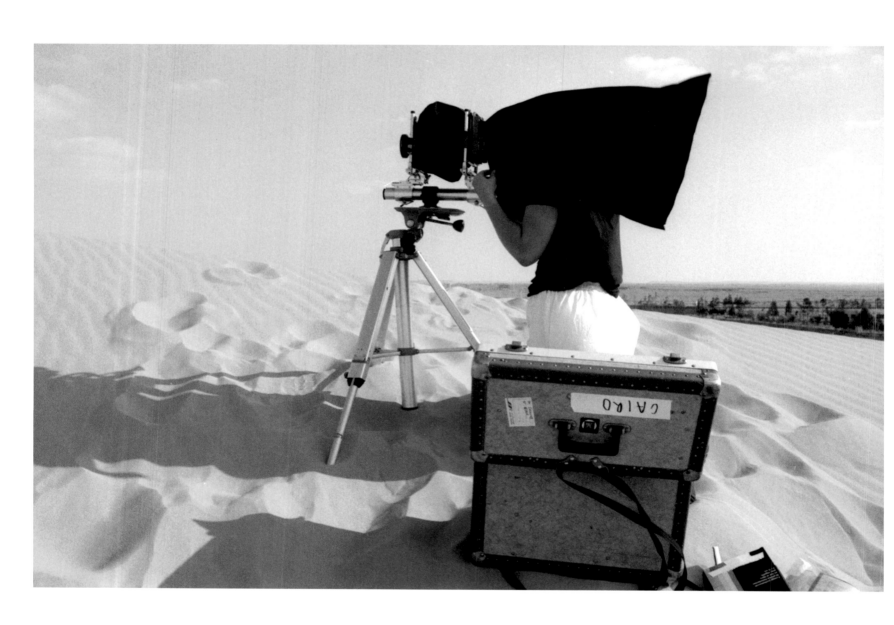

Working with **Hannah Collins** at Saqqara, Egypt, 1987

Mona Hatoum, photographed by Edward Woodman for her large-scale billboard work *Over My Dead Body*, 1988, inkjet on paper, 204 × 304 cm (80¼ × 119¾ in)

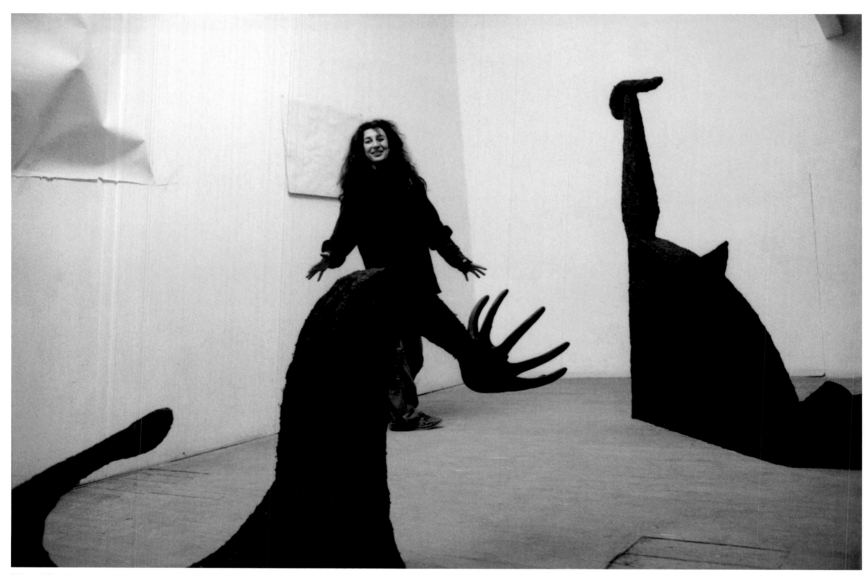

Shirazeh Houshiary, in her studio at Metropolitan Wharf, London, May 1982

Stuart Brisley, in his solo exhibition 'The Georgiana Collection', Serpentine Gallery, London 1987

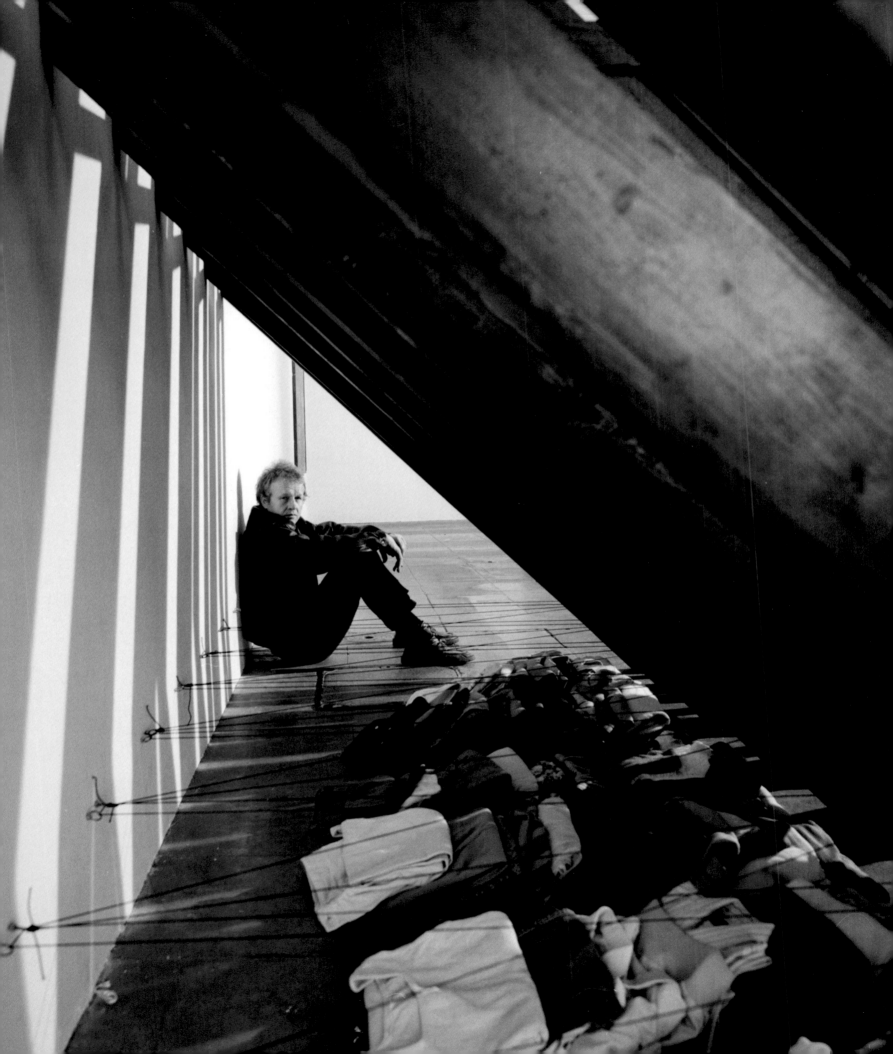

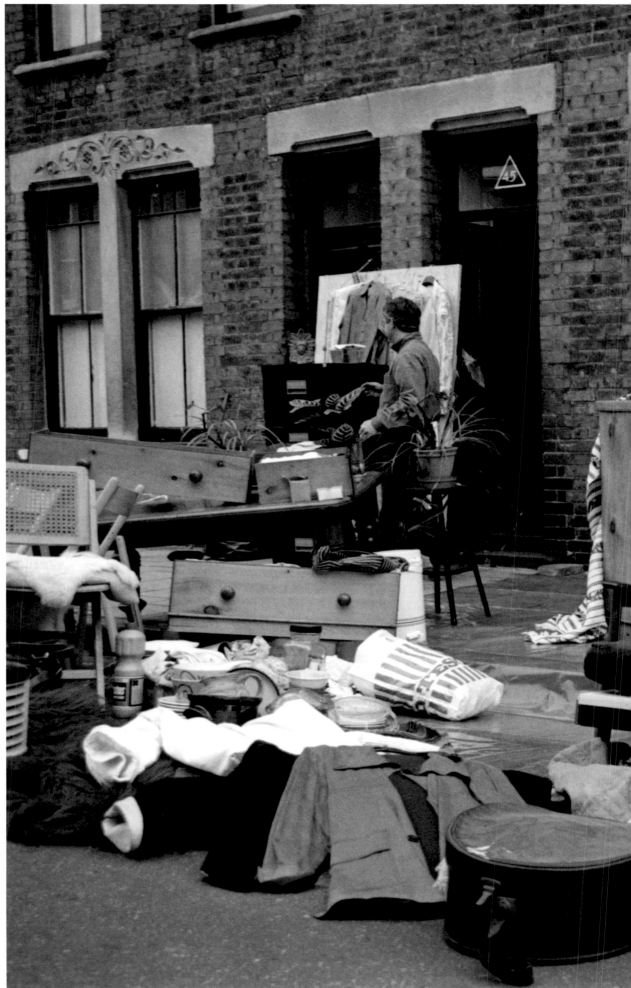

Helen Chadwick, photographed outside her home in
Beck Road, Hackney, London, while making *Three Houses
– A Modern Moral Subject*, 1987

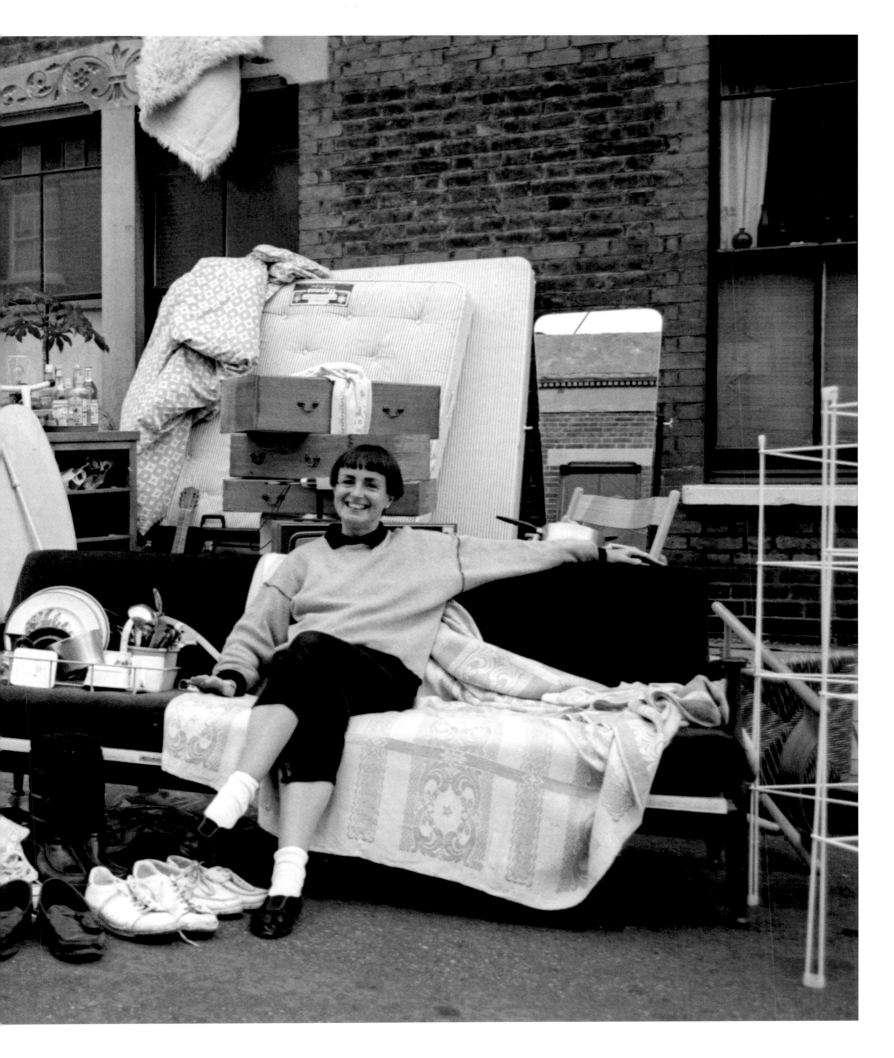

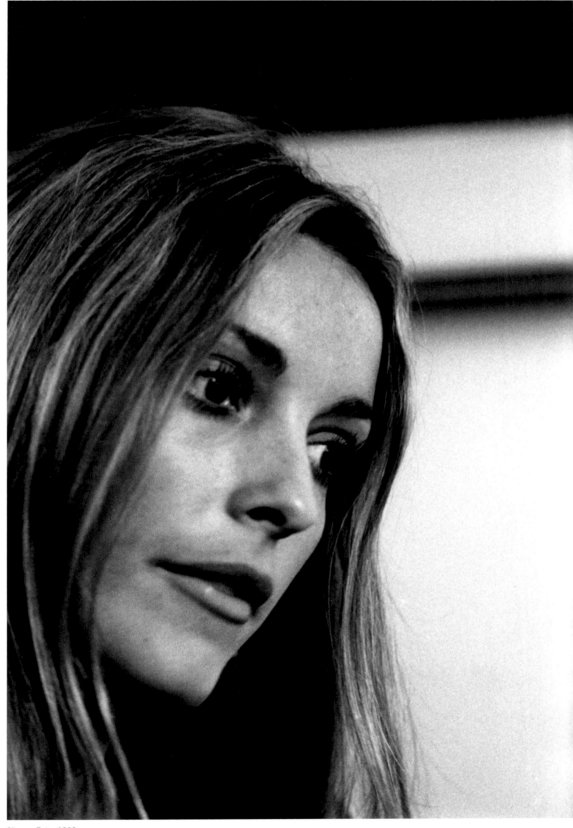

Sharon Tate, 1968

Molly Parkin, 1970

Frazer Hines, photographed in 1968 during filming of *Dr Who*, for *Petticoat* magazine

Ian McKellen, 1969

David Hemmings, photographed in 1968 at Chertsey, Surrey, during the filming of *The Long Day's Dying*

Edward Allington in his studio at Carpenters Road, Stratford, East London, 1984

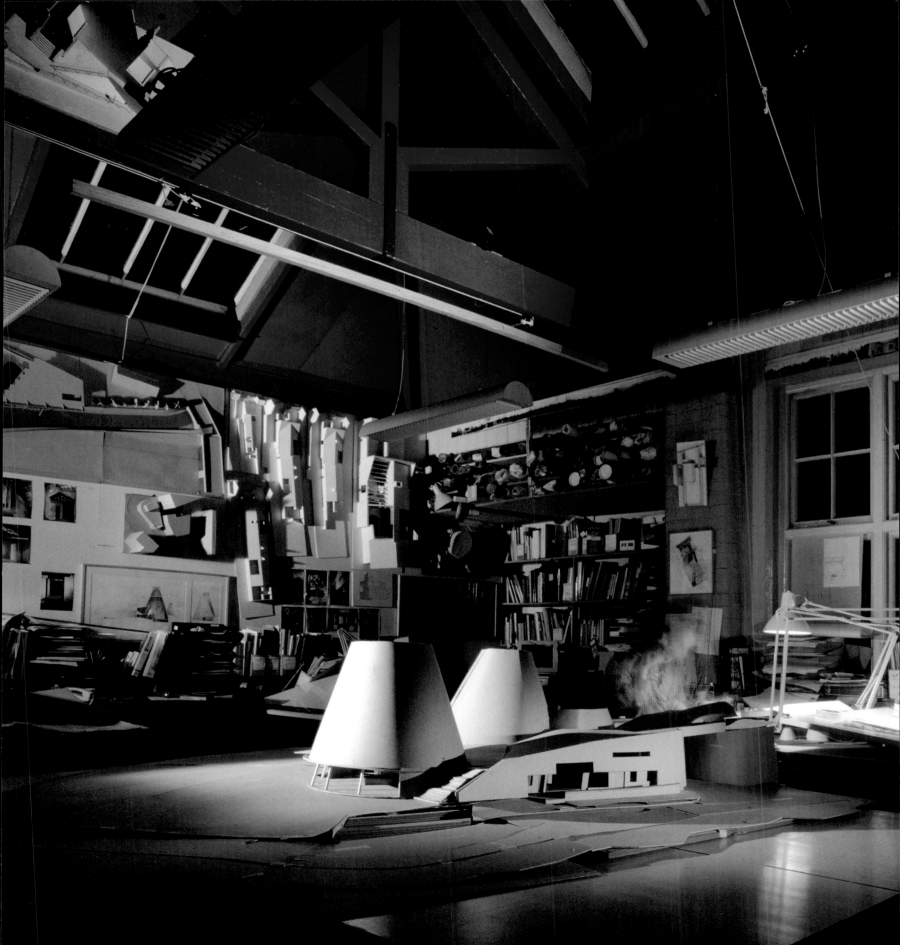

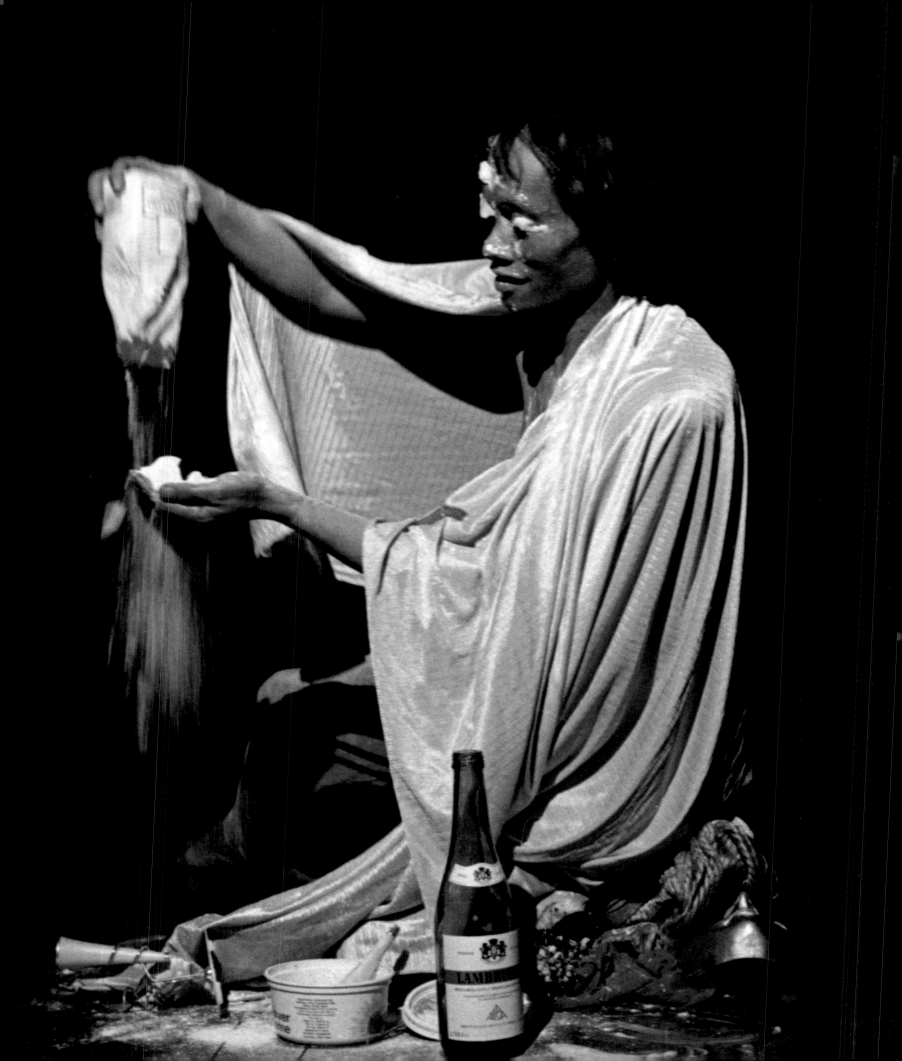

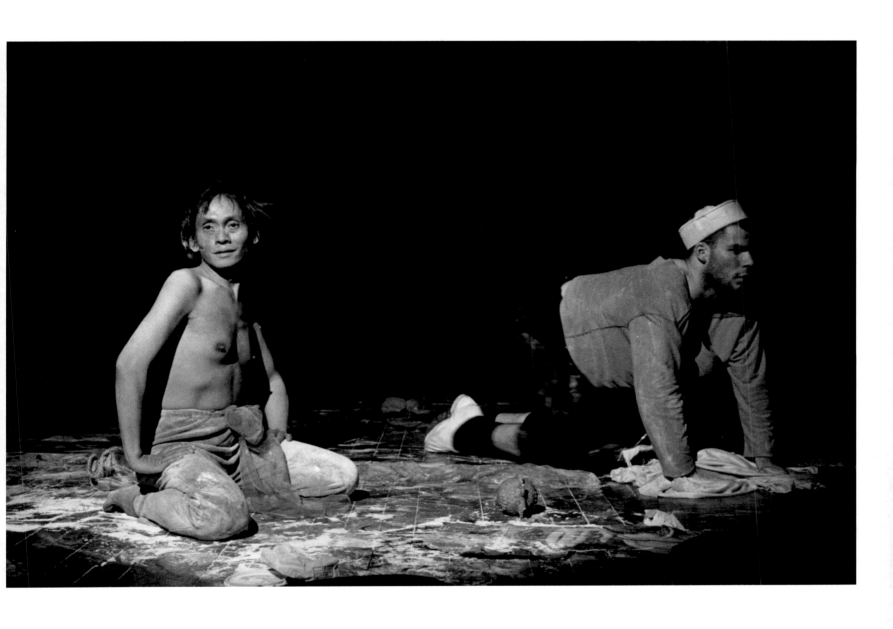

David Medalla, *Eloge de L'Exotisme*, 1986, Chisenhale Dance Space, London

Mona Hatoum, *Crosstalk* (performed with **Stefan Szczelkun**), Chisenhale Dance Space, London, 1986

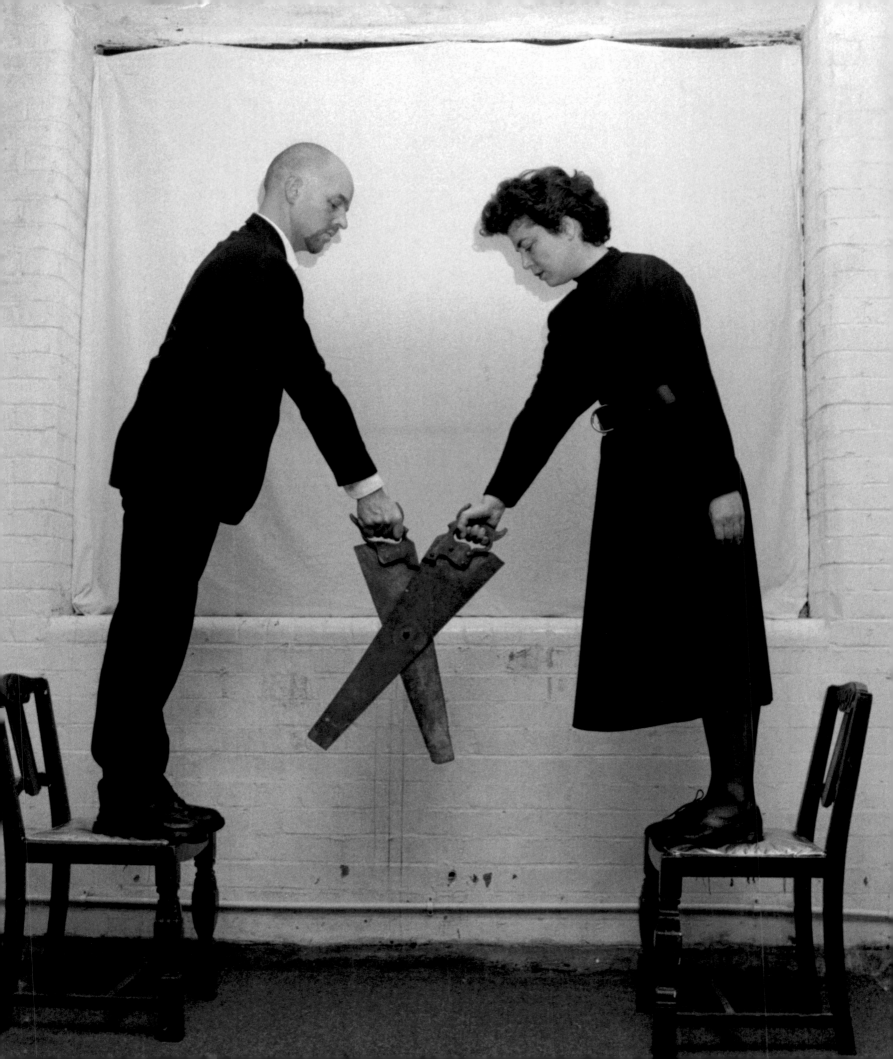

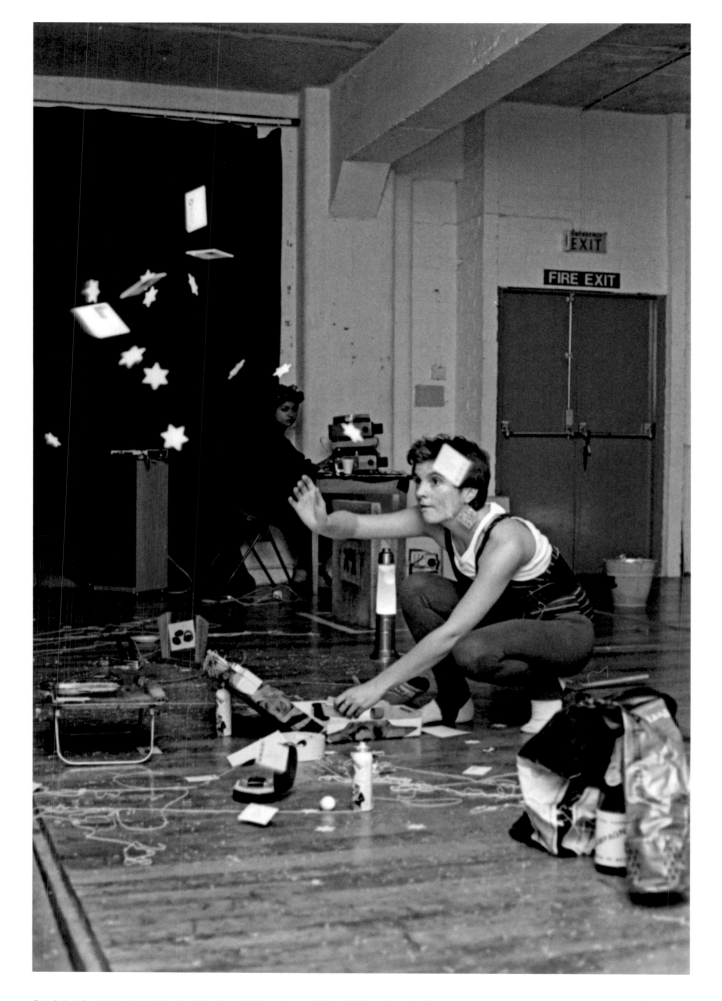

Tara Babel, *From the Comfort of Your Own Living Room*, 1986, performed at Chisenhale Dance Space, London

Heather Ackroyd in her studio, rehearsing *Uses of Enchantment*, performed at the Institute of Contemporary Arts, 1989

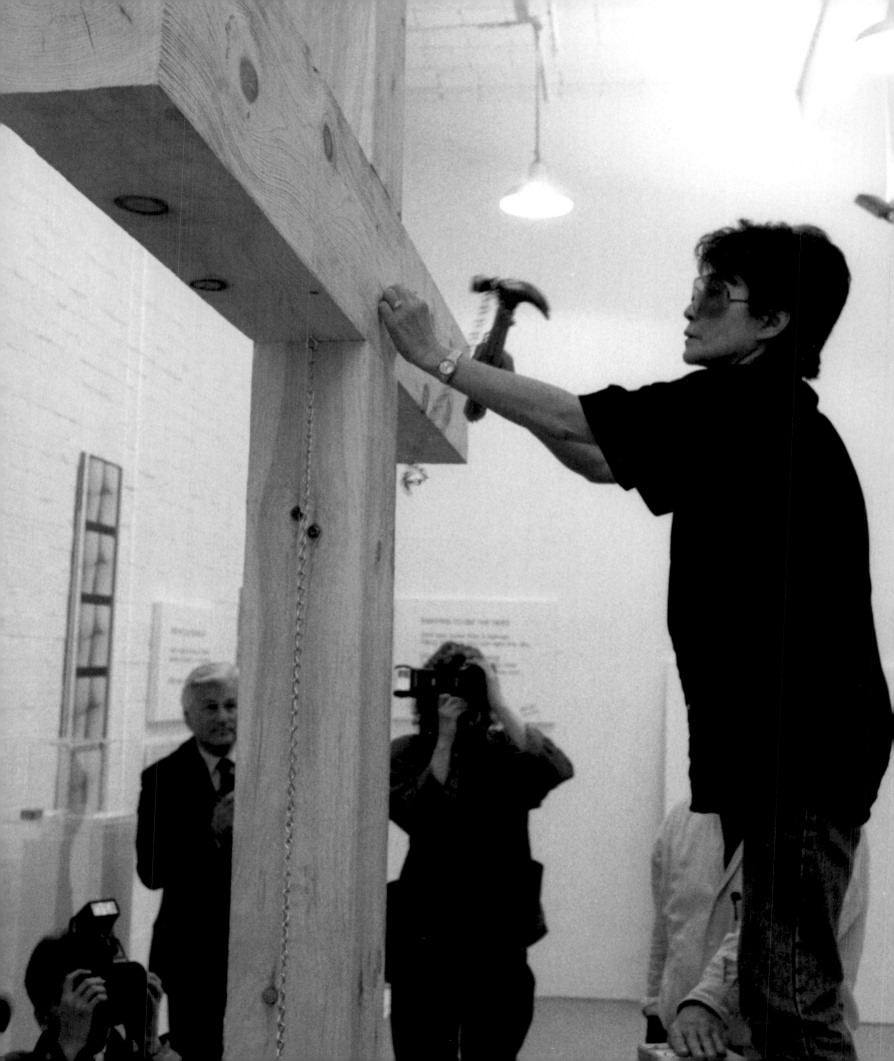

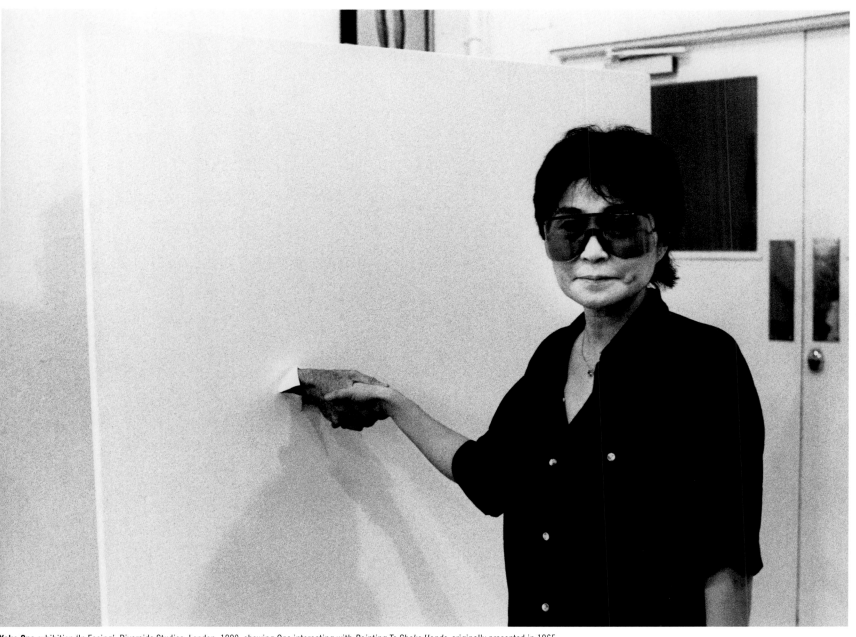

Yoko Ono exhibition 'In Facing', Riverside Studios, London, 1990, showing Ono interacting with *Painting To Shake Hands*, originally presented in 1965

Yoko Ono exhibition 'In Facing', Riverside Studios, London, 1990, showing Ono hammering in the first nail on her participation piece *Hammer Nail Cross*, a version of *Painting To Hammer a Nail*, originally presented in 1966

following pages **Michael Petry**, *Chaos Human Atomica: The Birth of the Parallel Universe*, 1988, Unit 7 Gallery, London

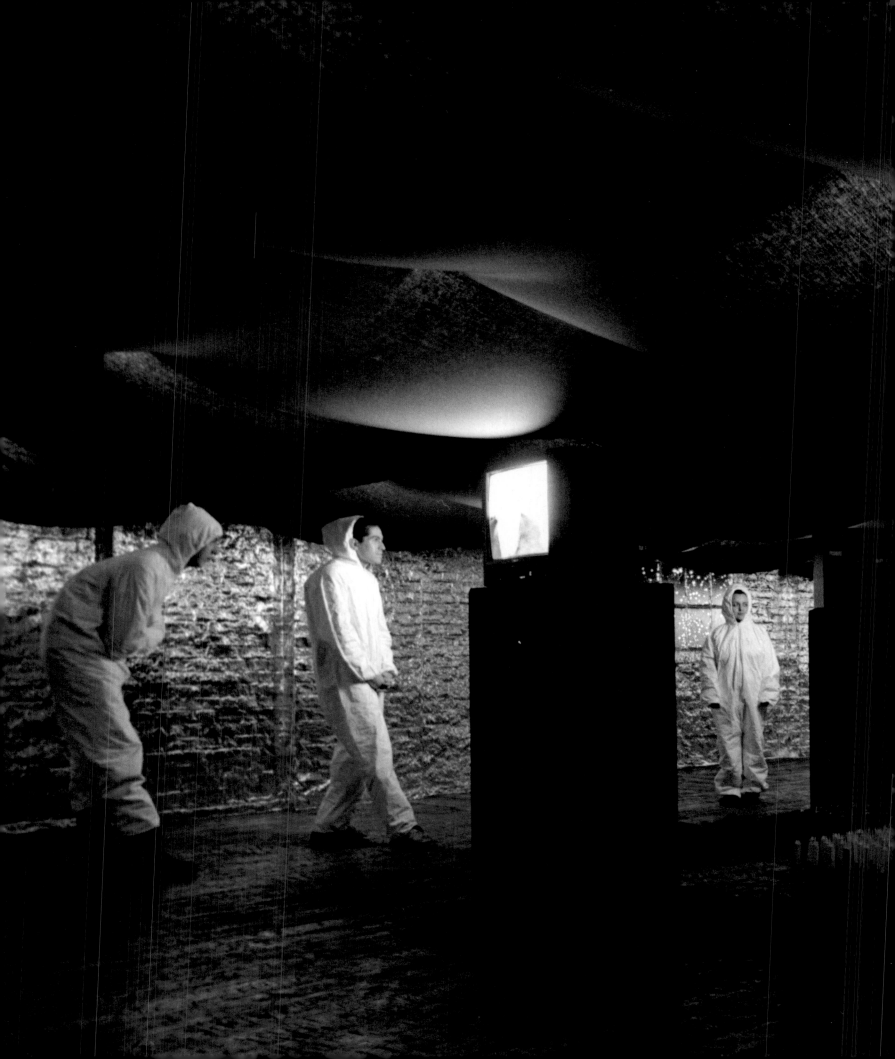

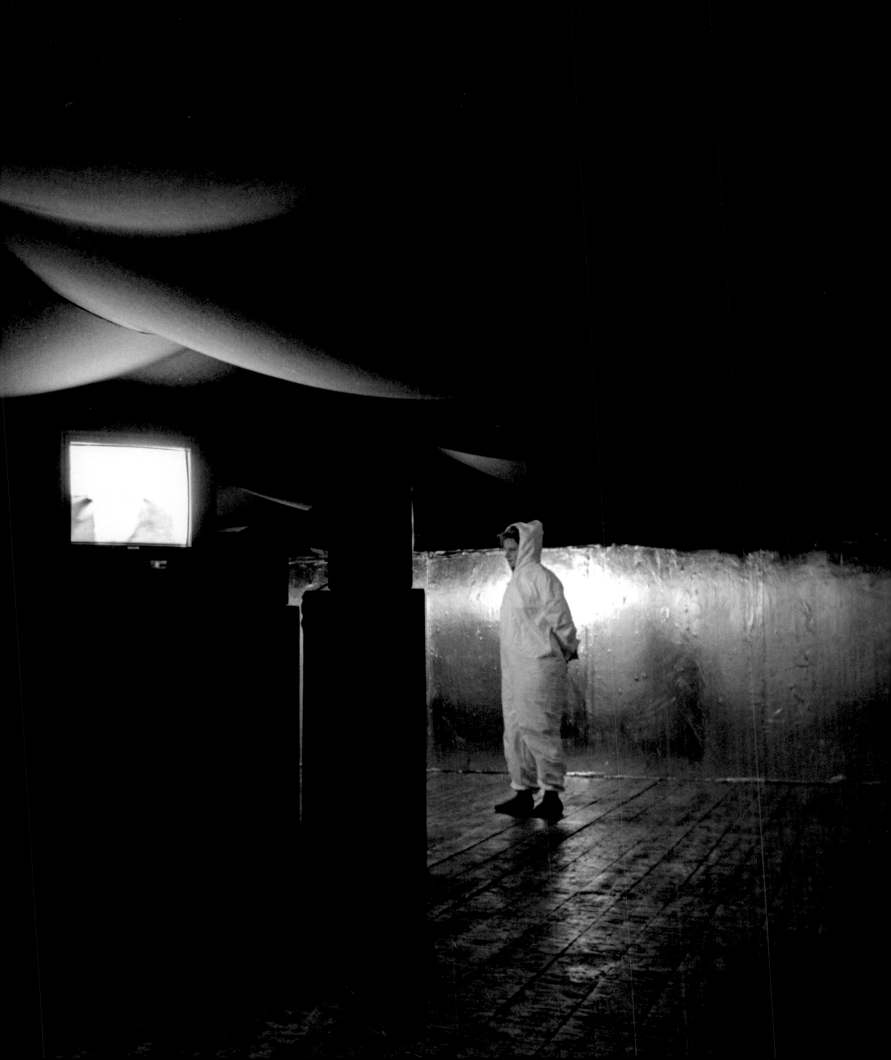

Antony Gormley's studio, Peckham, London, 1990

Antony Gormley, *Plateau*, 1985

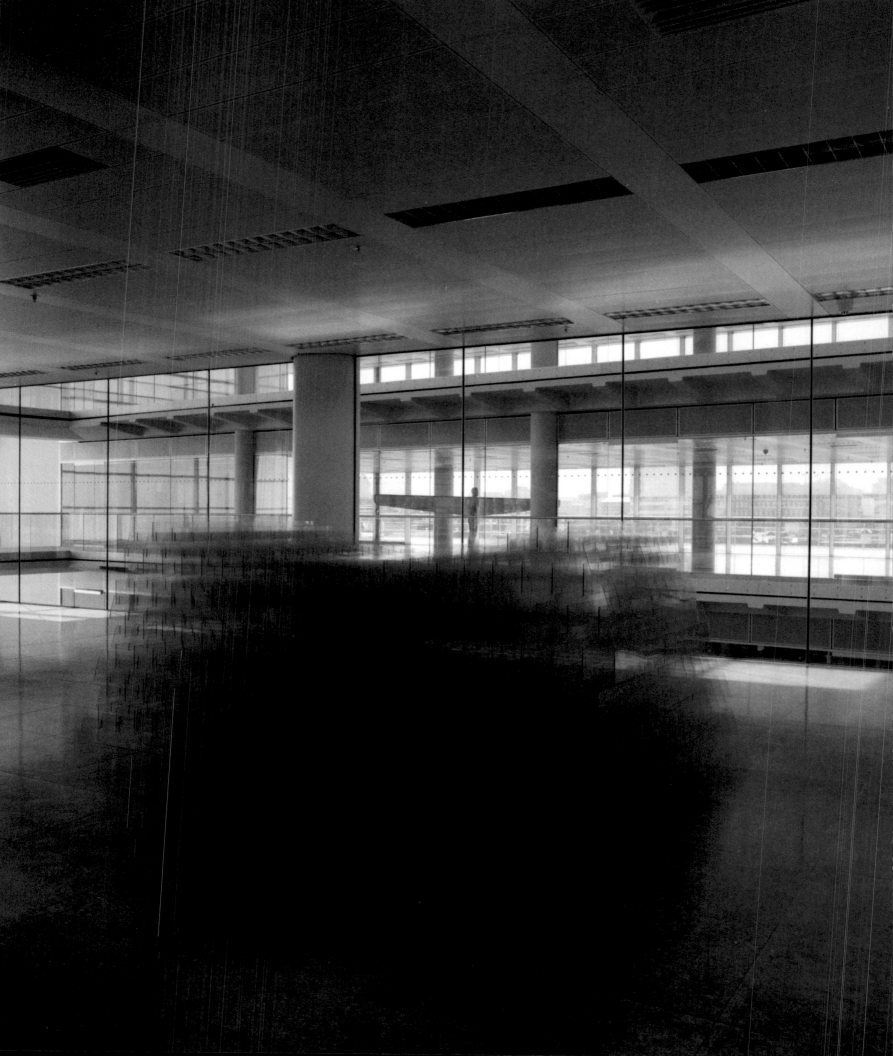

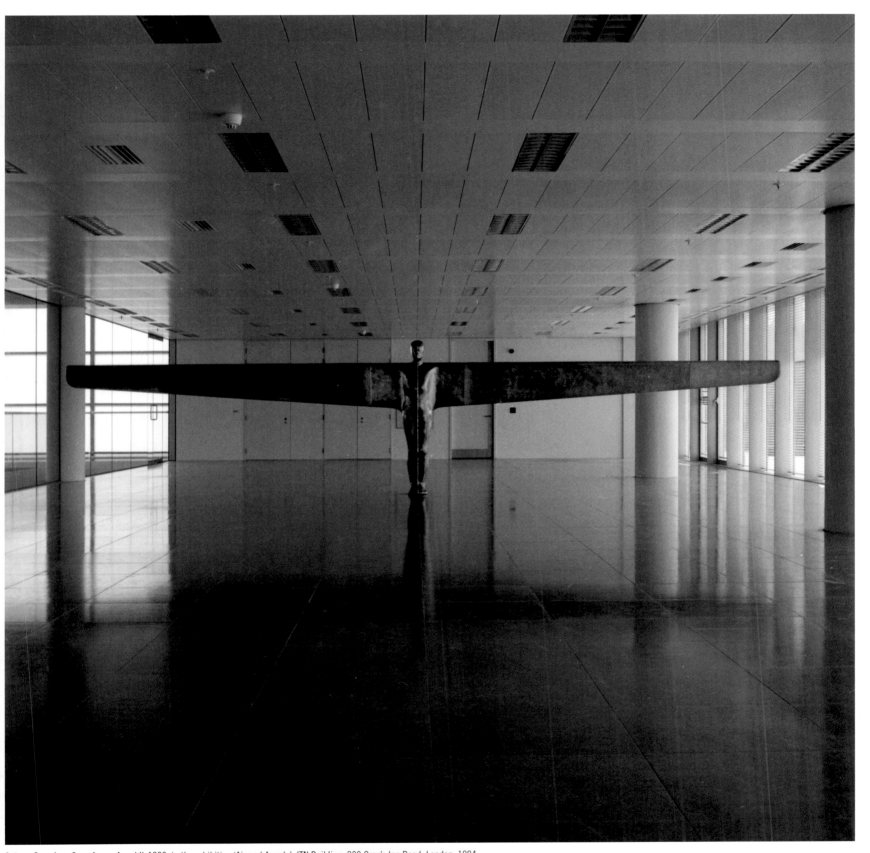

Antony Gormley, *Case for an Angel II*, 1990, in the exhibition 'Air and Angels', ITN Building, 200 Gray's Inn Road, London, 1994

Alison Wilding, *Blue*, 1993, in the exhibition 'Air and Angels', ITN Building, 200 Gray's Inn Road, London, 1994

'I photographed it from the side,
I photographed when the vanes were
moving, and none of them looked
as good as the static, symmetrical
shot where you can see all of the
first semaphor, with the others lined
up behind, threatening to move any
second.'

Edward Woodman

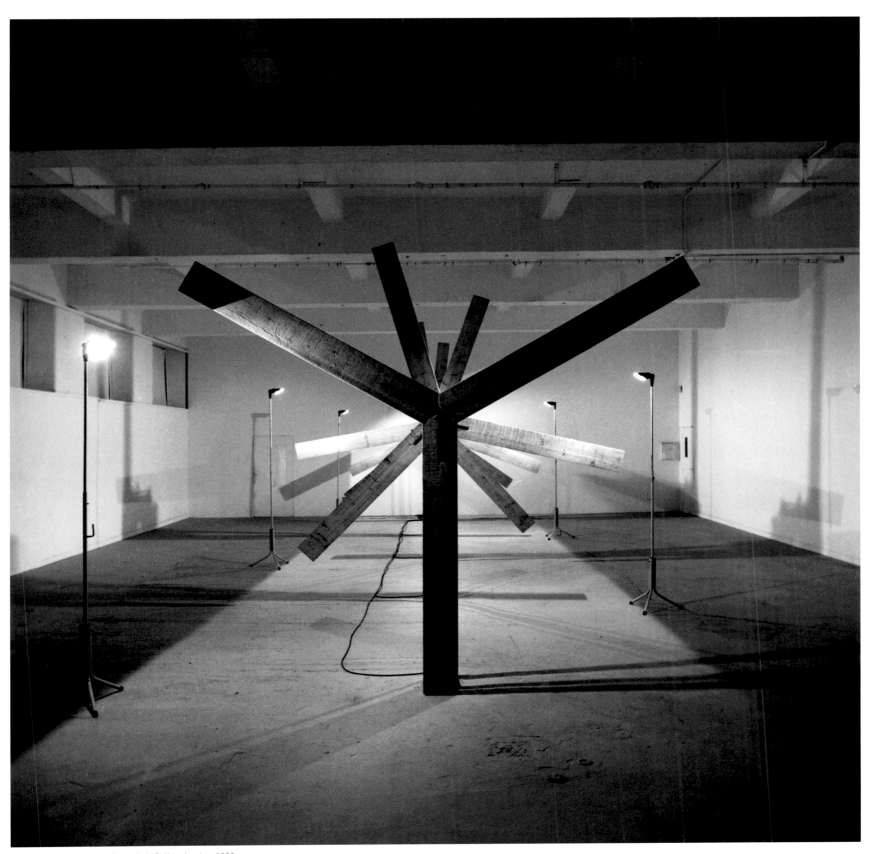

Darrell Viner, *Semaphore*, Chisenhale Gallery, London, 1990

following pages **Trisha Brown**, set for *Floor of the Forest* (1970), performed at documenta 12, Kassel, Germany, 2007

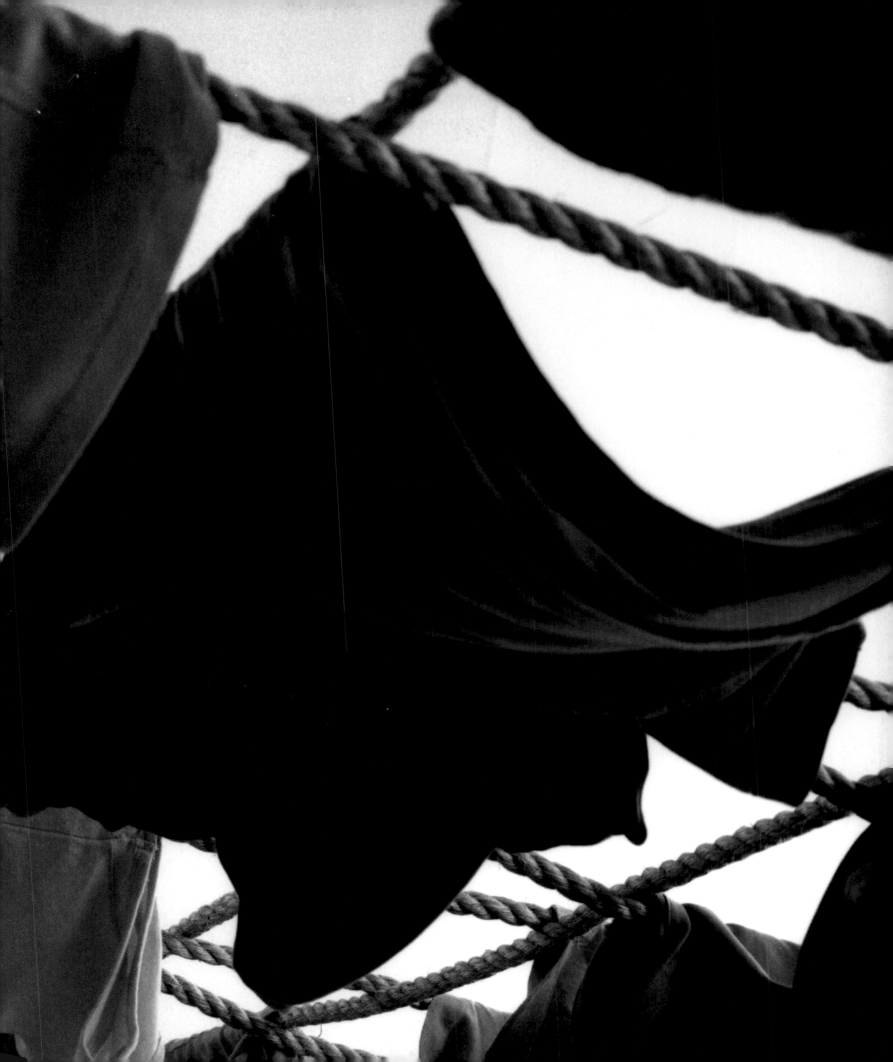

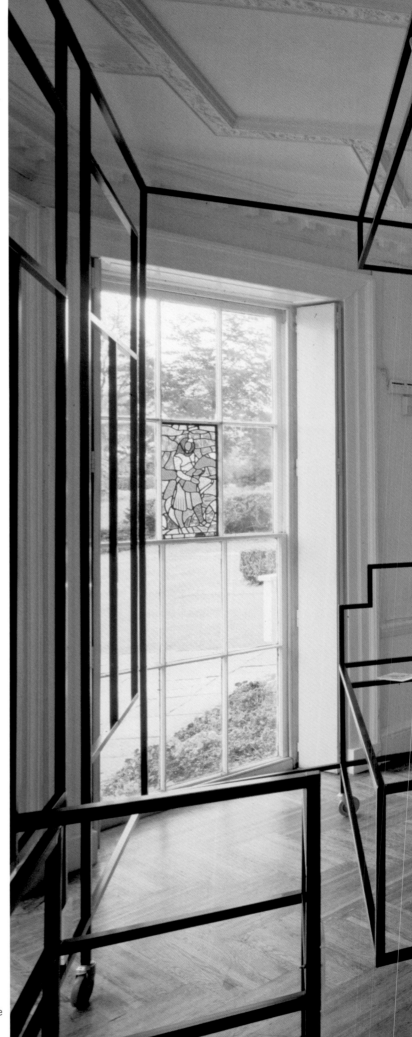

'I can't ever remember seeing him with an assistant. Most of the photographers I work with now have someone assisting them, but Edward was a one-person band, and he preferred it that way. He only had himself to blame if it went wrong. He wanted that focus. He didn't want to be thinking of someone else. It was very clever.'

Richard Wilson

Richard Wilson, *Room 6, Channel View Hotel*, 1996, Towner Art Gallery, Eastbourne

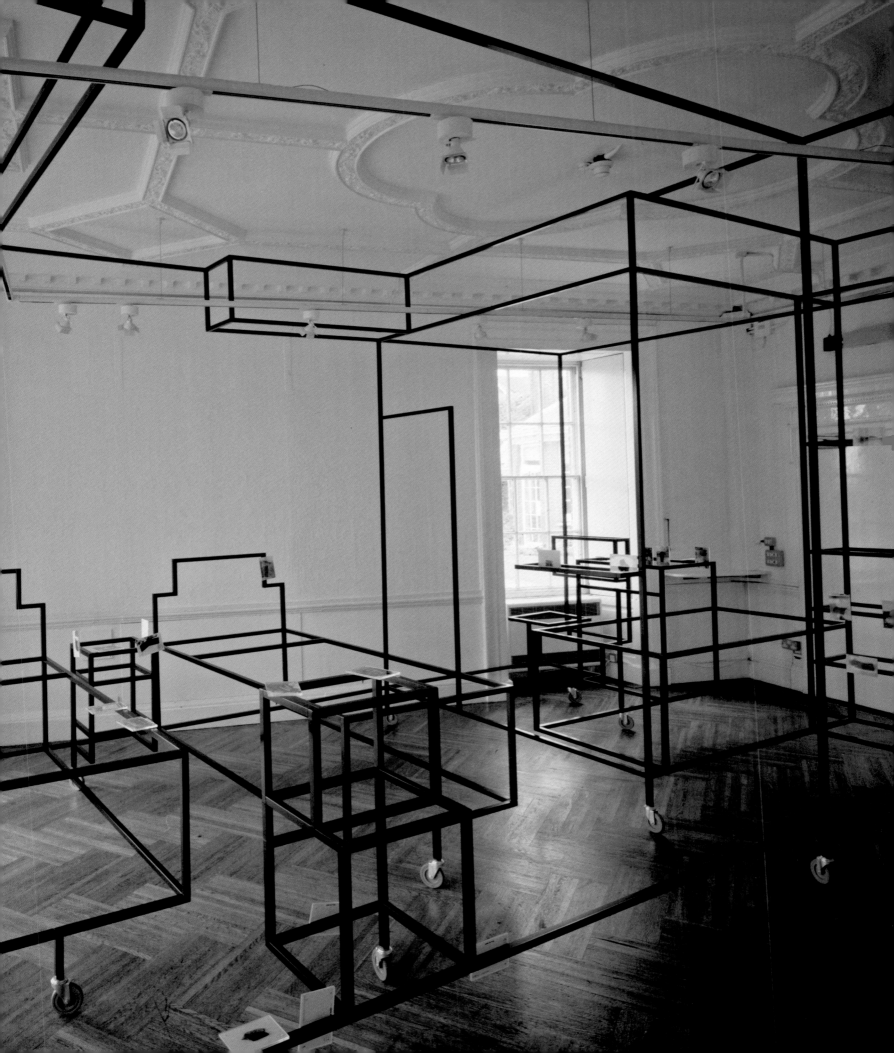

'He was able to pick up on various aspects and hold that within a single shot. You can see the corridor ... you can see the boundary of the room and you can see the disorientation of reflection. He put it all in there. And also it's that translation: his world is 2D, my world is 3D. He was able to take the 3D world, the real world, and see it as flat, to know exactly what he wanted to get.'

Richard Wilson

Richard Wilson, *20:50*, Matt's Gallery, London, 1987

Richard Wilson, *Sea Level*, Arnolfini, Bristol, 1989

Richard Wilson, *Swift Half and Return to Sender*, 1992, Galerie de l'Ancienne Poste, Calais

Richard Wilson, *All Mod Cons*, 1990, installation for EDGE 90 international art festival, Newcastle-upon-Tyne

London night view (St Andrew-by-the-Wardrobe, from St Andrew's Hill, Blackfriars), 1985

Stairwell, Fournier Street, Spitalfields, 1984

Demolition of Hunter Street, Bloomsbury, in preparation for the construction of the Brunswick Centre, 1960s

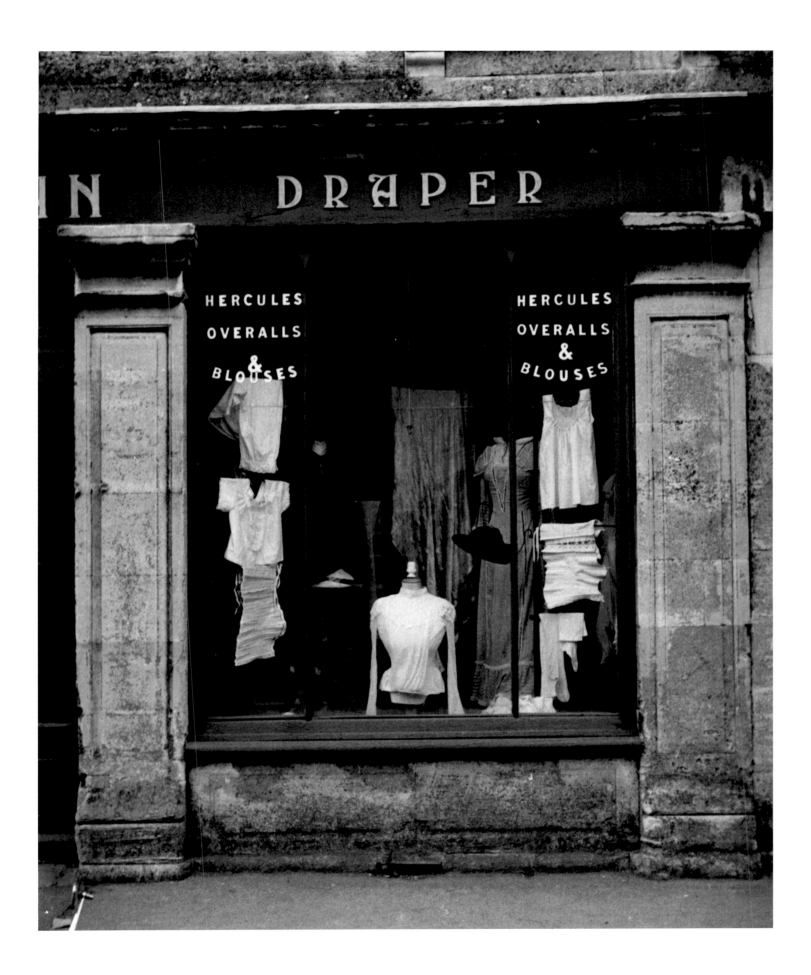

Draper's shop, Spitalfields, London, 1978

Artists and their families, living in houses with studios on Beck Road, Hackney, London, managed by Acme.
Photographed for the Beck Road Arts Trust Appeal, January 1988.

Installing works by **David Mach** and **Hannah Collins**, outside Interim Art, Beck Road, Hackney, London, in the 'Artangel Roadshow', June 1985, which also included works by **Boyd Webb** and **Julia Wood**

David Mach, *Hackney Cab*, 1985, in the 'Artangel Roadshow', June 1985

Fleet Street, 4am on strike night, 1970

Graeme Willson, *Passengers*, 1984, mural for Surbiton Station, a Public Art Development Trust (PADT) commission (destroyed by Railtrack, 1999)

John Eager, performance as part of 'Provisional Statements on the Rights of the Citizen', 1988, Smithfield Market, London

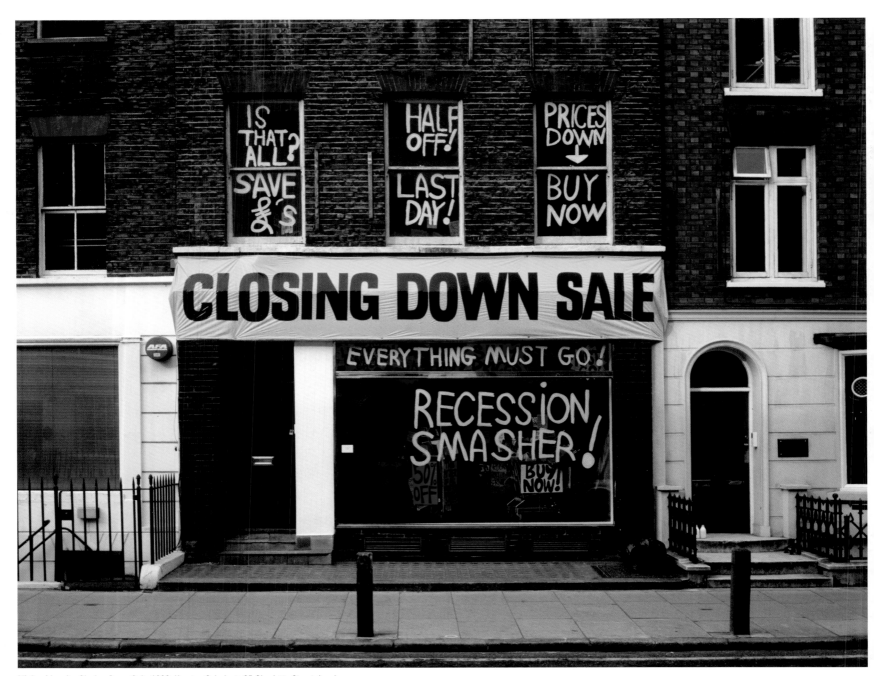

Michael Landy, *Closing Down Sale*, 1992, Karsten Schubert, 85 Charlotte Street, London

Michael Landy, *Market*, 1990, Building One, Bermondsey, London

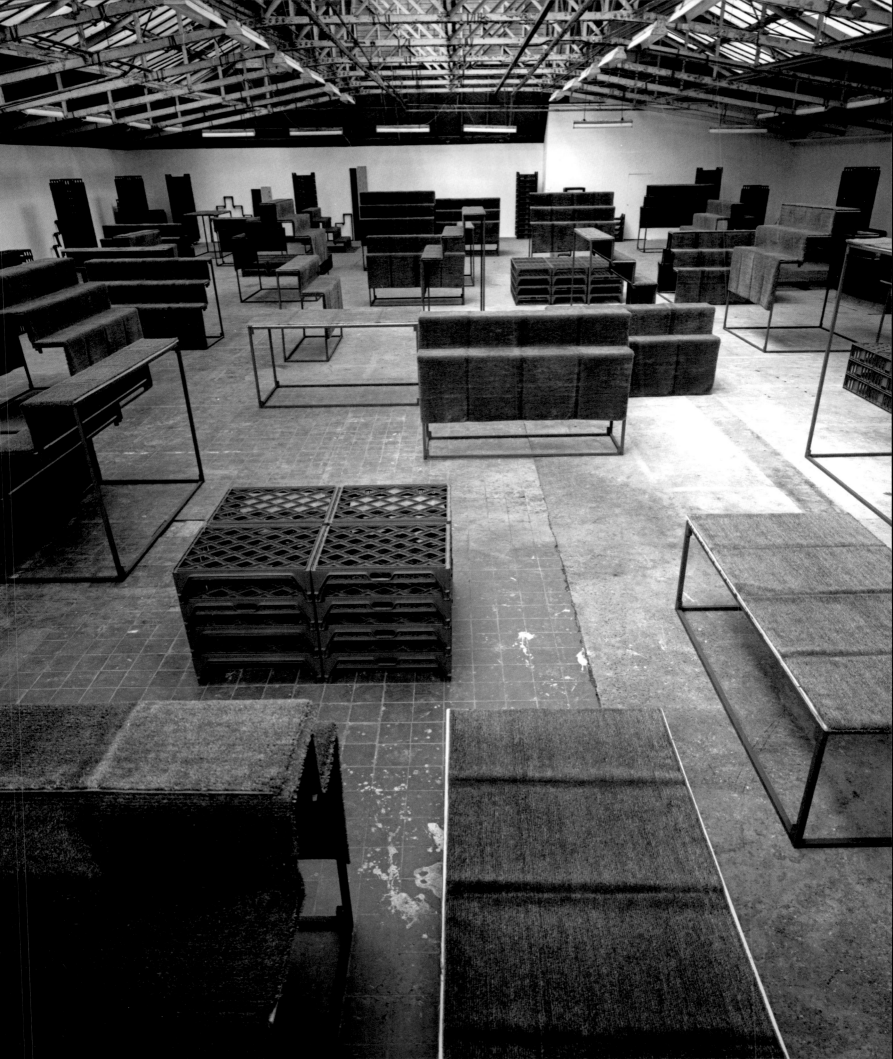

Michael Landy, *Michael Landy at Home*, 7–9 Fashion Street, London, 1999

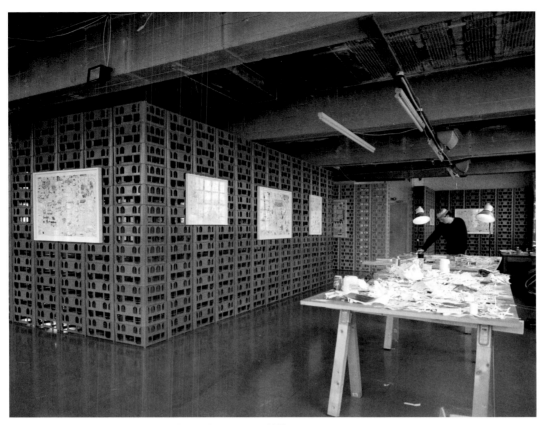

Michael Landy, *Michael Landy at Home*, 7–9 Fashion Street, London, 1999

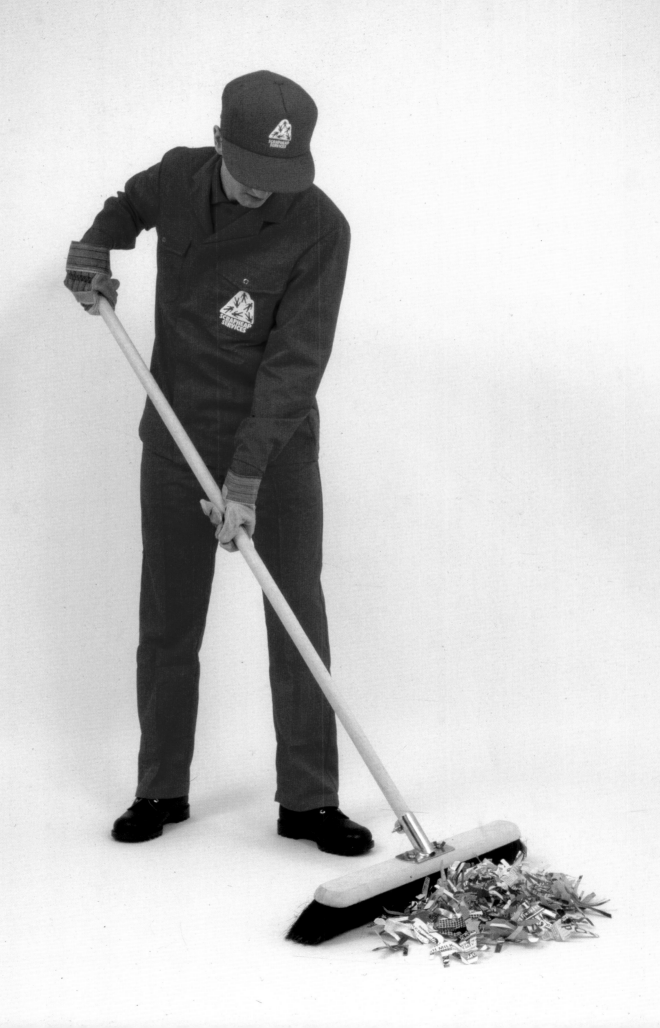

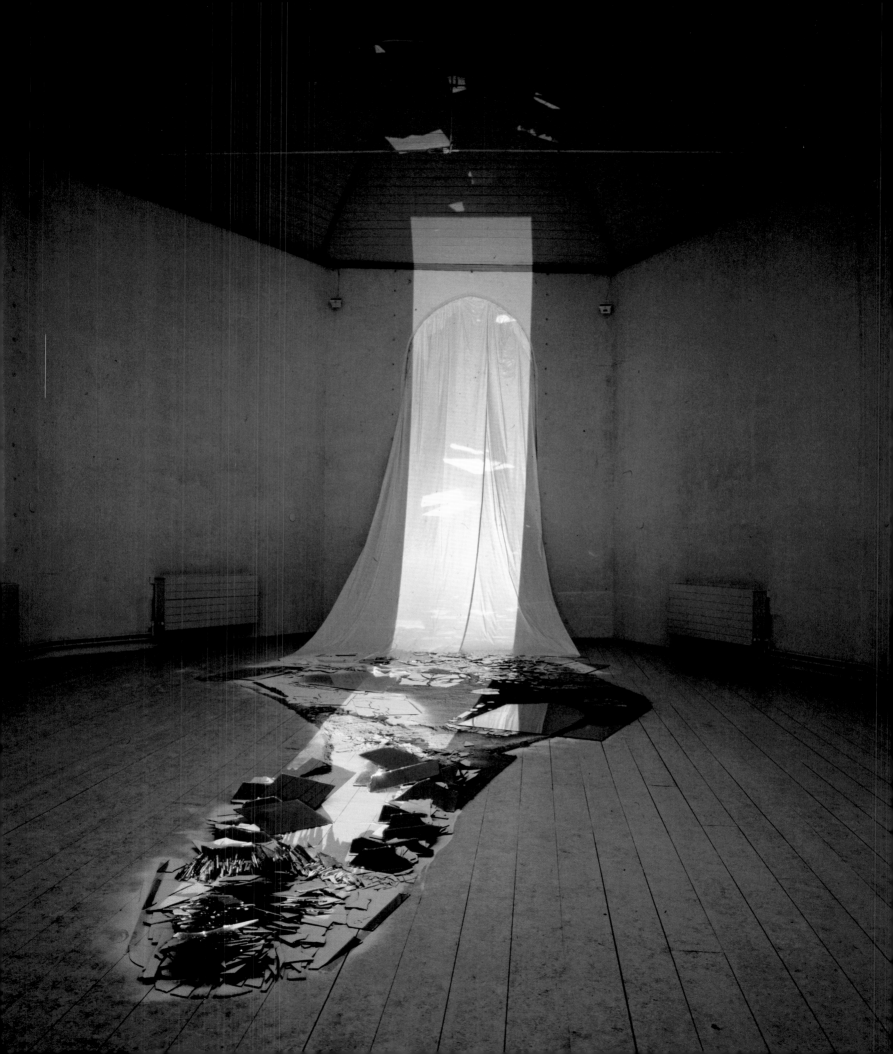

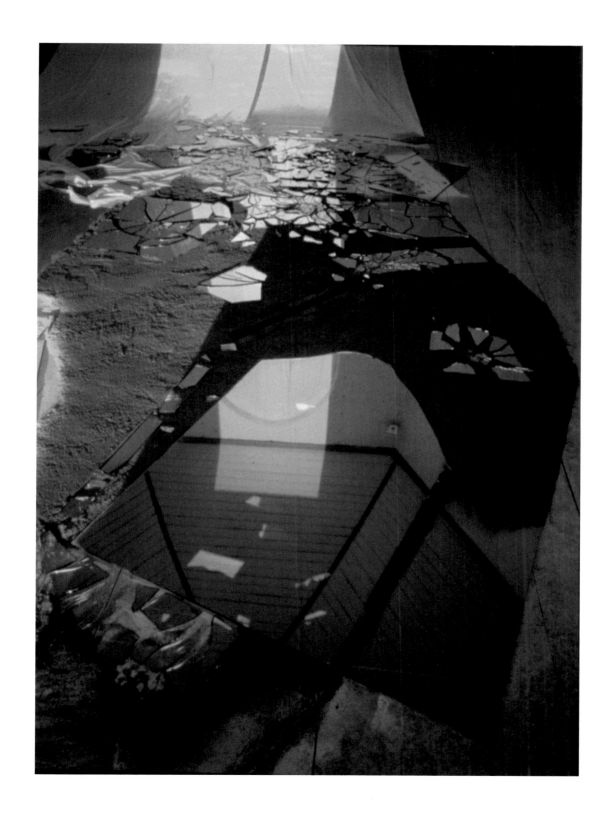

ane Boyd, *To the Warder of Things Present*, 1995, Mariakapel, Hoorn, The Netherlands

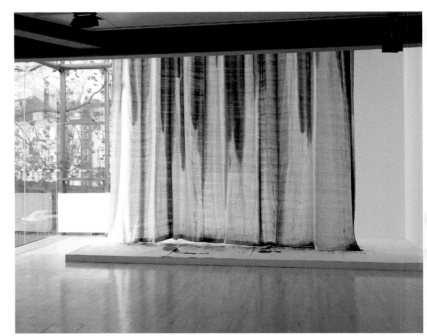

Anya Gallaccio, *All the rest is silence*, 1999, Sadler's Wells, London

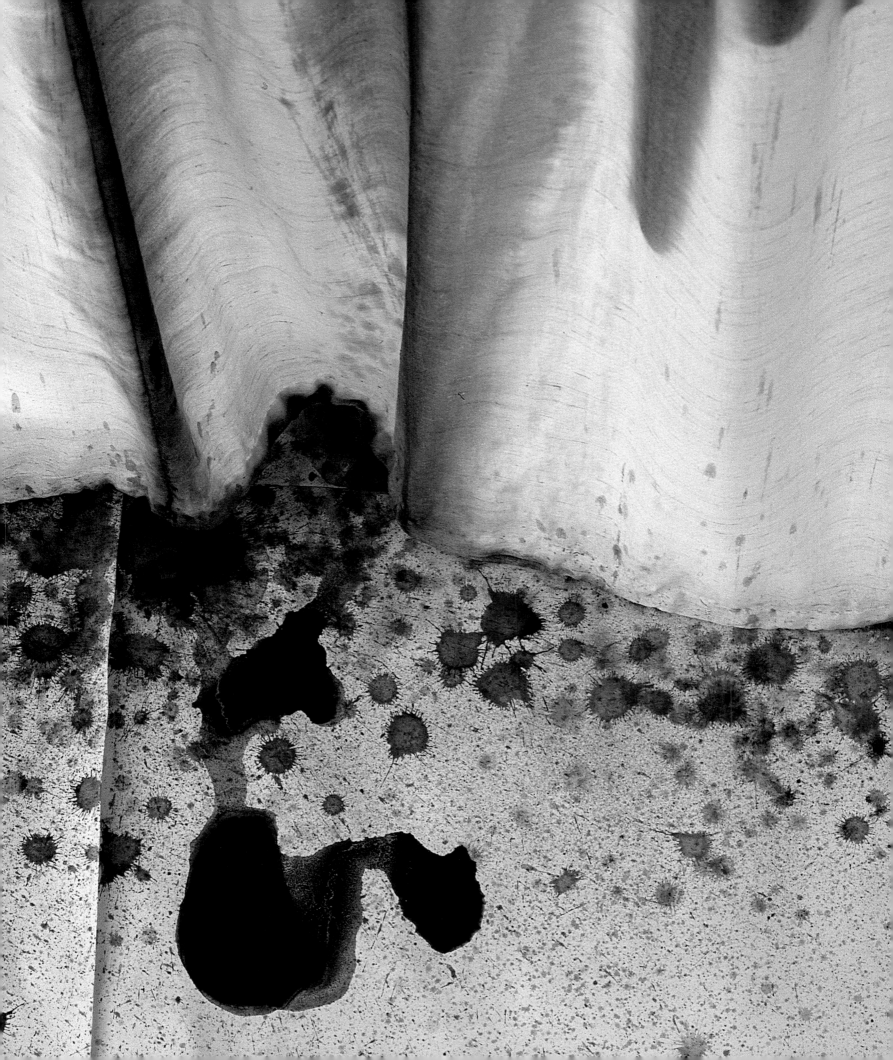

'It's fantastic when you find someone you connect with and you trust, and who can preserve, present, or reflect your work in a way that is meaningful. Edward always listened to what I had to say or what I thought was important, and then he tried to work out how to capture that in the shot. But it was also a way of seeing your work through the eyes or lens of somebody else in terms of how they focus the camera on what they think is important. When it was a medium-format image, it was a big deal. You would spend half a day discussing which two or three shots you could afford to have, and it just encouraged a different way of looking. Edward would shoot a roll of black-and-white film, negative film, and then take a couple of larger-format transparencies. The economy of that way of working seems strange to think about now, but I miss the precision and occasion of it.'

Anya Gallaccio

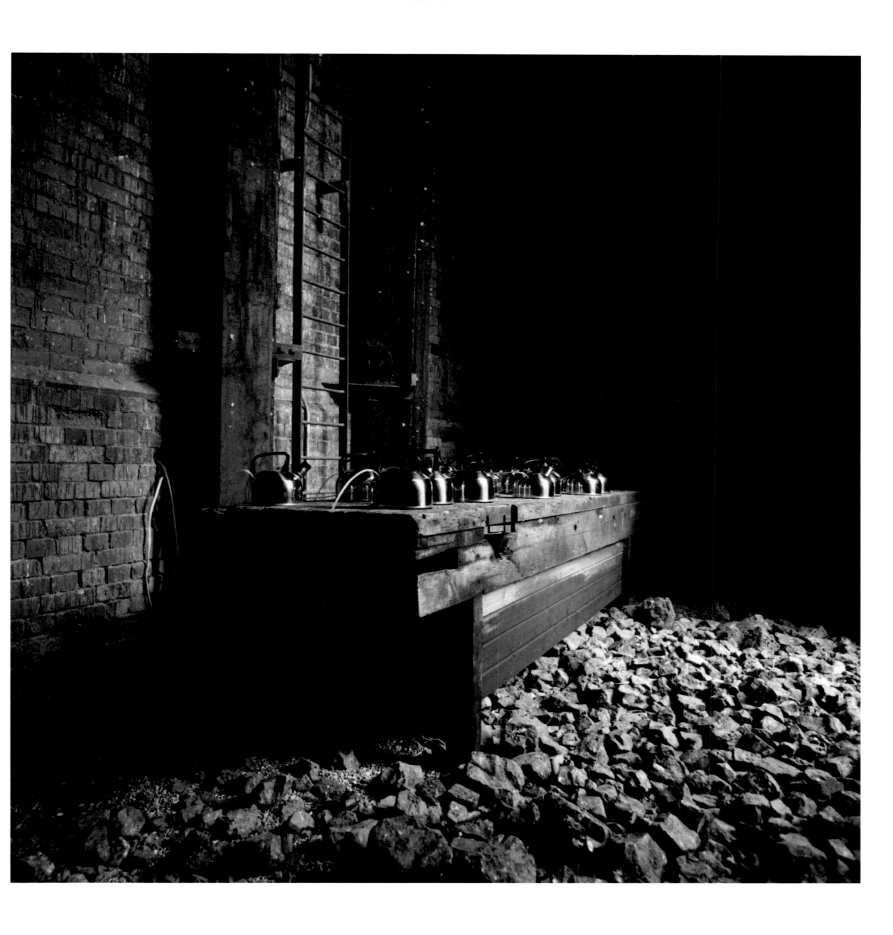

Anya Gallaccio, *Prestige*, 1990, Wapping Hydraulic Power Station, London

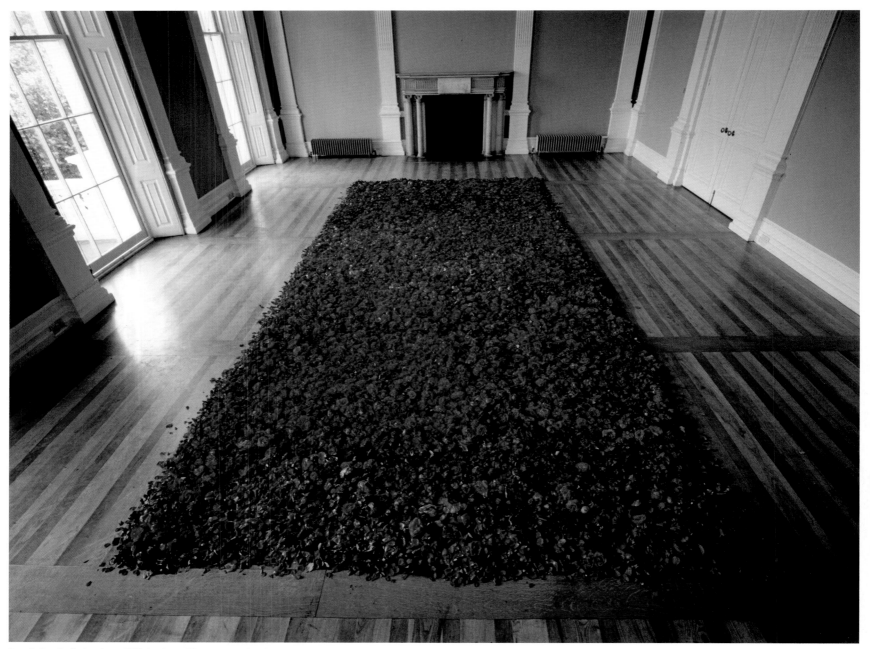

Anya Gallaccio, *Red on Green*, 1992, Institute of Contemporary Arts, London

Anya Gallaccio, photographed with *Red on Green*, July 1992

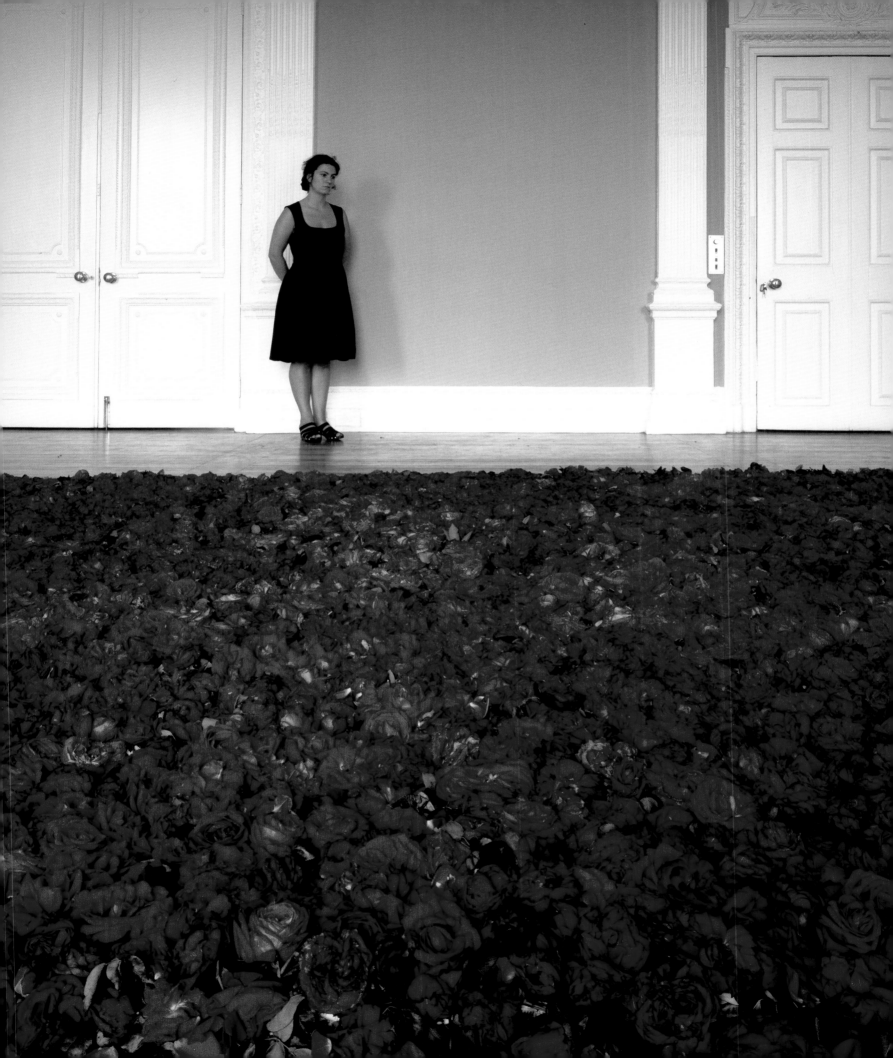

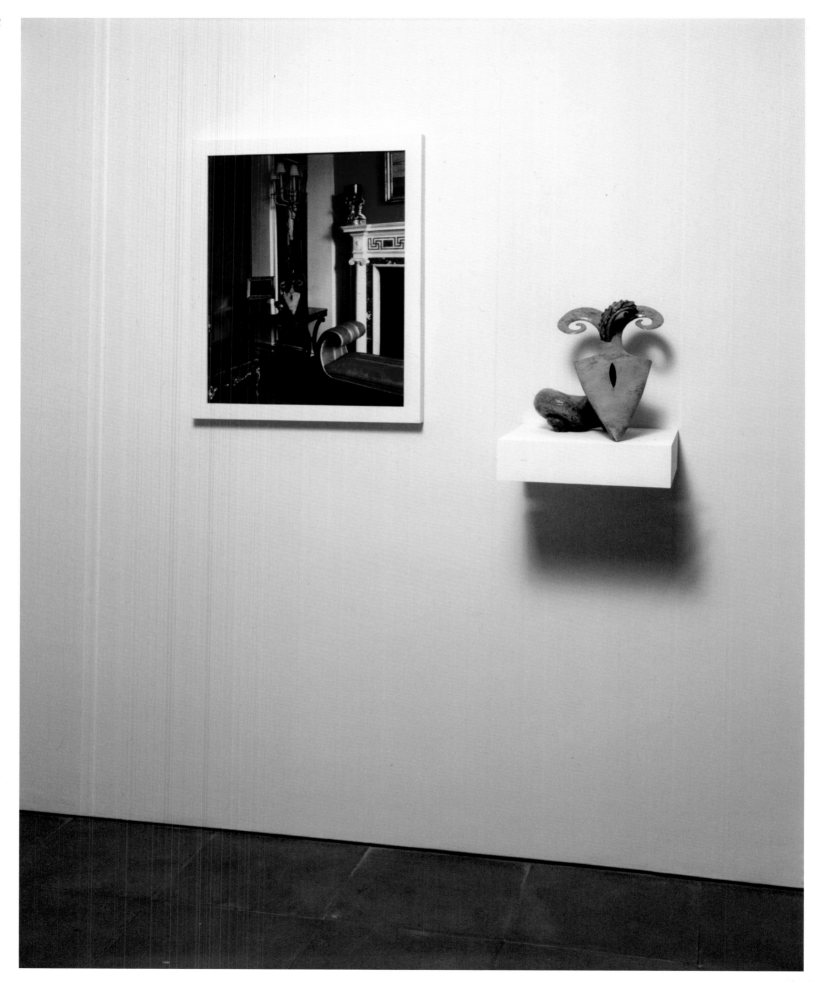

Edward Allington, *Pictured Bronzes: Waiting Unleashed*, 1988–9, photographed by Edward Woodman, directed by Edward Allington (at the Lisson Gallery in 1991)

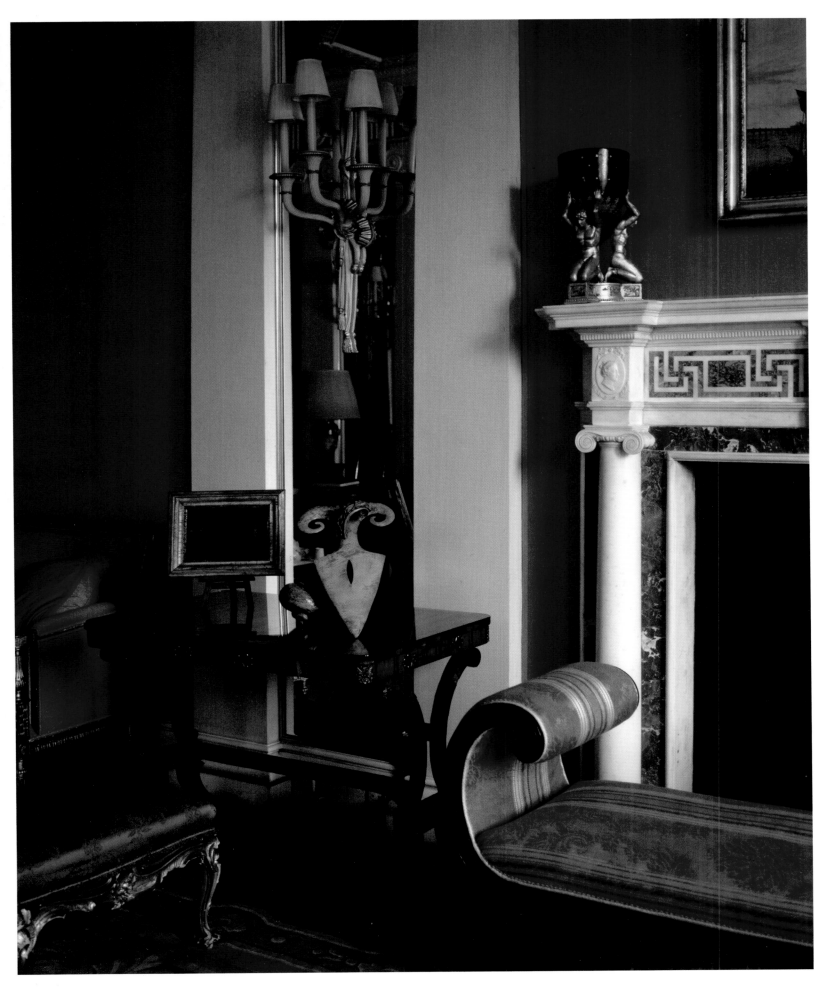

Edward Allington, *Pictured Bronzes: Waiting Unleashed*, 1988–9, photographed by Edward Woodman, directed by Edward Allington

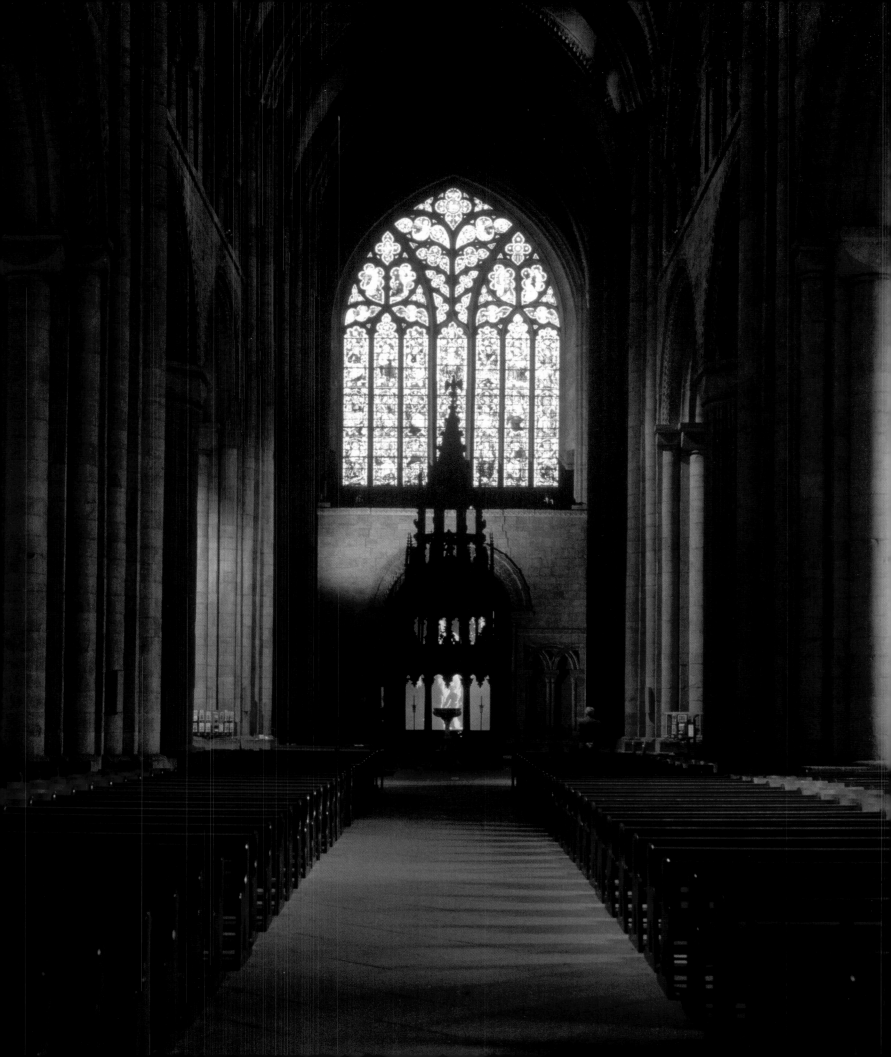

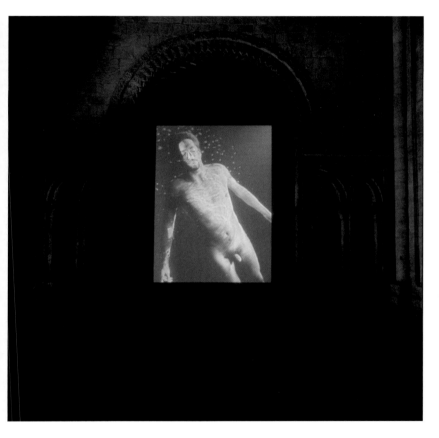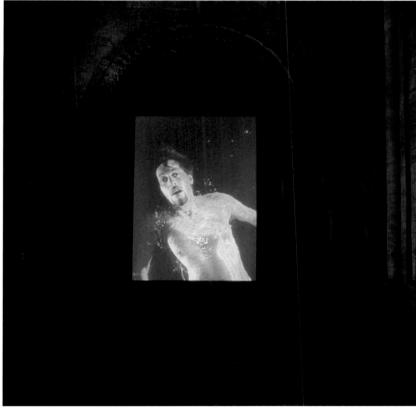

Bill Viola, *The Messenger*, 1996, Durham Cathedral, commissioned by the Chaplaincy to the Arts and Recreation in North-East England

Louise Bourgeois, *Cell*, 1996, The Bell Tower, St Pancras Church, in 'The Visible and the Invisible', a multi-venue group exhibition curated by Tom Trevor and Zoe Shearman and produced by inIVA in the Euston area of London in 1996

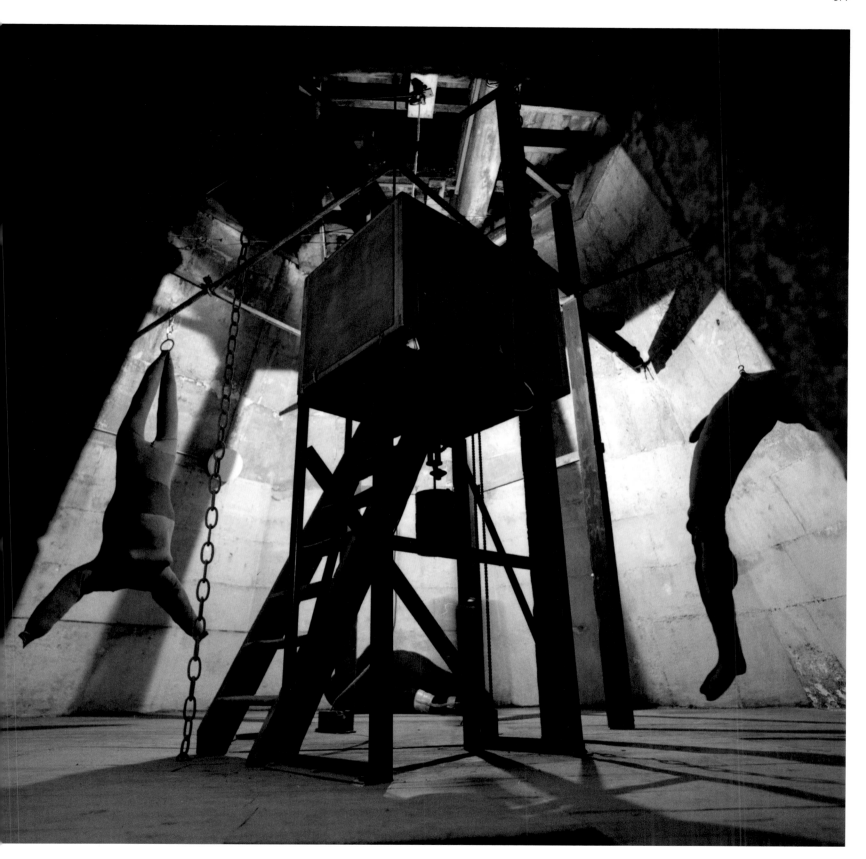

Stuart Brisley, *Chair*, 1996

Stuart Brisley, *1=66,666*, 1983 (detail), Lewis Johnstone Gallery, London

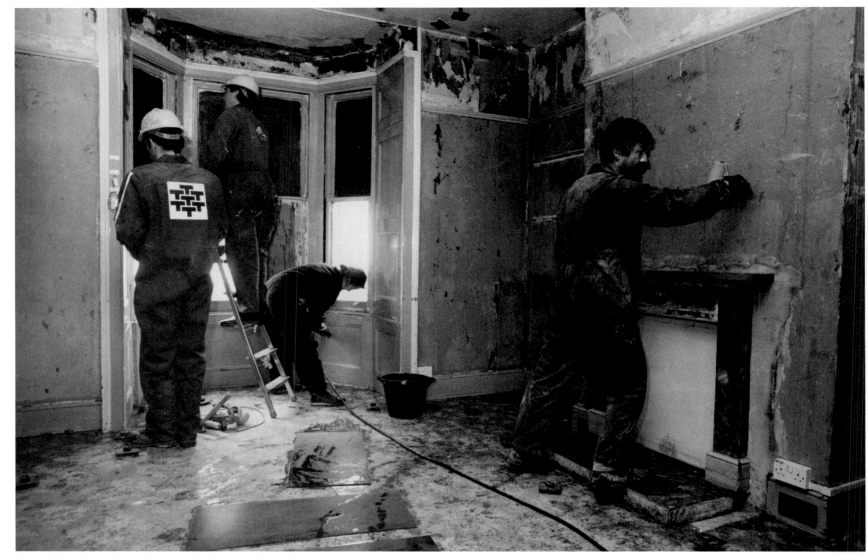

Rachel Whiteread and staff from Tarmac Structural Repairs working on *House*

'I have had people photograph things and you think, "I can't use the photos because they just don't work." I think he taught me how to look at things. And he was just a very nice presence to have around, very calm, quiet, a pleasure to work with. When he came to the studio, you always had very intense talks. He was quite an inspiring character.'

Rachel Whiteread

Rachel Whiteread, *House*, Grove Road, east London, September 1993, commissioned by Artangel with Beck's

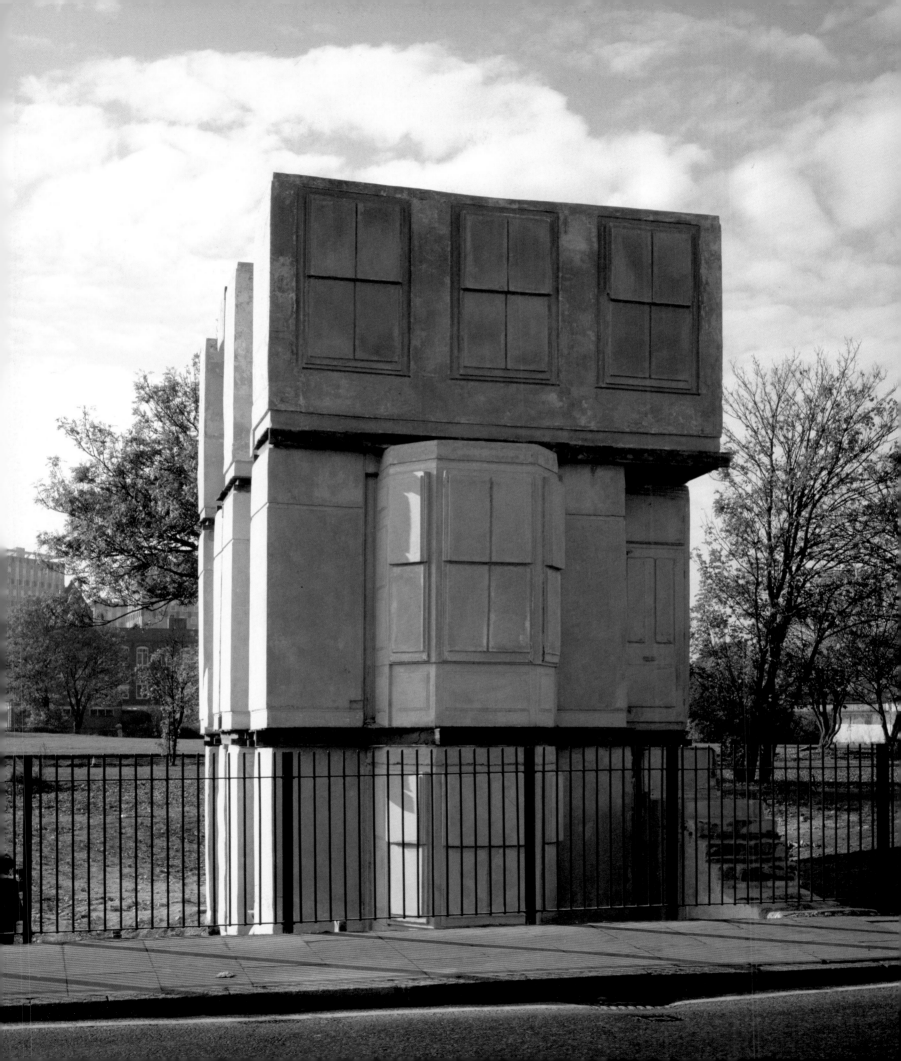

Chronology

1943
Born 27 July in St Albans, Hertfordshire, to Charles and Ruby Woodman.

1946
Family moves to Chadwell Heath, east London.

1951
Edward is given his first Brownie camera at the age of eight.

1953
Begins watching films from the projection box at the Odeon cinema in East Ham, where his father is the manager. Remembers 'honing in' on films, looking through cupped hands and framing specific parts of the image.

1955
School trip to Paris, where early photographs include panoramic views of the city, seen from above.

1959–63
Apprenticed 'to learn the art Trade or Business of a Commercial Photographer' at Charles Edwards & Son, a commercial and industrial photographic company at 84 Fetter Lane, London, where he learns how to use different types of cameras, including large-format plate cameras, and the techniques involved in black-and-white darkroom printing processes.

1962
Develops a friendship with fellow apprentice Frank Gillie, with whom he shares an interest in world cinema and New Wave directors.

1963
Edward and Frank explore London on long walks after work, taking photographs with Edward's Rolleiflex camera of subjects ranging from Georgian architecture in Lincoln's Inn to the warehouses and docks further east along the river. Moves to live at 15 Regent Square in Bloomsbury.

1963–4
Edward completes his apprenticeship and works for Charles Edwards & Son for another year, photographing a wide range of subjects from social events to fashion, furniture, and architecture.

1965
Edward and Frank continue their friendship and record each other in improvised performances in central London. Joins a small commercial photographers' firm in Bloomsbury.

Edward while at the Ilford Boys School, aged around fifteen

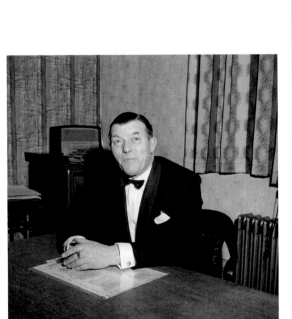

Edward's father, Charles Woodman, photographed at his cinema in 1966

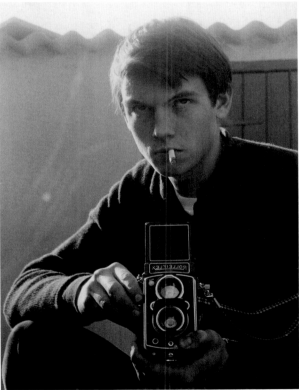

Edward with his Rolleiflex camera, 1963

Periodic photo booth self-portrait, c. 1978, c. 1993, and c. 2013

1966–73
Sets up as a freelance photographer. Work includes photojournalism for the *Observer*, features for the youth magazine *Petticoat*, and interview portraits for *Campaign*.

1968
Works as a freelance assistant to David Thorpe, a specialist car photographer, travelling with him to Portugal, where Edward becomes increasingly concerned with conveying objects in space and the potential effects of natural light in photography.

1968–73
Photographs the work of the interior designer David Hicks, focusing on complex lighting of furniture, interior spaces, and the surfaces of objects. Continues to make his own photographs, documenting the social history of London and demonstrating an interest in ruins and regeneration that continues to this day.

1970
Edward is married briefly.

1971
Birth of his daughter Sam.

1974
With his family, becomes one of the earliest residents in Foundling Court, in the recently completed iconic Brunswick Centre in Marchmont Street, Bloomsbury.

1975–9
Lives in Mortimer Square, North Kensington. Still makes his own photographs, while taking a break from commercial photography to do a three-year teacher-training course.

Late 1970s
Meets a number of Acme artists, whose work he begins to document.

1979
Returns to freelance professional photography.

1980
Moves back to Foundling Court. Meets his partner, the artist Rosemary Nag, who introduces him to the language of painting and drawing.

1981
Photographs joint exhibition by Hannah Collins and Ron Haselden, 'Drawings 1979–80', at the Institute of Contemporary Arts (ICA), London. Commissioned to take photographs for the catalogue of the seminal group exhibition 'Objects & Sculpture' at the ICA and Arnolfini, Bristol. Many of the works were photographed at the exhibiting artists' studios. Begins a life-long friendship and collaboration with Edward Allington, through whom he also meets Julia Wood. In December, solo exhibition at Centre 181 in Hammersmith, '66 Photographs by Edward Woodman'.

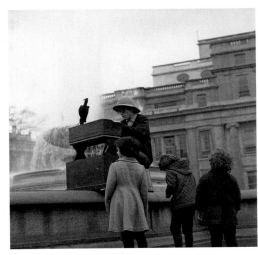
Edward photographed by fellow apprentice, Frank Gillie, in improvised performance in Trafalgar Square, London, *c.* 1965

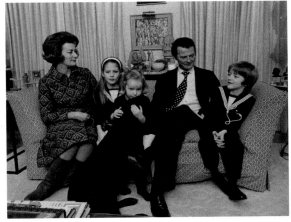
David Hicks at home with his wife Lady Pamela Mountbatten and children Edwina, India, and Ashley at Britwell House in Oxfordshire, *c.* 1970/1

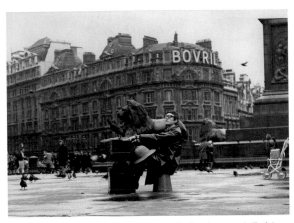
Edward photographed by Frank Gillie in improvised performance in Trafalgar Square, London, *c.* 1965

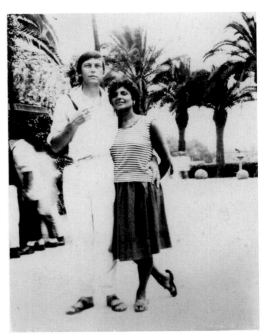
Edward and Rosemary in Barcelona, *c.* 1983

Contact sheet showing boys at play in Notting Hill; Notting Hill shops; and Edward, late 1970s

1982–3

Begins to work for a growing number of architects, and public and private gallery clients, including Lewis Johnstone Gallery, Kettle's Yard, and Chisenhale Gallery.

1983

Photographs Zaha Hadid's acrylic paintings as part of her prize-winning The Peak project. Hadid later invites him to photograph her models, leading to a close association with the architect and her work that lasted many years.

1983–7

Works as a stills photographer for Thames Television covering news and current affairs, 'everything from celebrities at The Embassy Club to riots in Brixton'.

1984

In January, takes photographs of Acme houses, studios, and staff (led by David Panton and Jonathan Harvey), for Acme's 1984 prospectus, *ACME: A Service Organisation for Artists*. Photographs installations by Julia Wood at Chisenhale Gallery, and at Riverside Studios, which becomes a regular client. Begins to document projects for the Public Art Development Trust. In September, invited by Maureen Paley to document Susan Hiller's solo exhibition at Interim Art, 'Inside a Cave Home'.

1985

First meeting with Helen Chadwick through her installation *Ego Geometria Sum* at Riverside Studios. In June, photographs the 'Artangel Roadshow', outside Interim Art in Beck Road, Hackney, with works in the street by Hannah Collins, David Mach, Boyd Webb, and Julia Wood to mark the launch of the Artangel Trust. In September, photographs Eric Bainbridge's solo exhibition at the Air Gallery.

Mid-1980s

Start of collaboration with Edward Allington, *Decorative Forms Over the World*.

1986

Documents Helen Chadwick's solo exhibition 'Of Mutability', at the ICA, after which she asks him to assist in 'all the tougher photographic challenges she set herself'.

1986–7

Photographs memorable performances at Chisenhale Dance Space by David Medalla, Carlyle Reedy, Mona Hatoum, and Anna Banana, among others.

1987

Travels to Egypt with Hannah Collins as her camera operator to shoot photographs in the desert for the 'Heart and Soul' series on a large-format 5 × 4 inch camera. In February, photographs the original installation of Richard Wilson's *20:50* at Matt's Gallery. In June, photographs Kathy Prendergast's *Untitled* installation at Unit 7 Gallery. In September, collaborates with Helen Chadwick on creating the slide-projection images for *Three Houses: A Modern Moral Subject* for the Hayward Gallery exhibition 'Art History', where he photographs the completed installation in November.

1988

In January, photographs the artists and their families living in twenty-five Acme houses with studios in Beck Road for the Beck Road Arts Trust Appeal. In March, photographs Bill Pye's *Slipstream* at Gatwick Airport. Photographs numerous Riverside Studio installations and performances, including Matt Mullican; Tim Rollins & KOS; Mark Wallinger; and Nam Jun Paik. In April, photographs solo exhibitions by Susanna Heron and Madeleine Strindberg at The Showroom, London, the first two curated shows at the gallery (curated by David Thorp). Between July and November, photographs the installation and three rolling parts of the seminal exhibition 'Freeze', at the invitation of Damien Hirst. In September, photographs Helen Chadwick's *Blood Hyphen* at the Clerkenwell and Islington Medical Mission, for the EDGE 88 festival. In November, photographs the process of flattening silver-plated objects by a steamroller for Cornelia Parker's *Thirty Pieces of Silver*.

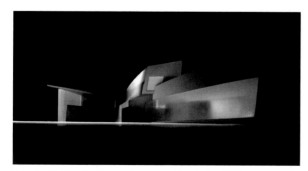

Zaha Hadid, Cardiff Bay Opera House, Cardiff, UK, project design, 1995

Zaha Hadid, Vitra Fire Station, Germany, project design, 1992

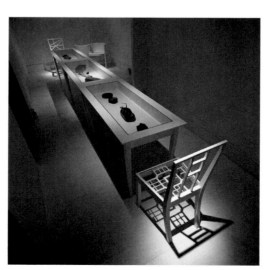

Langlands & Bell, *Traces of Living*, 1986, Interim Art, London

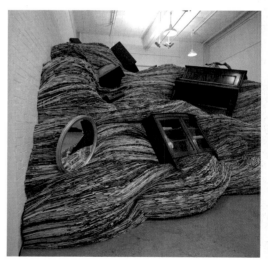

David Mach, *Fuel for the Fire*, 1986, Riverside Studios, London

Zaha Hadid contact sheet, mid-1990s

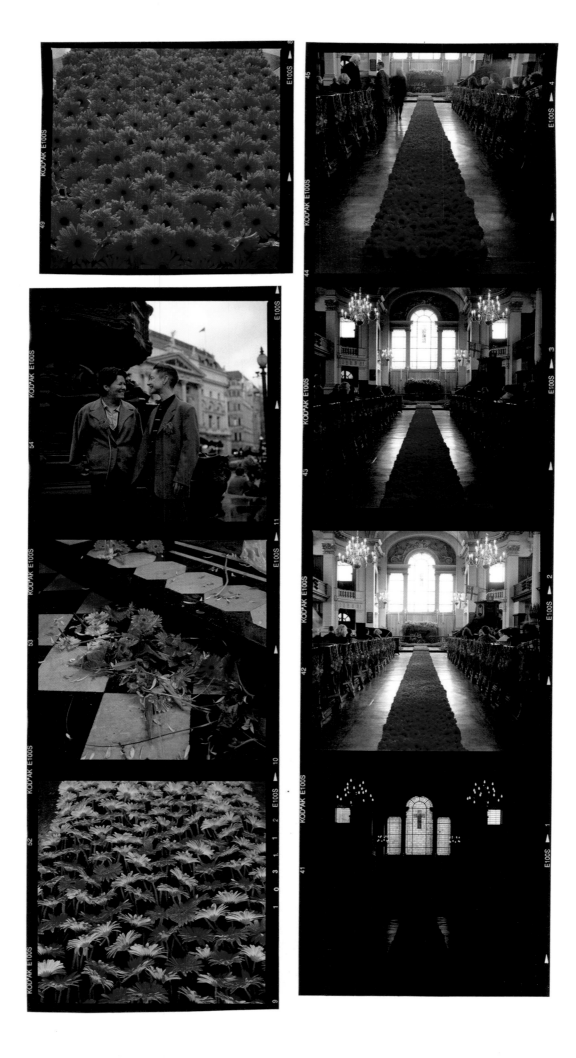

1989

In February, photographs Donald Rodney in his solo exhibition 'Crisis' at the Chisenhale Gallery, and in June, photographs Lubaina Himid's solo exhibition, also at Chisenhale. In July, photographs Mona Hatoum's installation *The Light at the End* at The Showroom. In October, photographs Melanie Counsell's installation at Matt's Gallery, and in November, photographs Christopher Le Brun's solo exhibition at Nigel Greenwood Gallery, London. In November, photographs Yayoi Kusama's solo exhibition 'Soul Burning Flashes' at MOMA, Oxford.

1990

In February, photographs Ron Haselden's *Fête* at the Serpentine Gallery, London (previously photographed at Feeringbury Manor, Essex, in May 1989). In March, photographs Yoko Ono performing in her solo exhibition 'In Facing' at Riverside Studios, London. In May, photographs Abigail Lane's work in 'Modern Medicine', curated by Billee Sellman, Carl Freedman, and Damien Hirst at Building One in Bermondsey. In June, photographs the exhibition 'Gambler', curated by Billee Sellman and Carl Freedman at Building One. In July, attends and informally photographs Cornelia Parker's Disaster Party. In October, photographs Michael Landy's *Market* at Building One.

1991

In January, photographs Richard Deacon's first large-scale, outdoor permanent commission *Let's Not Be Stupid*, sited at the entrance to the University of Warwick. In March, photographs Phyllida Barlow's installation *Deep* at the Museum of Installation. Photographs Edward Allington's 'Pictured Bronzes' series at the Lisson Gallery for the catalogue accompanying his exhibition at the Kohji Ogura Gallery in Nagoya, Japan, later in the year.

1992

In February, photographs the external works for the exhibition 'Doubletake: Collective Memory and Current Art' at the Hayward Gallery and installations at the Ikon Gallery by Shelagh Wakeley and Vong Phaophanit. In July, photographs Anya Gallaccio's *Red on Green* at the ICA.

1993

Photographs the creation of Rachel Whiteread's *House* in Mile End, Tower Hamlets. The Winter 1993–4 issue of *Untitled* magazine includes a feature entitled 'Edward Woodman … Photographing the Experience', in which he describes his approach to photographing site-specific ephemeral installations.

1994

16 March–30 April, solo exhibition 'Edward Woodman – Installation Art: The Collaborative Eye', at the Museum of Installation. Photographs 'Air and Angels', an exhibition of sculptures by Antony Gormley and Alison Wilding, presented by the Contemporary Art Society, in the ITN Building, Gray's Inn Road, London. Photographs the group exhibition 'Some Went Mad, Some Ran Away', curated by Damien Hirst and organized by Andrea Schlieker, at the Serpentine Gallery, London.

1995

In March, photographs Abigail Lane's solo exhibition 'Skin of the Teeth' at the ICA. In December, photographs Mat Collishaw's solo exhibition at Karsten Schubert Gallery, Foley Street, London.

1996

In March, Helen Chadwick dies. In July, photographs Juan Muñoz's *Conversation Piece (Dublin 1994)* at Ravensdowne Barracks, in the Berwick Ramparts Project. In September, Chadwick's memorial service at St Martin-in-the-Fields. In the same month, photographs Bill Viola's *The Messenger* in Durham Cathedral.

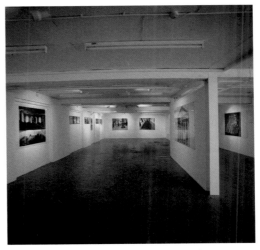

Installation view, 'Edward Woodman – Installation Art: The Collaborative Eye', Museum of Installation, London, 1994

Rachel Whiteread working on *House*, September 1993

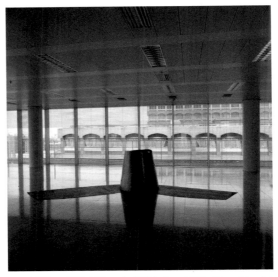

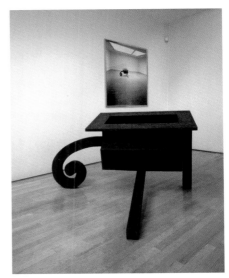

Contact sheet for Helen Chadwick's memorial service, St Martin-in-the-Fields, September 1996

Alison Wilding, *All Night Through*, 1986, in the exhibition 'Air and Angels', 1994

Edward Allington, *From the Sex of Metals III*, 1990

1997

In April, gives lecture on the theme of *Impossible Photographs* at University of North London, School of Architecture and Interior Design, describing himself modestly as a 'documentarist', creating 'just another version of reality' by moving through space to find the right angle and light, and then 'just pressing the button'. Photographs Dan Graham's solo exhibition 'Architecture 1' at Camden Arts Centre. In July, photographs Keith Piper's solo exhibition 'Relocating the Remains' at the Royal College of Art. Louisa Buck publishes her guide to contemporary British art, *Moving Targets*, which features Edward. Takes architectural photographs for Peter Cook at the Bartlett School of Architecture and Jonathan Hill at the Architecture Association.

1999

Photographs *Michael Landy at Home*, 7–9 Fashion Street, London.

2000

In January, photographs Mona Hatoum's *La Grande Broyeuse*, the inaugural Tate Britain Commission to create a new work for the Duveen Galleries. In March, suffers serious injuries in a cycling accident, which prevent him from working professionally. His physiotherapist and occupational therapists encourage him, however, to return to taking photographs, which aids his recovery.

2002

Edward explores his local neighbourhood and starts to document the redevelopment of the King's Cross area, returning to photograph the same views as the project progresses. Is introduced to the speech therapist Judith Langley, through whom he meets the artist Imogen Stidworthy.

2007

Is the subject of Imogen Stidworthy's installation *I hate*, commissioned for documenta 12, Kassel. Agrees to photograph both the work in which he appears and several other installations in the exhibition for a picture book commissioned by documenta.

2016

Is invited to participate in Art360 Foundation programme. Documents the 'living art work' by Anya Gallaccio and landscape architects del Buono Gazerwitz at the new headquarters of DACS in Bethnal Green, east London.

2017

Solo exhibition 'Shooting Performance: Edward Woodman', presented at Symes Mews, Camden, by the Art360 Foundation in association with the David Roberts Art Foundation.

2018

24 November – 2 February 2019, solo exhibition 'Space, Light and Time: Edward Woodman, A Retrospective' at the new John Hansard Gallery, University of Southampton.

Chronology compiled by Judy Adam

Edward's living room with his film drying cabinet at Foundling Court, Brunswick Centre

Edward with his camera in Café Bolivar, Avenue Secrétan, Paris, *c*. 2013

Contact sheet for documenta 12, 2007, showing Imogen Stidworthy's *I hate*, photographed during the installation process, and Ines Doujak's *Siegesgärten* (top left)

Artist's acknowledgments

I would like to thank all the artists and curators who have inspired and encouraged my work over the years, and to dedicate this book to my daughter. Warm thanks to my family and close friends, including my speech therapist Judith Langley, for all their support and encouragement. Special thanks to Gilane Tawadros, Herman Lelie and Ashley Mottram, and to Judy Adam, without whose tireless work this book would not exist.

Edward Woodman
September 2018

Editors' acknowledgments

First and foremost, we would like to thank Edward Woodman, whose gracious support, insightful judgment, and beautiful images have been the inspiration for this publication. We are enormously grateful to Rosemary Nag, Edward's rock and soulmate, whose support, advice, and understanding have been invaluable.

This book would not have been possible without Herman Lelie (alongside Stefania Bonelli), who has been instrumental in making the project happen and who has guided Edward and us throughout. Herman worked with Andrew Brown, to whom we are deeply grateful for his wonderful support and meticulous diligence in preparing and publishing this volume. Special thanks are due to Ashley Mottram, whose digital skills, boundless energy, and exemplary archival approach have been critical. We are grateful also to Frank Gillie, Edward's fellow photographic apprentice in the early 1960s, and the master printer Stuart Keegan, who worked closely with Edward.

Our thanks go to Phyllida Barlow for her poetic and perceptive foreword, and to all the artists who agreed to be interviewed for this publication and who contributed their brilliant insights. We thank also Abigail Lane for the wonderful cover photograph of Edward at work. We are grateful to everyone whose artworks and portraits are included, and who have been so helpful and supportive in the making of the book.

Thank you also to Mark Waugh, who has done so much to bring this book to fruition, and to the brilliant teams at DACS and the Art360 Foundation for all their hard work, especially Laura Ward-Ure. Edward's participation in the Foundation's Art360 project has been vitally important, enabling the scanning of his archive and providing the opportunity to introduce Ashley to the project, which has literally transformed Edward's life.

John Hansard Gallery in Southampton has curated a major and important exhibition of Edward's work in partnership with Art 360 Foundation to coincide with the publication of this book, the first time that Edward's work has been brought together and shown in this way since 1994. Sincere thanks go to all the John Hansard Gallery team, and in particular Woodrow Kernohan and Ros Carter, for their thoughtful curation and realization of the exhibition, and for their ongoing support and commitment to Edward and his work. The John Hansard Gallery exhibition follows on from David Roberts Art Foundation's (DRAF) exhibition of Edward's performance and installation works in 2017, which was generously supported by Indre and David Roberts and Vincent Honoré.

Finally, the book would not have been possible without the generous support of Arts Council England's Grants for the Arts programme, funded by the National Lottery, and the generosity of Edward's friends and supporters who have contributed financially to its production. We are indebted to all of them for their support.